More Than One Life

A Memoir of Life, Love, and Laughter

GAIL INGIS

For permission requests, write to the publisher at the address below:

Gail Ingis

gailingisclaus@gmail.com

ISBN EBOOK: 978-1-7373369-4-5

ISBN PRINT BOOK: 978-1-7373369-5-2

What People are Saying...

"I haven't laid eyes on Gail in person for over 25 years, but somehow, we remain friends like not a day has passed. Gail's thirst to learn and drive to do haven't diminished one bit over the course of her life. When others retired, she ramped up. How? Why? The answers to those questions, and the reason she still inspires me, can be found in these pages."

— Stephanie Bower ~ Artist and
Instructor of Architectural Illustration ~
Author of the Urban Sketching
Handbooks Series

"A riveting and moving journey from start to finish. Gail Ingis has written a delightful and, at times, heart-wrenching memoir. This story takes the reader from her early beginnings in Brooklyn, NY, to a lifetime of defining experiences that explore the challenges and joys of family and parenting, while pursuing a successful career in the world of art and design."

— Susan Gilgore, PhD, Executive Director Lockwood-Mathews Mansion Museum

"It's a tale of resilience that emerges when life takes you on unexpected paths. This well-crafted memoir tells of Gail's hard choices, disappointments, and missteps with honesty, humor, and a rare depth of insight. Her journey will leave an indelible mark on your heart; the pearls may help point the way on your quest for a happy ending. I highly recommend reading on to find out for yourself."

— Alan M. Reznik, MD ~ Chief Medical Officer CT Orthopaedics Associate Professor of Surgery Frank M Netter School of Medicine Quinnipiac University ~ Author of: *The Knee and Shoulder Handbook for All of Us* and *I've Fallen and I CAN Get Up!*

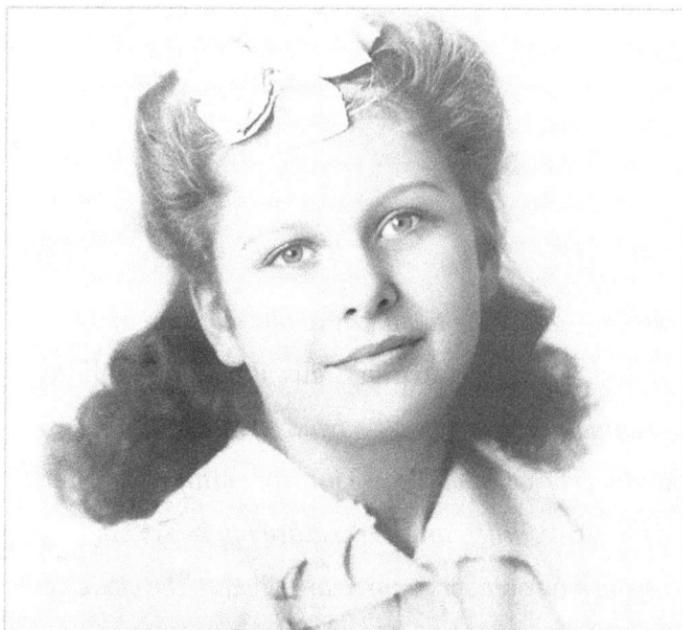

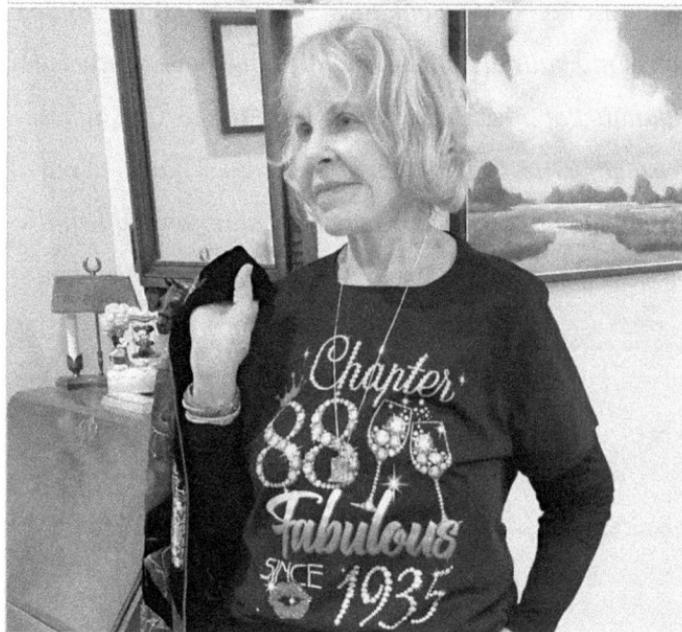

Gail ~ 11 & 88

Behold, allow me to introduce my husband and best friend, Thomas Harrison Claus, PhD—a committed companion throughout a triad of decades. My hero hubby crops my wild prose into an entity resembling a botanical garden and makes sure my books have the polish our readers appreciate. Clad in the cloak of domestic domain, he valiantly confronts tidying while I wield my culinary sorcery. United, we have concocted a banquet of affection and fun! In praise to Tom, whose steadfastness rivals that of Hercules. Thanks to my amazing hubby, who acted as an editor on my behalf, tirelessly supporting me and my writing. He has shown me what happily ever after means.

For that, and a million other reasons, this memoir is dedicated to you, Tom.

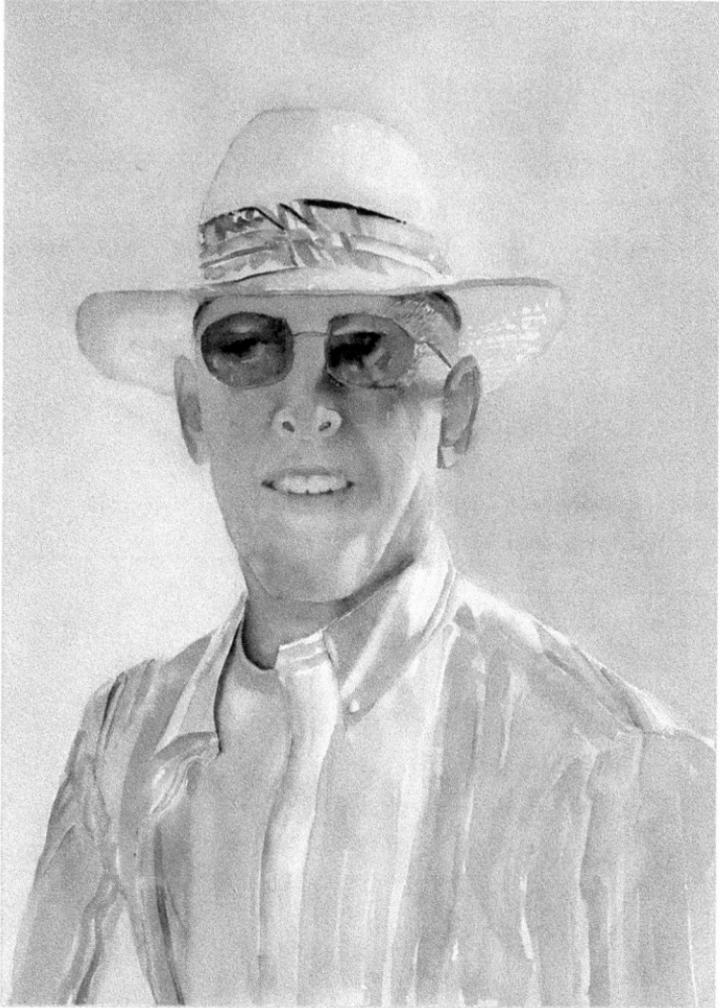

Thomas H. Claus
Portrait by Gail Ingis

Contents

More Than One Life

A Memoir of Life, Love, and Laughter

Gail Ingis

Ingis Design Ideas

"*More than One Life* is a memoir about one woman's incredible drive to always be curious and engaged. Although her life was filled with a loving, supportive family, it wasn't always perfect. Gail writes with intelligence sprinkled with humor and wit. Gail Ingis provides a well written memoir with lessons on how to create a rich and rewarding life."

— *Blake Schnirring Executive Director Westport Writers' Workshop*

"Gail has written her exciting life story with bravery and truth"

— Rahla Xenopoulos ~ Author of *A Memoir of Love and Madness;* Instructor at Westport Writers' Workshop

Why I Wrote This Book

Hello Dearies,

Here I am, Gail Ingis—your guide to aging gracefully and finding laughter in the wrinkles! When people say to me, "I want to be you when I grow up," I say, "Sweetie, you better start hoarding moisturizer now! Life's challenges may be tough, but a good dose of humor, positivity, and clean cream can make them a little easier to bear."

Please permit me to paint you a picture. The visual aspect is rather eye-catching. A defining moment at age eight shaped my perspective on the uncertainties of life's unexpected changes. On the shores of Rockaway Beach in Queens, I nearly drowned in the unforgiving waves of the Atlantic Ocean. With its undercurrents of

danger, the beachside location became a metaphor for the complexities of my existence.

Additionally, allow me to inform you about those churning waters. I unearthed a resilience within myself —an unyielding force. I learned to adapt and thrive amidst the unceasing curves of fate hurled my way. I assumed the role of the central character in my own narrative, navigating each plot twist with elegance and, occasionally, some stumbles.

Am I fitting in? My darlings, I gave up on that a long time ago. I'm too busy learning to be myself and finding satisfaction in the chaos. The human brain is a complex thing—I'm a living testament to that. I've shifted personas like a fashion model changes outfits. And speaking of fashion, looking fabulous is a must. My mother always said, "Dress well, darling. You never know when you'll run into your ex." I say dress well, even if you're going to Costco. You never know when paparazzi might mistake you for a celebrity.

At the tender age of seventy-four, I embarked on a writing career. The inspiration behind this literary adventure arose from Albert Bierstadt's majestic paint-ing, *The Domes of Yosemite* that long ago hung in the rotunda of Lockwood-Mathews Mansion, where I serve as a trustee and art curator.

A desire to write surprised me too, considering my childhood issues with reading comprehension. I never

received a dyslexia diagnosis growing up, but I discovered in 2009 as a new writer, I *don't* always understand what I'm reading.

The impetus for my memoir came unexpectedly, sparked by my editor and friend Joanna D'Angelo. Joanna insisted that my tales of growing up in the 1940s and 1950s in Brooklyn were captivating, poignant, and historic.

The prospect ignited my curiosity. I discussed it with Tom, my eternally wise sounding board. We found ourselves on the backyard swing, sipping wine amid the blooms of Dipladenia. Tom, a brilliant scientist and skilled gardener, endorsed Joanna's idea with a toast.

Sharing my life wasn't easy, but I gained the confidence to embrace the challenge with my family's support. I attended workshops by Westport Writers' Workshop and read several memoirs, including *The Glass Castle* by Jeannette Walls, *The Liars' Club* by Mary Karr, *Eat Pray Love* by Elizabeth Gilbert, and more amid my memoir-writing. I found inspiration from remarkable individuals who, like me, dared to share the intricacies of their lives.

One such luminary is Rahla Xenopoulos, an instructor at Westport Writers' Workshop, whose memoir on her profound struggles with eating disorders left an indelible mark on my narrative exploration. Rahla's candid account served as a poignant reminder

of the varied and tumultuous paths we navigate. Her willingness to lay bare her mental health challenges, a topic often shrouded in silence, spurred me to approach my memoir with an even more significant commitment to authenticity and openness. I am grateful for Rahla's profound influence on my writing and her contribution to the broader conversation surrounding the human experience. Through her courageous storytelling, she personifies the power of words to heal, inspire, and connect us all.

So here I am, staying steadfast, a symbol of the strength that emerges when you go on those unexpected journeys. But hey, who doesn't stumble in life's obstacle course? Although my life still has humor, poise, and a touch of sparkle. Oh, and always a good lipstick!

As I embarked on the monumental task of encapsulating eighty-eight years in approximately 300 pages, I couldn't help but recall Bette Davis's iconic line from *All About Eve*:

"Fasten your seat belts. It's going to be a bumpy night."

Ellis Island ~ immigration documents

Chapter One
Ellis Island ~ July 1914

C rowded with immigrants wearing long, bulging coats and head coverings, the family of four kept to themselves aboard the dark, foreboding train. Clara, my mother, who was five, clutched her older sister Miriam's hand as they huddled closer to their parents. Their mother, Rose, had layered clothes to save space in the valises and sewed pockets in skirts and aprons to hide bread. Nothing was more precious than chunks of challah stuffed in those pockets ready to eat when they needed sustenance. The trip from Proskurov, Russia to Rotterdam, Holland exhausted her, but she was more than ready, in the summer of 1914, to board the ship *Campanella* for their voyage to America.

At first, passengers in steerage kept the area clean,

but the ship encountered thundering storms, prolonging the journey and causing seasickness. Clara's father had bought decent berths for sleeping and had arranged permission for his family to take walks on the upper deck. Rose kept her girls close and made sure they had food and water. She rationed the bread from their pockets until there was no more. Food given out by the ship's kitchen was sparse. Most of the time, Clara would huddle in her berth, where she wasn't so afraid. People quickly overwhelmed the latrines.

The damp steerage air smelled of urine and feces. Rodents crawled over the dying, spreading disease. A little girl held the hand of her mother, who moaned and cried as one of the ship's attendants wrapped her dead infant son for burial at sea. Clara wept at all this sorrow. It took twelve days to reach America but felt much longer. As soon as they reached port, Clara got squeezed between everyone, pushing and shoving to get off the ship. She and Miriam huddled close to their mother, each gripping a hand. One behind the other, they hurried down the gangplank and off the ship of horrors. My mother heard people say that America had streets made of gold. Clara knelt on both knees and kissed the ground. She jumped up and grabbed her sister, hugging, dancing, and giggling.

Clara's father, Harry, was a jeweler in Russia, where violent mobs had threatened his store. My mother

remembered crouching in her grandfather's soap barrels when attacks drove everyone into hiding. It was a wise choice to leave Russia. Jews that remained would lose their lives. More than 100,000 Jews were killed in the Russian pogroms.

After my Katz relatives settled in America, Grandpa Harry opened a jewelry store in the Williamsburg section of Brooklyn, near the tenements. The streets were bustling with immigrants, each chasing the American Dream, and my grandpa was no exception. His shop became a glittering beacon on the crowded, cobblestone streets, offering a slice of elegance in a rough-hewn world. He made more than an adequate living dealing in watches, diamonds, and gold. His reputation for fairness and craftsmanship spread quickly, making his store a cherished establishment in the neighborhood.

I remember the day he gave me a pinky ring with seven diamonds forming the letter *L* for Lenora, my middle name, after my grandmother's sister, Lifsha. The ring sparkled with the same vibrant energy that Grandpa exuded. It was not just a gift but a symbol of our heritage and his hopes for my future. Years later, I gave the ring to my daughter, Linda, who was eight. It fit her pinky perfectly. But she lost the ring the first day, and it broke my heart. Something so tiny and delicate lost forever. Linda was a child and could not be faulted

for doing what children do. I blamed myself for not being more careful and waiting to give her the ring until she was older and could take care of it. Note to self: pinky rings slip off easily!

Grandpa's jewelry store was a magical place to me. He gave me a gold wristwatch with a white face, black numbers, and gold minute and hour hands. Grandpa taught me how to keep it working. "Wind it every morning," he said. It kept perfect time. I cherished that watch for years. It was a link to him, a reminder of his love and the lessons he imparted. When Grandpa passed away, the light in my life dimmed.

When my watch stopped working, it was like losing Grandpa again. I took it to the jeweler, hoping for a simple repair, but the news was grim. The jeweler could do nothing to restore it. My stomach churned with a sense of loss.

After his death, Clara had the daunting task of cleaning out his shop. She found drawer after drawer filled with what seemed to be endless amounts of tissue paper. Bewildered, she discarded them by the handful, flushing them down the toilet, until a neighbor, who had often visited Grandpa's store, revealed that each tissue held a diamond. My mother's shock, she told me, was palpable, a poignant reminder of how Grandpa's careful and meticulous nature had been lost amidst our grief.

Despite these sorrows, Grandpa's legacy lived on. His store, even emptied of its treasures, stood as a testament to his hard work and dedication. Our family carried forward his spirit of resilience and ambition. My mother and my Aunt Miriam, with her lively household, were the living embodiments of the dreams Grandpa had once harbored. As I gaze at the now silent watch, I can almost hear his voice reminding me that time, like love, is the most precious jewel of all. In the end, it wasn't just the diamonds and gold that defined Grandpa's success. It was the way he touched my life, instilling in me a sense of pride and purpose. I inherited a proud legacy.

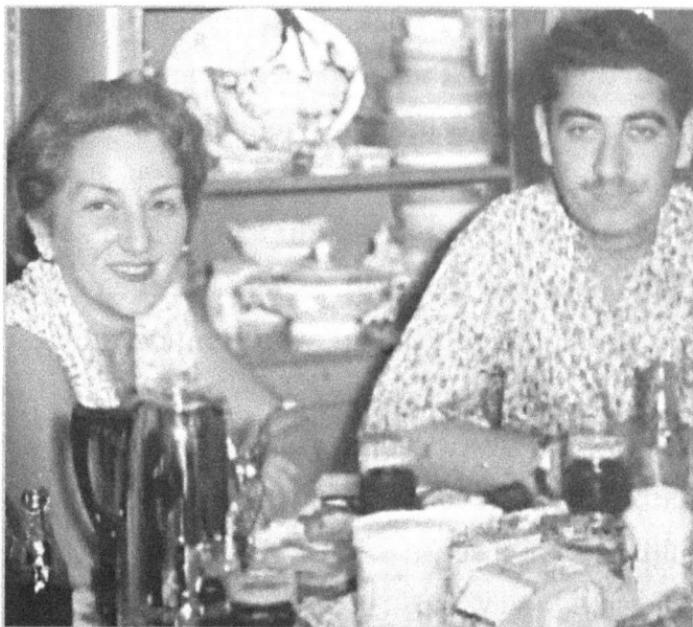

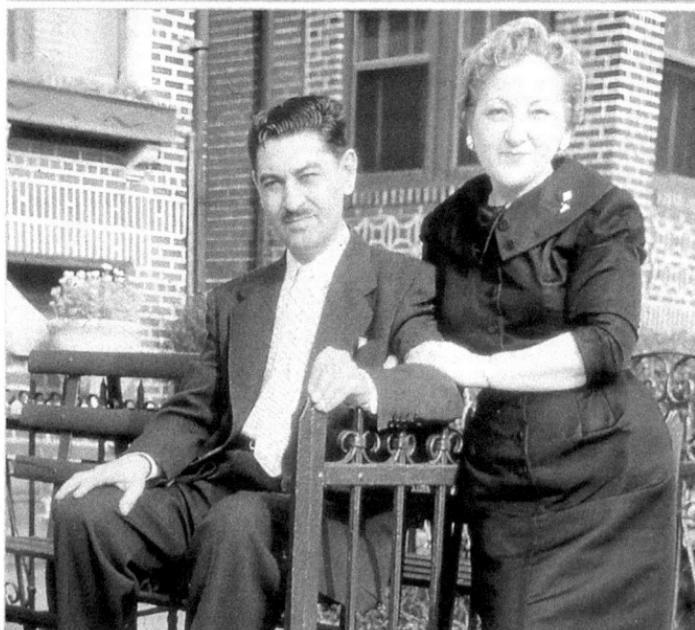

Mom and Dad ~Clara (Claire) & Bernie

Chapter Two
When Bernie Met Clara ~ Spring 1929

Grandma Rose Katz became a matchmaker with a zeal reminiscent of Jane Austen's Mrs. Bennett, who famously fussed over her daughters in *Pride and Prejudice*. Dreading the specter of spinsterhood for her daughter Clara, Rose followed the suggestion of the neighborhood yenta and wrote a letter to Nathan and Dora Gerber. In the letter, Rose proposed that their son, Bernie, meet Clara, her lovely daughter. The communication was successful, and all four parents agreed to the alliance. I don't know all the details of this extraordinary matchmaking meeting, but I am here to tell you it was a resounding success.

Grandpa Harry was far more captivated by the allure of his jewelry store than by his wife's relentless

matrimonial machinations. He discovered that diamonds, supposedly a girl's best friend, as in the movie starring Marilyn Monroe, gave him an escape hatch from his wife's persistent chatter. Are diamonds, in fact, a man's best friend?

In a rare moment of unity, all four elders concluded that Clara Katz and Bernie Gerber would make a flawless pair. It was less a love match and more a masterstroke of parental plotting. After all, what could be more romantic than meeting your future spouse through the meticulous scheming of four doting parents?

Clara Katz, my mother, most likely lived with her sister's family at 182 Bay 22nd Street in Bath Beach, Brooklyn. Clara, a woman of formidable determination and ambition, presents a historical problem, with her residence listed on their marriage license as being built in 1933, four years *after* their marriage in 1929. This puzzle deepens, considering the Gerber family worshiped at Borough Park's Congregation Beth El, far from Bath Beach. In those days, people typically lived where they worked and worshiped where they lived. Clara's parents, Harry and Rose, had an apartment above Harry's store in Williamsburg, which made perfect sense. So if the parents did not live or worship close to each other, how did the Katz and Gerber parents arrange the meeting of Bernie and Clara?

Enter the yenta, matchmaker extraordinaire! A Jewish woman bustling about with an air of authority, her ears ever attuned to the whispers of eligible bachelors and bachelorettes. With a twinkle in her eye and the wisdom of the ages in her heart, the yenta wove her matchmaking magic. She extolled the virtues of Bernie and Clara to each set of parents, ensuring their paths would cross despite the logistical hurdles, thus crafting love stories with heart and a dash of chutzpah.

"Ah, Bernie!" she no doubt exclaimed to Rose. "Such a handsome young man, so tall and strong. He will make a fine husband for your Clara."

"Ah, Clara," she no doubt confided to Dora. "Such a virtuous young woman, determined to help her future husband succeed. She will make your Bernie a wonderful wife."

Clara was open to love, provided it didn't hinder her career aspirations. She took after her mother, a math teacher in Russia. After all, Clara had graduated from an all-girls secretarial school in Bay Ridge, Brooklyn. That was where she learned the skill of bookkeeping, which would give her earning power throughout her life.

Clara, who kept a diary, surely must have mused romantically about Bernie, but with her particular pragmatism: *If I must marry, I certainly couldn't do better than Bernie Gerber. He's handsome, secure, and working for*

his father. I appreciate his trim, six-foot-tall frame and chiseled features. His sparkling green eyes and thick dark hair are certainly a bonus. His manicured hands and long, elegant fingers with no dirt under his fingernails are also pleasing.

Clara and Bernie tied the knot on July 24, 1929, at Manhattan's City Hall, 32 E. Fourth Street. Bernie was twenty-three, and Clara a fresh-faced twenty. What? No grand celebrations with flowers, family, and friends? Only a reverend was officiating, with a clerk as the sole witness. Strange, this low-key affair. It had to be a lack of money. I couldn't imagine my mom settling. Maybe that was why she fussed so much about my wedding.

Bernie's father, Nathan Gerber, was a wealthy property owner. Why didn't he throw a lavish party for his son and new daughter-in-law? Did he know what was coming? Talk about timing! No one could have predicted the stock market crash, but it happened just a few months later, on October 24, 1929, causing the Great Depression of the 1930s.

After the wedding, my mother changed her name to Claire. I remember her telling me her name was old-fashioned. Her name had to fit her new persona. After all, she was now a married woman with a handsome husband who worked in the family business. They left for their Niagara Falls honeymoon, and when they

returned, Dad continued working for his father until the crash.

I still have the small, fringed brown beaded purse Mom bought in Niagara Falls. I use it to hold my SE iPhone. Imagine that! It fits perfectly with my tissue and lipstick.

Dad was the epitome of sartorial elegance in those days, strutting about in his navy wool suit with two buttons undone. His shirt was a dazzling white, perfectly pressed with French cuffs. His handkerchief peeked out from his left pocket, and he had just a hint of shirt sleeves showing—exactly half an inch, because anything more would be anarchy. He wore leather alligator-laced oxfords and matching cotton socks, proving that even his toes were too stylish for the rest of us. He held a prestigious job working alongside his father in the family property management business and walked with his head held high, exuding pride for his role in his father's legacy.

Dad's three brothers were all college men: Moe, the lawyer; Sol, the orthopedist; and Jack, the businessman. Though he dreamed of studying architecture, Dad didn't get the chance to earn a degree, because Grandpa needed him in the family business. He would've made a brilliant architect, but alas, with no choice, he ended up working in lucrative real estate.

The newlyweds lived in the Gerber three-family

house in Borough Park, Brooklyn, a cozy arrangement with relatives. But then a fallout with Bernie's father changed everything. More than likely, the fallout was Black Thursday, the October 1929 crash. Grandpa lost all his money and had to let Dad go.

No more jobs in the family business. No more financial security. And no more sartorial elegance. Nobody ever disclosed the details, but Mom distanced herself from Dad's family and urged him to do the same. What kind of man disowns a son, leaving him penniless and without a trade? Over the years, Dad would only say that he and his father had a falling out. Was it fair that Nathan Gerber had prevented one of his sons from going to university, claiming him for the family business, only to rip that security out from beneath him?

My father didn't talk about the situation but occasionally visited his father. He could not claim a career like his brothers or embrace his envisioned livelihood. He was a hard worker and often worked two or more jobs. With the abrupt end to the good life, Bernie and Claire were resilient and stuck together. This is when Claire's older sister, my aunt Miriam, offered a temporary invitation to live in the Bath Beach apartment alongside her and her family.

Dad became the neighborhood "Mr. Fixit," earning respect and a few bucks by mending and tinkering

everything for the neighbors. Back then, a man's worth was related to his earnings, and every dollar counted.

Bernie and Claire were living with relatives, but poverty loomed on the horizon, though not as dire as Frank McCourt's heart-wrenching memoir, *Angela's Ashes*. Dad's real estate training was useless; he had no money to invest nor land to build on. But then, they caught wind of a rent-free apartment on Snyder Avenue in the Flatbush section of Brooklyn.

"Is it too good to be true?" Claire asked her sister.

"Maybe, maybe not. But news like that is worth looking into," Miriam replied.

The building on Snyder Avenue stood four stories tall with a wraparound porch. The owner of the building offered a free apartment for a handyman. Dad, who'd earned his "Mr. Fixit" nickname, became a handyman extraordinaire—fixing faucets, replacing windows, tightening screws, and painting walls. Like a doctor, he was always on call.

Meanwhile, Claire kept the hallways and staircases spotless. She was always baking chocolate chip cookies. The cookies were so popular among the tenants that it's a wonder she didn't open a bakery.

The porch was a social hub, with fainting couches for the ladies, poker tables for the men, and an icebox for cold drinks. When I was a little kid, it became my playground, with plenty of rockers to hide behind when

thunder rumbled and lightning turned the sky shades of stormy gray and green.

My brother, Jay, was born at Israel Zion Hospital, and a few years later, I arrived at Adelphi Hospital. Mom named me Gail, after the actress Gale Storm. I never asked why she spelled it differently. My middle name, Lenora, honors my maternal Great-Aunt Lifsha, who I had heard was a gentle soul.

Mom said I was a good baby, albeit plagued by hives. She soaked me in oatmeal baths to stop the itching. Eventually, she discovered strawberries were the culprits. But not the only culprits. The food allergies have persisted throughout my life. My allergist told my mother to stop smoking for my sake, but she couldn't quit. It turned out that her smoking made me more sensitive, and my allergies worsened.

Smoking was her nemesis. But it didn't bother George, the supermarket owner who ran an ad for a bookkeeper. Mom, having had training in bookkeeping at the girl's school, answered the ad, and from the time she got the job, we always seemed to have enough money.

She took me to dance school with Anita, George's daughter. I was five, and Anita was a year younger. We learned ballet and tap.

Dad took a side job to pick up and deliver laundry. His work kept food on our table. On Saturday, when I

didn't have school, he invited me to come along. Every trip felt like a mini adventure. The old box truck had a unique personality. One of its quirkiest features was the round hole in the floor—my potty place if needed. It was up front, with a small passenger seat behind the hole and next to my father.

In the winter, air rushed through the hole, making the inside of the truck as chilly as the great outdoors. If Jay came, we rolled around on the laundry bags in the back of the truck. I could see my breath in the frosty air. The ride was a winter expedition.

Mom always ensured we were well-fed, packing snacks and meals for the road. Crisp apple slices made the whole truck smell like an apple orchard. She packed sandwiches on rye bread, fresh veggies, and tuna with mayonnaise. In the winter, she'd send a tin of hot soup. When I lifted the lid, the steam swirled to warm my nose. Every trip in the truck was a picnic, no matter the weather. Those Saturday rides are some of my fondest memories. Even now, they bring a warm smile to my face.

When Mom was pregnant with me, she tumbled down the porch stairs and injured her back. After suffering for six years, she finally agreed to surgery. About that same time, my father received a letter from Uncle Ed, a real estate mogul and builder. The letter asked if Dad would move to Jackson Heights, Queens,

and work for him. Indeed, this was serendipity. After Mom recovered from back surgery, we planned on moving for Dad's new job.

The next thing I knew, we left the truck and Snyder Avenue behind and moved temporarily to Grandpa and Grandma Gerber's three-family brick house. No one mentioned the past estrangement. This was the same house where my cousins lived. The tiny attic apartment with one window and a thin wall separating the two small bedrooms had no privacy. I had to share my room with my brother, but at six years old, it didn't bother me.

There was nothing remarkable about the apartment. The walls had peeling paint in spots, revealing paint from previous years. The yellowed linoleum on the floor was clean but worn here and there. My cousin Harriet came up to visit, but there was no room for her to come in. I had to go downstairs to her parent's apartment, which was more significant than ours. I missed our comfortable apartment on Snyder Avenue, especially that wraparound porch.

This kind of living was not permanent. After Mom healed, we planned to find a house to fill with toys and dolls from Aunt Anna. Sunlight beaming through the windows would brighten pale pink walls, and my bare feet would sink into deep pile rugs. Ah, perchance to dream.

Playing with my cousins, Bobby, Harvey, and

Harriet, was the best part of living there. My Uncle Sam and Aunt Esther (my father's sister) were their parents. Aunt Florie (Dad's other sister) lived there too. She impacted my life with the advice to never raise or squeeze my eyebrows. It would make creases in my forehead. She looked funny, wiggling and squeezing her brows then making them go up and down. Even now, I have the smoothest forehead of anyone I know.

My cousins and I played hide-and-seek often. Skinny Harvey would tuck himself behind the old oak tree that stood in front of the house, so I could not find him. Then, laughing and giving up trying to catch him, I'd holler, "Olly, olly oxen free!"

Beyond the top of the driveway were patches of trees and wildflowers. I picked the beautiful yellow ones and brought them to Grandma as a thank-you for feeding me. She put them in a vase of water. In a few days, the flowers disappeared and became feathery, making a mess. That's when Grandma told me they were wild weeds. She thanked me, gave me a hug, and said they were not the best flowers for inside the house.

One day during Mom's recovery, Dad surprised me with shiny roller skates with a leather strap to fasten around my ankle. It had a key to tighten the brackets that held the front of the skates on my brown and white saddle shoes. Dad cautioned me to stay away from the busy street. I fell and scraped my knees hundreds of

times, rolling up and down the steep, hilly cement driveway. I stopped at the bottom by turning my feet to avoid slipping into the gutter. After school and on the weekends, I skated until dusk, when Grandma would open the window over the driveway and holler, "Suppertime!"

I skated until I got good at it. But I had other interests too. Harriet, who was one year older than me, had learned to play the piano. After witnessing her piano skills and the joy she brought everyone with her version of "Twinkle, Twinkle, Little Star," I asked my mother for piano lessons, aspiring to become a concert pianist.

Following doctor's orders, Mom rested in bed, surrounded by pillows, wearing a pink bed jacket and matching barrettes in her hair. She would pinch her cheeks, trying to dispel their sallow color.

I don't know what my father did during this period of our lives except take care of Mom. During her stay at the hospital, I was shipped off to camp—a three-week stint that doubled as a crash course in character building. There, I faced the relentless mockery of my fellow campers, which miraculously cured me of thumb-sucking and bed-wetting. To top it off, I learned to swim, which proved quite handy in a place where water was more foe than friend. When camp ended, my father, who had been dutifully escorting me to the bath-

room nightly to prevent nocturnal mishaps, was pleasantly astonished by my newfound dryness.

Dad's music was our sanctuary. His melodies filled our little apartment. I tried to copy his peculiar vibrating whistle, but I wasn't able to do the vibrato. As I sang and whistled with him, I found peace despite the tension with Grandpa Nathan. That sorrow followed us all my life. I don't remember my Grandpa Nathan ever talking to me. Maybe he was always working. But the evenings came and went, and an invitation to spend time with him never came.

When I was fifteen, Grandpa Nathan died. During his funeral I sat in the car, watching everyone at the burial site in the cemetery. My mother told me that Jewish children could not walk in the graveyard while their parents were still alive. That was a strange rule. Did my mother make it up?

When my mother was well enough, we thanked everyone, took our leave, and moved to Jackson Heights, Queens.

Gail ~ 2 & 5

Chapter Three
Jackson Heights ~ 1942

J ackson Heights was a neighborhood with diverse families, lively street vendors, and children playing in the parks. Our two-story white shingled house stood as a handsome relic from the past. It had Victorian-style turrets—no peeling paint, well-maintained windows and awnings, and nothing broken. Mom found a rocker for the inside porch. It was a cozy touch for seven-year-old me. Despite the house's ten-foot ceilings, the dark red wallpaper and window awnings made the house feel small.

Our backyard garden smelled good. I stuck my nose into the ruby-red florals—the scent dizzied me. One bee, caught up in the smell, almost went up my nose. I swatted at it, and luckily, it didn't sting me. I'd heard

that a bee sting could stop your breathing. Was I allergic to bee stings? I was glad I didn't have to find out.

I loved the tire swing Dad rigged up in our garden. He tied it to a sturdy branch of an old, majestic oak tree. The tire branch bent like an archer's bow in the wind. When the sun was hot, the leaves sheltered me. In the fall, the air glowed with foliage fluttering down into a gold, red, and orange carpet. The days were mild, but it got chilly at night. Behind our house was a wooded hillside awash in vivid fall colors. I reveled in its beauty.

Mom found a music school where I learned to play the ivories (they were in those days) under the watchful eye of Mr. Bishop. My memories of that place were all about the piano. Mom always said I wouldn't have had those lessons if it weren't for George., who also paid for the dancing and almost everything else. I dabbled in the classics, banging out beginner pieces by Chopin, Bach, Beethoven, and even Mozart. I sure loved playing the piano.

Fast forward to the first day on the job. Uncle Ed introduced Dad to Charlie and Sammy, his sons and partners. We lived down the street from Aunt Sadie and Uncle Ed's house, which felt like Aladdin's cave with piles of rugs, vibrant paintings, and endless family photos. The windows were decked out in curtains with ribbons and bows, and the abundance of stuffed chairs and couches was like a sitting wonderland.

Aunt Sadie, Grandma Rose's sister, was a tall woman with a sweet smile and sparkly brown eyes. She greeted us warmly, along with the mouth-watering aromas of her potato pancakes and pot roast. "No, thank you," Mom said when Aunt Sadie invited us to sit and enjoy a bite.

"It's hard to reciprocate, so I turn down dining invitations," she confided to me later.

In hushed tones, Mom whispered that Aunt Sadie and Uncle Ed had oodles of money.

But those potato pancakes...oh, well.

A candy store around the corner was where I indulged my sweet tooth. It had my cherished chocolate-covered Clark Bar with crunchy peanut butter and soft caramel. One day, I snagged the candy bar without the shopkeeper noticing. I tucked it into my pocket with my nickel allowance. Later, I spilled the candy caper beans to my friend, Ginny, while constructing a mud castle at her house. Despite her fondness for adventures in mud, Ginny was the voice of reason. My fun, free-spirited friend made an honest girl out of me. She insisted I either return the candy or cough up the coin. "Gail, that's stealing," she admonished. "Do you wanna be a crook?"

"Nope," I sighed, feeling the weight of my candy crime as it started pouring. The house lights flickered

on, and Aunt Sadie's cooking wafted through the air. Ginny retreated into her house, and I trudged home.

The next day, my stomach in knots, I went to the candy store, confessed to the man, and held out my hand with the nickel.

The man smiled. He picked the nickel from my palm and looked into my eyes.

"What's your name?" he asked.

"My name is Gail."

"Gail, this is a very special nickel. Thank you, I'm proud of you."

I never stole anything ever again.

One rainy Sunday during lunch, Dad said, "We can't go to the zoo in the rain, so let's see the funny movie, *The Canterville Ghost*, at Loew's."

"Good idea, Dad."

I didn't find the movie funny. The ghost followed us home and hid in our fireplace.

The fireplace in the center of the wall in our living room had a red-brick facade extending to the ceiling. The brick formed a classic arch framing the hearth. Above was a wooden mantel adorned with a few family photos and a ticking clock. In the evenings, the glow of flickering light and shadow brought the room to life with a warm, inviting ambiance. Nestled into the corner beside the fireplace was a worn leather armchair, Dad's favorite spot for relaxing. A small stack of firewood was

ready to kindle a blaze to chase away the chill of a winter night—or, in my case, a ghostly visitor.

The fireplace was a centerpiece of family gatherings, a silent witness to countless stories and fun. Occasionally, the deep laughter of a ghost resounded. Indeed, he was charmed with our home. Whenever I passed, the ghost let out a deep belly laugh.

One evening at dinner, I proposed a solution. "Please, let's make a fire and chase out the ghost," I whimpered.

Dad frowned. "I'm so sorry. I thought you would laugh at the ghost."

My father couldn't convince me the ghost hadn't followed us home. I only dared go to the porch, passing the fireplace, when Dad took me. Then, the ghost stayed silent.

My father chuckled. "Silly girl, the ghost is actor Charles Laughton."

I gasped, placed one hand on my hip and, with my other hand, shook my finger at him. "Well, you could've told me sooner," I said, laughing.

Unfortunately, another Charles wasn't as funny. After Uncle Ed died in an airplane crash, his sons Charlie and Sammy closed the business. The closure ended Dad's dream job. When he told me, his face sagged, and for a moment, he looked at me, then burst into tears.

"Dad, you're the best. There'll be other jobs," I assured him.

He wiped his eyes. "Such good advice. When did you get so smart?"

Aunt Sadie and her sons found themselves in desperate need of support, both with food and the constant stream of visitors paying their respects during Shivah. Dad, with his ever-generous heart, offered to step in. They gratefully accepted.

Meanwhile, my mother must have confided in their friend George about Dad losing his job yet again. It wasn't long before Mom dropped the news on us: we were moving back to Brooklyn.

Rockaway Beach and Bungalows, Queens NY
(courtesy Wikipedia)

Chapter Four
The Undertow ~ 1943

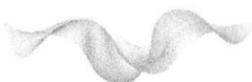

The sunlight peeking through the curtains woke me—not the alarm clock or anyone shaking me—I didn't need either. I blinked and sat up in my cot tucked against the wall in our tiny bedroom of the bungalow in Rockaway, Queens. Mommy was comfy in her cot, sound asleep. I got out of bed, quiet as a mouse, so she and the others didn't wake up. My plan was a secret. Mommy had no idea. No one did.

Maybe she'd sleep till I got back. I wasn't worried she would find out and I'd get in trouble—I just wanted her to rest while we were on vacation. Mommy worked so hard at home to make everything perfect.

I frowned, making hospital corners on the bedsheet as the counselors showed me at camp last summer. I

loved keeping my room clean, but learning how was tricky. It was never good enough, but wanting to please Mommy, I kept trying.

Daddy always told Mommy there was no need to worry, and I knew it was the truth. Daddy would make sure everything was okay back home so that Mommy could enjoy her rest here in Rockaway.

Summer in the city bothered her. It was hot, sweaty, and smelly. "I can't abide this heat and humidity—it tires me out," she said.

My brother Jay said he and Dad would take over the reins until we returned. Jay always talked like he was in a Western movie, like John Wayne in *Stagecoach*.

The lamp sat alone on a chest of drawers between our cots. I hoped it wouldn't wobble and wake up Mommy. My heart was beating in my ears as I slid open the drawer, just a little so it didn't make that squeaking sound and give me away. My blue two-piece bathing suit was right on top, making it easy to change. I put my pajamas on the cot, all folded and neat. Mommy always said, "Don't be messy. We are guests here." I didn't know why she said that, since I was never messy except for my dresser drawers, which always got sloppy, but never my room.

I tiptoed down the hall, passing the rooms where Aunt Ruth was sleeping with her two kids, Jerry and Harriet, and Aunt Lilly with her three—Arnie, Anita,

and Freddie. All the fathers were working back home in the city. My brother was with his friends. They all came to Rockaway on the weekends.

It felt like forever to reach the kitchen, where I found my beach towel draped over a chair, dry from yesterday's swim. My white bathing cap hung on a hook beside the back door. I hurried out, holding on to the screen door to keep it from slamming closed.

A cool breeze greeted me, giving me goose bumps on my arms and legs. I shivered and wrapped my towel around my shoulders. After plopping down on the back step, I grabbed my rubber shoes from the pile and slipped them on.

I'd made it! My big chance to be on my own. No grownups clucking around. No friends dragging me to look at their sandcastles. It wasn't that I didn't like sandcastles. I did. But not as much as Anita and Harriet.

My towel became a cape wrapped around my shoulders like Wonder Woman. I skipped along, singing my favorite camp song, "She'll Be Comin' Round the Mountain When She Comes."

I slammed my hand over my mouth, remembering my mother warning me never to sing in the morning.

I passed a sea of one-story bungalows like ours—three steps up to the front porch—with wooden benches, white rockers, shuttered windows, and swimming gear drying on the rails.

The breeze felt good on my face. One bungalow with nine of us for two weeks got hot and stuffy. It belonged to our close friends. Aunt Ruth and Aunt Lilly weren't my real aunts. Mommy said I should call them Aunt because it was respectful.

I liked lots about staying at the bungalow, including the biggest kitchen I ever saw. It's where we all gathered to eat and play games like Monopoly and Go Fish. We also got together there when it rained and at night. For most suppers, we ate hot dogs slathered with mustard and relish. But when the mustard got all over my mouth, it would make Anita and Harriet giggle. "Gail, your mouth is all yellow. You look like a clown when you smile," Anita would say. I would quickly wipe my mouth with the back of my hand so I would not look like a clown. Mostly every night we had corn on the cob dripping in butter. Yum, my favorite beach food. Even my fingers tasted good. The aromas lingered until Aunt Lilly made those melt-in-your-mouth chocolate chip cookies. She set them on the counter with their chocolate chip eyes staring at me. They got swiped pretty fast.

When we came back from the beach, there was an outside shower to wash off the itchy sand—it also came in handy if it was too hot and we were sleeping in our tents and bags in the back garden. The bathroom had a sink and toilet, with enough room to turn, sit on the toilet, and when you got up, take a step to the sink and

wash your hands. The flush toilet was the best invention ever, and so was toilet paper. Mommy said toilet paper was a luxury.

Once I reached the shore, I dropped my towel on the sand and pulled off my shoes on an empty stretch of beach with no sandcastles from the day before. The tide had washed them away. Seashells lay scattered on the wet sand. I scooped one up and held it to my ear. *Whoosh.* It sounded like the ocean, reminding me of the jingle.

She sells seashells by the seashore,
The seashells she sells are seashells,
I'm sure. So, if she sells seashells by the seashore,
Then I'm sure she sells seashore shells.

I didn't know why seashells sounded like that, but I loved the whooshing sound and could listen all day. The beach was clean, except for some straws sticking up in the sand. Some forgetful boys must have left them.

A warm breeze blew strands of my long blonde hair around. My mother didn't bother making curls when we came to Rockaway. She knew I'd be in the water all day. I twisted my hair, tucked it into my bathing cap, and ran into the water. I dunked myself, got up, and wiped the salty water from my eyes. I stood at the water's edge, wiggling my toes as the water rushed over my feet. The sand sucked them in.

It was a funny feeling, like the sand might suck my toes off.

I wanted to swim out past the waves, where it was peaceful.

The ocean waves sparkled as they soared toward the sun. They dared me to jump. I waited for the next wave —it came closer, closer, closer.

Ready. Set. Jump!

I waited for the next one and did it again.

I loved wave-jumping.

Here came another one, bigger than the last.

It could be too big and too fast.

It knocked me down and flung me toward shore. As the water receded, it tore me away and pulled me back in. I thrashed my arms and tried to swim, but I couldn't. The next wave came roaring in like a lion before I could stand. Again, the undertow pulled me in deeper as I struggled to free myself from the watery monster.

My ocean was trying to drown me.

I stopped flailing around and squeezed my eyes shut.

Stop fighting, Gail. You know how to do this—you know how to swim.

The waves were getting bigger. The next wave was coming. I sucked in a breath as the water rushed over me, and waited until it propelled me toward the beach. I had but a few seconds before it would drag me back

out. I scrambled up and ran to the beach, pumping my legs as fast as possible. Gasping, I collapsed onto the sand.

I saved myself!

I sat, trembling, my towel around my shoulders. Still air surrounded me. The empty beach went on forever, and the sky fell in the distance. The crashing waves vibrated in my ears. Kneeling, in the sand, I wept, my head cradled in my hands.

A hand touched my shoulder. I turned and gazed up into a stranger's eyes. "What's wrong, little girl? Can I help?" he asked in a deep voice.

I managed a shaky smile. "No, thank you. I'm alright now."

The kind lifeguard smiled back.

I was alright!

On my way home, I skipped to the bungalow with no song on my lips this time. Everyone was up and milling about. They hugged my damp body and asked me a flurry of questions about my morning swim. Mommy shook my shoulders. "When I woke up, I couldn't find you. Why didn't you wake me?" she asked, her face taut and pale, her eyes wide.

I hugged her and felt like I wanted to cry. "Sorry, Mommy," I blurted. "Oh, Mommy, it was awful." I collapsed, sobbing, into my mother's soft, flower-draped bosom. "I got caught by the waves."

"What happened?" she asked.

"A big wave pulled me in, and I couldn't stand. I almost drowned." I told her how scared I was but didn't tell her about my secret plan. How could I say I wanted to be by myself? She wouldn't understand.

Mommy stroked my head, and everything was okey dokey, as Daddy always said it would.

"They taught you well at summer camp. You knew what to do in the water, but sometimes nature has other ideas," she said. "You were brave. But you know what? I would have enjoyed going with you. I know you won't ever swim alone again, will you?"

I felt the hair on my neck stand up. "Never again, Mommy."

Listen to the voice in your head.

Whether it's a whisper or a shout—that voice is God.

Stop! You know how to swim.

That voice tells you what's right and what's wrong.

Always listen to that voice. It will steer you back home. It's God's armor.

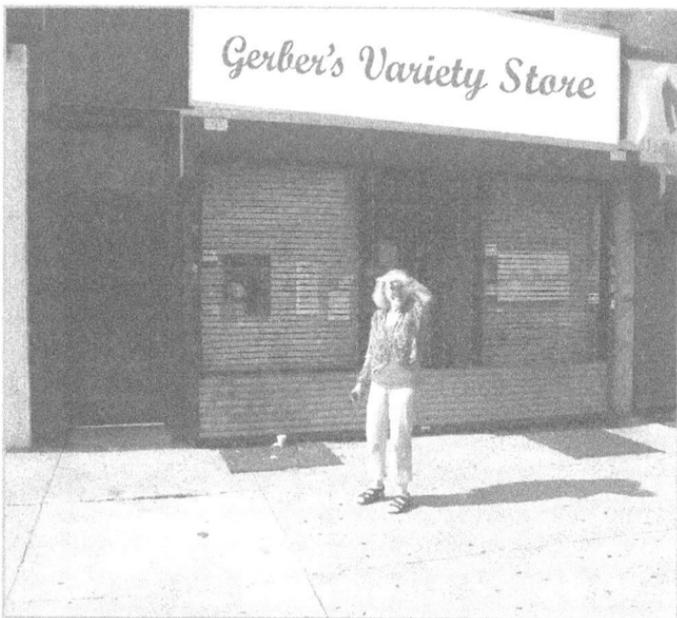

Gerber's Variety Store location (Borough Park);
Gail & Tom visit the old neighborhood

Chapter Five
Gerber's Variety Store ~ 1946

Hopefulness was in the air—World War II was finally over, and the Allies had triumphed. They defeated the menace that had gripped Europe and the world since 1939. Gone were the days of ration books that turned grocery shopping into a bizarre scavenger hunt. Those little books, with their removable stamps, had controlled our access to sugar, meat, cooking oil, canned goods, and more. You couldn't buy anything without the proper ration stamp, and trust me, those stamps were precious like gold. We learned to do without, like my parents did during the Great Depression. I remember tearing out those stamps like it was yesterday.

In a twist of fate, my parents found themselves at the helm of a variety store, all thanks to their dear

friend George. He graciously helped finance this venture, ensuring my dad would have a job he couldn't lose. But this wasn't a walk in the park or a bouquet of roses. The store itself was in decent shape. A little elbow grease, and it could shine. We tackled the washing, dusting, assembling of pegboards, scrubbing, cleaning, and setting up merchandise on the existing counters with the fervor of ants building a new hill. It was a spectacle!

Mom, with her keen eye for bargains, became the buyer extraordinaire, curating a delightful array of goods that would make any customer do a double-take. She headed out into town, and soon other similar stores interested in growth had Mom doing their buying. She was a glorious businesswoman while Dad, on the other hand, was the customer service champion. He had a knack for chatting up anyone who walked through the door, turning even the grumpiest shopper into a loyal regular.

Together, they created a lively, bustling haven in the heart of our neighborhood. The variety store wasn't just a job for Dad; it was a vibrant community hub where stories were swapped, friendships blossomed, and everyone felt at home.

Sure, there were challenges—what new business venture doesn't have its share of bumps? But the joy and laughter that filled our variety store made every dusting

spree and pegboard assembly well worth it. So, here's to my parents for turning a simple store into a cherished local landmark!

The rooms in the back of the store, where we were to set up housekeeping, were the opposite of our clean, white house in Jackson Heights. The tenant before us was a furrier. The store was his showroom to sell his furs, but he made fur coats in the back and lived else-where, so he didn't care about the bugs or the mess.

The water bugs thrived in damp, dark places, and the cellar was their home. The cellar was scarier than the haunted fireplace back in Jackson Heights. Those cockroaches were the size of Dad's thumbs and gave me the creeps. I quickly learned to squash them on sight as they came out from the cellar. Or who knew where they'd end up—my bed, perhaps? Cleaning the place up would take a miracle, but luckily, Mom specialized in miracles. She unearthed a filthy white refrigerator buried under piles of fur. Dad donned his old chinos and flannel shirt to keep his undershirt clean. He moved the fridge away from the wall, checking to make sure it was in one piece.

Mom cleaned the filth off the stove. It glowed white in its reborn state, ready for cooking. I didn't know how to cook, but I loved baking chocolate chip cookies with Mom.

My favorite room was the bathroom after Mom

scoured it with muriatic acid. The muriatic box had a picture of a skull and crossbones, and the printed directions read *DANGEROUS*. Nothing else would clean the rot and rust from the porcelain fixtures. I had confidence in her and knew she had taken steps to stay safe. The toilet, sink, and deep porcelain tub on claw feet cleaned up like magic.

The toilet had a wooden seat and a high wall-mounted flush tank with a long chain. It flushed with a mighty whoosh. The sink's hot and cold handles were like wagon wheel spokes.

Every morning, a man and his bike arrived. He left his bike, opened the cellar doors in front of the store, and went down the concrete stairs into the dark, damp cellar below. After adding the coal and stoking the furnace, he got on his bike and left. In a short while, hot water came from the bathroom faucet so I could wash up for school. I prayed every morning, asking God to give me hot water to wash up for school. Thank you, Lord, He did!

Mom worked night after night to transform those four dingy rooms. She wore a scarf wrapped around her hair and a housedress covered with an apron. Dad hauled garbage and junk to the cans out front. I did my share of work wearing my dungarees and an old shirt.

Now, let me tell you about the corsetorium right next door. Yes, you read that right—corsetorium. On

display in their store windows were mannequins wearing brassieres, girdles, and garter belts. My mother dragged me at the tender age of twelve into this fortress of fabric and elastic to purchase my first bra. She insisted I wear a girdle, as if the bra wasn't mortifying enough. According to her, it was essential to "hide my behind." I couldn't see my behind, so what was the fuss about? And did hiding my behind mean I was fat? None of my friends wore a girdle; they were busy living their best girdle-free lives. I remember reading somewhere that in the Victorian era, women wore chastity belts. Maybe my mom had some wild idea that the girdle was a modern equivalent, a secret weapon to safeguard my virtue and squash my behind into submission. The whole ordeal was absurd. She convinced herself it was for my own good, but I eventually rebelled. A girl's gotta breathe, after all!

After we settled in, my mother dressed for a business buying adventure once a month. She wore stockings with seams and her platform shoes to make her taller than her sixty-two inches. She tucked in her white blouse and smoothed her blue skirt and jacket. "How do I look?" she would ask, chin up. "Do you like the hat and white gloves? Am I overdressed?"

"You look pretty, Mom."

My mother took me on her buying trips to the wholesalers on Delancey Street in New York City. She

was a self-made local jobber and eventually expanded to busy MacDonald Avenue, buying for various shops and stores in the neighborhood and beyond. I remember her coming home one day and telling Dad about an owner of one of the local stores, OK Stationers, asking her if she would pick up merchandise for his store. The word spread, and she ended up with several accounts in Brooklyn. I listened and watched her business dealings and how she bargained with each salesman, who kept their eyes on me, all prettied up in my belted blue dress with the Peter Pan collar and puffy sleeves. They kept lowering the prices in agreement as they fussed over me. I realized at this writing how clever my mother was, diverting their attention with me there, an innocent distraction.

I didn't think about how my mother did business; she just did an excellent job by buying more for less. She ordered by job lots, a practical way to do business. She knew her bookkeeping and a way to get the best prices. She opened a wholesale division for our store and drove back and forth to Florida from New York several times. She didn't have enough money on one of those trips, so she made a deal with a motel owner to give her a room for a couple of nights, in exchange for her cleaning the whole motel.

My life revolved around my home in the back of the store, like my friends and their homes. One fine

Saturday in 1950, Dad burst into the kitchen with a grin that made him look like a kid getting gelt on Hanukkah. Clutched in his hands was a mysterious cardboard box covered in scribbles and doodles.

My eyes widened, my heart racing. "Please, Daddy, can I open it?" I asked, jumping up and down.

"It'd be easier with my pocketknife," Dad said, laughing.

"Hurry!" I urged, foot tapping impatiently and arms crossed.

Dad carefully sliced open the box, and I let out a delighted squeal—a television, just like the ones in the store windows. This was no ordinary Saturday; this was a momentous occasion, the likes of which we'd talked about for years.

Dad set up the gleaming twelve-inch marvel on a sturdy shelf opposite our red Formica table, the centerpiece of our cozy kitchen. As he adjusted the twin metal antennae on top—long, extendable rods that we later learned to call "rabbit ears"—and plugged it in, the screen flickered to life, and the room buzzed with anticipation.

I couldn't wait to share the news and called all my friends. "We have a television!" I shouted into the phone. We'd heard tales of these magical boxes that showed moving pictures, but seeing one in person? Unbelievable!

Minutes later, my friends arrived, wide-eyed and breathless. Salva—she and Stan got engaged before me —and Cookie, another good friend, whose father made lots of money buying and selling rags on the streets with a horse and wagon. They'd moved to Long Island with the three others whose names elude me—we had our jump rope crew, after all. They filed in, each finding a spot on the floor, jostling for the best view and making room for everyone. This was a moment to be shared.

We gazed in awe at the black-and-white screen where figures danced and stories came to life. The images were grainy until Dad moved the metal rods around, the colors non-existent, but to us, it was a portal to another world. Every frame and scene held us captive, transporting us beyond our small neighborhood.

Mom, never one to miss out on an occasion, baked a batch of chocolate chip cookies. The warm, gooey smell of chocolate mingled with our excitement, creating a sensory memory etched forever in my mind. Cookie sweetness heightened our joy as we experienced television for the first time.

The soft hum of the TV filled the room, interrupted only by giggles and gasps as we watched, spellbound. The stories on the screen captured us entirely, making

the outside world disappear. It was a simple pleasure that felt monumental.

That day wasn't just about watching television for the first time. It was also about the shared wonder, the thrill of discovery, the unbreakable bond of friendship, and the comforting presence of family. It was the joy of experiencing something new and magical together, a memory that became a cherished part of my childhood —and, I suspect, a million other childhoods too.

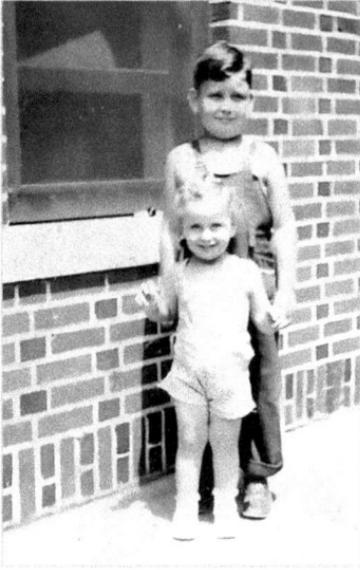

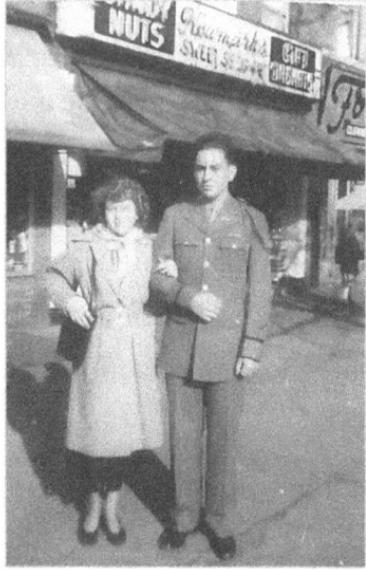

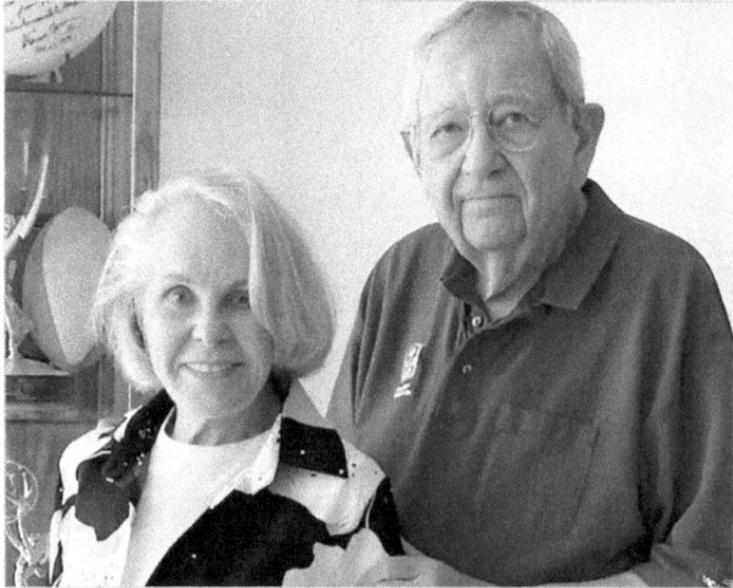

Gail & big brother Jay
(then and now)

Chapter Six
The German Measles ~ 1947

Excitement and nerves made my stomach all squishy with somersaults. Today was the big day—meeting new friends and my sixth-grade teacher. I ditched my PJs, threw them in the drawer, and began rummaging through the narrow closet Mom and I shared. I found a green checkered dress with short sleeves and a belt. I sneaked through Mom and Daddy's room to the bathroom, not wanting to wake them up. The variety store kept them busy. They needed their sleep.

Jay, who could sleep through anything, was snoring in the next room. At fifteen, he would catch the trolley to New Utrecht High School later. It wasn't fair—older kids got to sleep in longer.

I wiggled my fingers under the hot water tap to

warm them up. "Come on, furnace, work your magic," I muttered, wetting and lathering a washcloth with soap. Looking into the mirror above the sink, I gasped at what looked back at me. "Oh no, my face!"

My cheeks were a landscape of bumpy red dots. Touching the bumps, I wondered what happened overnight to turn my face into a field of wild strawberries scattered across my skin.

So much for not wanting to wake up my parents, but I had no choice. Who else was going to fix my face?

"Daddy, Daddy, wake up," I whispered, shaking his shoulder. "What's this on my face?"

His sleep-filled eyes blinked open and then widened. "My God, what happened?"

"I don't know, Daddy, I woke up like this." The worried look on my father's face made me even more scared, and my lips trembled as my eyes filled with tears. If my father didn't know, what was I to do?

"Does it hurt?" he whispered, touching the side of my face with the back of his hand.

"It feels hot and itchy."

"Run to the school and see the nurse. She'll know what to do."

With my hot and itchy face, my wobbling lips, and my stomach growling like an angry beast, I sprinted to PS 131. I looked both ways before darting across the

trolley tracks. Bursting through the front door, I hollered down the hall, "Miss Betsy, Miss Betsy."

The nurse wore a white dress and apron and had a cap perched on the top of her head. While pinning a bulletin on the wall outside her office, she turned to me and gasped like I had. Eyes wide, mouth forming a perfect O, she snagged my arm, ushered me into the infirmary, and plunked me down on a hard chair by the door. Waggling her finger, she warned, "Stay here. Don't move." And with that, she vanished.

Where did she go?

I craned my neck like a giraffe, but the window was too high. Supply cabinets stood like vigilant sentinels on opposite walls, and a solitary cot held its ground beneath the window.

What was happening? Why did Miss Betsy run off? Reaching up to touch my face, I felt the heat and the red bumps. Tears flowed. Was I going to die?

A few minutes later, my Uncle Solly showed up. He was a doctor and one of my father's younger brothers.

He cupped my face and pressed his fingers against my neck.

"Ouch! That hurts, Uncle Solly."

"Sorry. You have swollen glands caused by the measles."

"I already had the measles."

"Not the German ones." He took my hand and

walked me home, crossing the trolley tracks. Above the tracks was the elevated BMT station, where riders waited for trains that ran downtown or to Coney Island.

I looked up at my tall, skinny uncle. He wore a white shirt and tie under his one-button jacket. He was handsome—like Daddy, he had green eyes and a mustache under his pointy nose.

"Can you catch German measles from me, Uncle Solly?"

"Grownups are not susceptible."

He handed me over to my smiling mother, who was standing outside the store. Her hands were in the pockets of her pink floral dress.

"Sol, thanks for your help." Her voice sounded polite.

"Good thing you caught me early at the office, but I'm sure you know that rubella is not dangerous like measles." Uncle Solly hugged me. "Stay home so you don't make other kids sick."

He turned to my mother. "Do the usual: liquids, bed rest. You don't have to keep the room dark for the German measles. She'll be better in a week. Usually, there aren't complications."

I rarely got sick, but Mom gave me a hot, soapy-water enema whenever I did. Wouldn't I have gotten well without it? I still had to stay home until the spots

went away, and the enema didn't make them go away any sooner.

At least I wasn't the only one. My brother got enemas too, but lucky for him, he hardly ever got sick. Mothers practiced using enemas as a folk remedy when their children were ill. Maybe it was a punishment for getting sick.

"It hurts, Mom, it hurts. Stop," I hollered.

"It's almost done. Hold it in," my mother said in a stern voice.

I was drowning, but there was no lifeguard. I would never get sick again—ever.

I held the water in as she ordered until she said, "It's all done. Go sit on the toilet."

I rose on wobbly legs and rushed to the toilet just in time. Afterward, I stumbled to my room and crawled into bed. Getting sick wasn't fun, especially during the first week of school.

A few minutes later, Mom knocked on my open door and stuck her head in. "Here's a warm water gargle and a spit bowl," she said. "Gargle five times with the liquid, making a gurgling sound so I can hear it, then drink this glass of juice." She set it all down on my bedside table next to my clock and radio and placed the bowl on the floor.

I took a small mouthful of the salt water, leaned my head back, and made bubbles in my throat. The

soothing gargle was a gentle river washing away discomfort, and spitting into the big round bowl was fun.

I drank the orange juice Mom had made in her glass juicer. The juice smelled fresh and cheerful, like a warm summer day. It had so much pulp, she should have just given me the whole orange. It tasted good, though.

My mother returned to the room to get the bowl and the empty glasses. Her hand was a warm blanket on my forehead, wrapping me in a sense of love and comfort.

Stuck in bed, fighting off a bug. Gargling, munching on whatever Mom doled out. Resting up, dreaming of the day I'd bounce back. I could read, but there were no books. I clutched my doll from Aunt Anna like it was my lifeline in this germ-infested house. You can have German measles more than once, said my Uncle Solly. My mother hoped Jay would catch it and get it done, but he didn't.

Mom's homemade chicken soup with lokshen (skinny egg noodles) was the best. She would not win any culinary awards—her pot roast could double as a weapon—but that soup was a tasty surprise. She fried crispy latkes served with a dollop of sour cream—the magic potion for a speedy recovery. Even when I wasn't

hungry, it was Mom's healing arsenal—crispy and downright delicious.

This time, there was no butcher escapade to get the chicken. Flashback to the last encounter: Mom and I went to the butcher, and he disappeared into a secret chamber. Then out he came, holding a headless chicken dangling from his fingers like a prize. He plucked some feathers, and the bird went straight into a bag for Mom. Note to self: Avoid butcher shop field trips. They're disgusting.

"Mom, he only plucked a few feathers," I pointed out.

"Don't worry. I'll show you how to clean the bird."

Mom laid the bird on a newspaper on the porcelain counter. Operation cleanup took place at the kitchen sink—guts, gizzard, liver, you name it. She cut the fat away, and the liver went into a hot water bath for fifteen minutes. Then a mashup with onions and chicken fat, namely schmaltz, the flavor boss, replacing mayo and salad dressing with pure yum. The schmaltz was my mother's secret weapon for those latkes and onion perfection, a kitchen mystery.

My mother smiled. "Using schmaltz instead of butter or oil keeps taste buds on their toes. Someday, you'll do this for your family."

"I'll cook, but I won't clean a chicken. Um, never."

"You'll see. Making chicken soup is no joke," my mother said.

"I couldn't care less. Guess chicken soup's not my calling either. Too much yuckiness for my taste."

Back to the measles. After school, Jay came home with a comic book for me. "Here's Wonder Woman."

"Thanks," I croaked.

"I got you a drawing pad and pencils, too."

I managed a smile and a nod of gratitude.

My throat was on fire, even with gargling and drinking juice. Talking? Forget about it.

An hour later, Dad popped in, his short-sleeved white shirt tucked into his brown trousers. "How are you doing, Toots?"

"Mom's here every minute with another cure. There's no time to think how I am," I said.

"Her system works."

"Tell her not to do those enemas," I whimpered.

"It's important to clean you out."

"When I have kids, I'll never give them enemas. Never, ever."

"We'll see about that. Rest and do what your mother says, okay?"

"Are there any other choices?"

Dad shook his head and kissed my forehead. "You still have a fever. Rest and gargle. The store's busy. I'll check in later."

My mother appeared in my doorway, wearing her pink floral housedress. One hand was in her pocket, the other waggling her pointer finger at me. "Even though you're under the weather. I'm entrusting you to take care of my secretary. Someday, it'll be a family heirloom," she said.

"Are you an heirloom, Mom?"

"Hardly." She laughed, pointing to the necklace around her neck. "This lavaliere is a family heirloom belonging to my Great-Aunt Lifsha. Your middle name, Lenora, honors her. Your Grandma Rose wore this. She gave it to me, and I'll pass it on to you one day."

"It's so pretty, and those two dangling stones sparkle."

"Those are diamonds."

"Are diamonds special?"

"Absolutely. You can see the sparkle. Diamonds are durable and rare. They have great value. Engagement rings have diamonds and represent love."

"When can I have it?"

"Most likely after I'm gone."

"Where are you going?"

She laughed again. "Nowhere. Just take good care of the secretary."

The secretary, perched in the corner of my room, was beside a window that offered a view of a small yard, tenements, and clotheslines loaded with drying laun-

dry. My workspace seemed destined to be this 1929 Lord & Taylor acquisition my folks bought. It came with a radio and a speaker behind a secret door. My father had removed the radio and speaker long before. The slanted top unveiled a desktop supported by pull-out arms when opened.

"The only place the secretary fits is your room. Treat it kindly," Mom reminded me with her hands on her hips.

My heart yearned to sit at the desk and draw, but it was time to rest. The thought of getting sicker and facing another enema from Mom gave me the creeps.

Oh, how I loved Wonder Woman! She never had to worry about red, itchy bumps all over her face—her bracelets were practically a dermatological shield. As I drew her, I felt an instant connection to her mission to save humanity from the forces of darkness. With every stroke of my pencil, I channeled her power. Following the lines with my left index finger and bringing her to life with my right hand, I felt like an artist-warrior on a mission.

Jay brought the paper, and I had the magic. Those drawings have since disappeared into the Bermuda Triangle of lost childhood treasures, but the memories? They're etched in my mind forever, like Wonder Woman's indestructible tiara.

HOW AN AUTOMAT WORKS

FIRST DROP YOUR NICKELS IN THE SLOT

THEN TURN THE KNOB THE GLASS DOOR CLICKS OPEN

LIFT THE DOOR AND HELP YOURSELF

HORN & HARDART

Memories of Katy at Horn and Hardart
Courtesy (CANVA & Wikipedia)

Chapter Seven
Cousin Katy ~ 1947

There was a knock on the open door, and Cousin Katy stuck her head in. "Hey there, little girl."

"Ooh, Katy, come in," I said with a big smile. "I'm so glad to see you. Guess what? I have the German measles."

She nodded. "Mom called. It was a spur-of-the-moment decision to see you."

"Please stay and visit a little. Uncle Solly says grownups can't catch it."

Okay, dearies, let me tell you about Katy, my father's second cousin. She was fabulous, just fabulous. Friends with my mother and father, but let's be honest, she really liked me. She treated me like I was the daughter

she never had. And believe me, she never got married. A smart woman—but that's a different story.

Now, little me, covered in spots from the German measles. And with my past measles event when I was eight, I'm like a measles overachiever. Katy showed up like Florence Nightingale with a book bag. She brought me books to read. Books! I'm lying there, miserable, and Katy's like, "Here, read *War and Peace*." I mean, who does that? Katy does, because she's a saint.

Then, as I grew up, I started outgrowing everything. My winter coat? Forget it. I looked like a sausage ready to burst. So what does Katy do? She takes me to S. Klein on the square in New York. It's like shopping with royalty. We're picking out coats and trying on hats. I'm strutting around like I own the place. I have no idea if my mother ever paid her back, but Katy never cared. She was too busy making me look like I stepped out of *Vogue*.

And then, the pièce de résistance: As soon as we bought out Klein's, we'd head straight to Horn and Hardart on the IRT uptown. Oh, the automat! It was like a giant vending machine with real food. You put in a nickel, and voilà, a sandwich appears. I was in heaven. Katy would give me quarters, and the nickel lady, wearing rubber tips on her fingers, gave me nickels to drop in the coin slots. I felt like I was making a bank transaction. I'd get my stack of nickels, and off we'd go.

I loved it. I'd put in a nickel, the turnstile would spin, and an egg salad sandwich would come out. And don't even get me started on the lemon meringue pie. It was divine. I'm telling you, if you haven't had pie from an automat, you haven't lived. It's a lost art. Here in Connecticut, I found them in Duchess, of all places! Ah, my lemon meringue pie with that ten-inch-high sugar frosting that melts in your mouth. Decadent.

Katy was just the best. The fairy godmother, who always cared for me and had impeccable taste. Her kindness and generosity were legendary. She was my hero, my fashion consultant, and my shopping partner.

So, here's to Katy, the woman who could turn a trip to the city into a grand adventure and a coat shopping spree into a runway show. We should all have a Katy in our lives. She made the ordinary extraordinary, and she did it with style—pure style.

Katy's dark brown eyes twinkled almost constantly, and her short, salt-and-pepper wavy hair bounced when she laughed.

"I hope you'll like these, *Father's Dragon* and *Homer Price*."

So, it wasn't *War and Peace* this time, thank goodness.

"I love the books you bring me."

"Do you want me to sit on the bed, or the piano

stool?" She was a speed talker, if there's such a thing. Good thing I didn't have my hearing problem yet.

"Wherever."

She picked the wheely piano stool I sat at when practicing. She smoothed her dress beneath her backside, as ladies should do, according to my mother, and rolled closer to me.

"I can stay awhile."

"Will we go to New York for a new coat and lunch at Horn and Hardart soon?"

"Yes, we will."

I clapped my hands. "When are we going?"

Katy tilted her head, and her eyes twinkled again. "Your mother said you've outgrown your coat and need a new one. We'll go as soon as you're better."

"Can I disturb you two girls?" Mom was at the door with another gargle and a glass of juice.

Katy got up from the piano stool and came over to me. Her hug felt good.

"I guess it's time for me to leave. I'll see you next week. If you're better, we'll go to Klein's."

I smiled at my cousin. "Bye, thanks for coming and bringing the books."

A cool breeze stirred the curtains at the open window as Mom walked Katy out.

Mom brought me a cup of tea with milk, honey, lemon, and whiskey at bedtime. It smelled terrible and

tasted bitter, like cough medicine. "Mom, why can't I have cookies and milk?"

"You want to get well, don't you?"

"I'm sorry I got sick and made you work."

"It's not work taking care of you."

"I thought you were mad at me for getting sick. Everything smells bad and tastes awful. And that enema hurts so bad. Are you sure you aren't mad?"

"I'm not mad at you. I want to make sure you get well."

"Can I have cookies and milk, then?"

"When you go back to school, you can have cookies and milk."

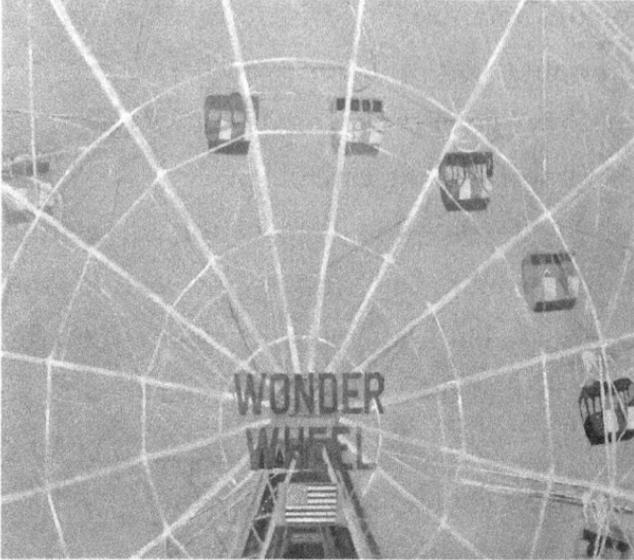

Coney Island Memories - paintings by Gail Ingis:
Wonder Wheel;
Parachute Jump;
Coney Island Carousel Horses;
Nathan's at Coney Island;
Complete gallery: gailingis.com

Chapter Eight
Almost Twelve ~ 1947

Of all the wild ideas my parents could cook up, they decided in August to spring a surprise for my twelfth birthday—but here's the thing—it wasn't until November! Out of the blue, my mother asked, "How about a trip to Coney Island this Sunday? The store is closed, so why not celebrate your twelfth birthday three months early?"

Who in their right mind could resist such a tantalizingly delightful offer?

I dove headfirst into my summer clothing drawer, fishing out my blue skirted bathing suit. After slipping it on, I eyed myself in the mirror, feeling a surge of anticipation. Thrilled at the prospect, I envisioned the amusement park rides, games, and the beach. It was summer and a great day to swim and build sandcastles

—this was a special treat, even if it was a bit early. I couldn't wait to dive into all the fun and laughter with Mom and Dad.

But wait, parking was always a challenge in summer. The quest for parking on Stillwell and Surf was an adventure in itself. When we arrived, my mother, with the urgency of a general in battle, commanded, "Bernie, there's a spot. Hurry before we lose it!" Determined as ever, my father revved up Old Nellie and snagged the coveted spot. "Good for you, Dad!" I shouted.

When I stepped out of the car, the mile-long entrance sign—the iconic emblem of Steeplechase Park embellished with George Tilyou's toothy grin—greeted me. Despite the slightly demonic undertones of the smile, I knew hidden realms of play, slides, and thrilling rides awaited behind that facade.

Today was beach day, but I couldn't resist the thrill of the Steeplechase at Coney Island. Mounted on a mechanical iron horse, I raced along the rail, clutching the reins as we dashed through fantastical scenes— soaring over Venice's canals, brushing past the Bronx Zoo, and even glimpsing an airship high above. It was a wild ride unlike anything I'd ever experienced! After- wards with Mom's prompting, we hurried to claim our spot on the beach, right by the water's edge before they disappeared. My father sported a mustache that gave him an air of significance, accompanied by green eyes

adorned with long, dark lashes. Gazing up at my tall and handsome father, I couldn't help but aspire to find a boy as stunning as he. Even at twelve, I recognized no one could match my father's allure. My mother was undoubtedly fortunate to have him, and I imagined he must have had countless admirers vying for his attention.

"Daddy, can I ride on the carousel?"

My father gently clasped my hand, his eyes revealing a sense of sadness. In contrast, my mother shook her head, showing a somber atmosphere. "There's no time. We have to get to the beach." We kept walking away from the Steeplechase.

"Please, Mom." Mom came to a halt and turned toward my father. They paused, engaging in a conversation in Yiddish. In her authoritative tone, Mom shook her finger at Dad. Dad nodded, smiled, and embraced her. He was always the peacemaker. Their dialogue, however, sounded like incomprehensible babble to me. I might have known two Yiddish words, but their exchange didn't involve them. I enjoyed witnessing their interactions this way; perhaps it held a surprise in store.

"Since we're celebrating your birthday, Toots, we'll treat you to a ride." I loved that nickname for myself.

We rushed back to the carousel, where Dad lifted me onto a vibrant wooden horse with a rainbow of

colors. Adorned with an Abraham Lincoln sign on its blanket and various button-type decorations, the carousel horse moved rhythmically to organ music from the mirrored center. With my left hand gripping the shiny pole behind its neck, I balanced like I was on a bucking bull, the carousel spinning round and round, tousling my blonde hair. Living in the city didn't allow for an actual horse, but this carousel ride was the next best thing.

The brass ring called out to me. I leaned away from my horse toward the ring stuck at the end of a protruding device fastened to the wall and reached with my right hand until I was standing on one foot in the stirrup. I leaned farther, holding my hand out, ready to grab it as the carousel rotated. The crowd gathered on the boardwalk, hollering, clapping their hands, cheering. "Go, go, go!" With a little more effort, my arm stretched farther. As it was the only thing I could focus on, I made one last attempt to get that ring. Was it possible for me to do it? I stared at the spot and hooked my finger, ready to stick it into the small hole in the ring. I missed.

The carousel kept going, my eyes riveted to the ring as we rotated away. I tightened my hold on my shiny pole and pulled myself back onto my patient horse. How I wished I could've grabbed that ring for a free

ride. My parents smiled and waved at me from the boardwalk.

"Dad, come on. Ride with me," I yelled out.

I bet he could have reached that brass ring. Were grown-ups allowed? I'd have to ask.

As I got ready to get off my horse, Dad hopped onto the almost-stopped rotating wooden platform with its inner and outer edges painted red. "Alright," Dad said. "We bought you another ride and one for me, okay?"

"Oh, Daddy, thank you." I kissed his cheek. "Can we ride together on my horse?"

"We can, but I can't grab the brass ring. Would you like to try again?"

"You got me another ride. Riding with you is my prize."

My heart thumped loudly, drowning out the sound of the carousel's organ music. I wished the ride with my father could last forever. When it ended, he lifted me off my horse, announcing, "Beach time," with a smile. Holding his hand, I briefly imagined myself as a princess, with my father leading me to meet my prince.

Mom was in the lead, me in the middle, and Dad brought up the rear. I walked up the side ramp to the boardwalk.

"Keep your sandals on to avoid getting splinters," Mom said.

"Okay, Mom, thanks for the reminder," I said in a cheerful voice, delighted with this birthday.

Walking along the Coney Island boardwalk, I noticed various characters, from tattooed nerds to beachgoers in strange getups. Some dug in garbage cans; perhaps they had no money for beachwear. Grateful for my skirted bathing suit, I encountered weird sights, reminding me of the freak house near the Steeplechase. The steps to the beach were tricky, so I left my slip-in sandals on to walk on the hot sand. Halfway to the water, my sandals filled with sand. I kicked them off, picked them up, my feet burning from the hot sand, and ran the rest of the way on my toes. The pail and shovel handle were over my arm. Dad carried the rolled blanket with his towel inside, following me. Mom walked in front with a big towel. She turned to wave for us to hurry. Kids ran with their pails and shovels to the water's edge to build sand-castles.

Mom squeezed two towels and a folded blanket between two families, so close I could smell their baby's poop. Why didn't the mothers clean them up before they came to the beach? We rolled the third towel up for a pillow and to dry off if we went swimming. Mom caught my eye and rolled hers, grinning and saying with her eyes, "I told you all the spots would disappear."

I know, I thought. Mom was right again.

"It's getting late, Claire. I'm going to Nathan's before a long line of people want hot dogs."

In her black-skirted bathing suit with wide straps on her shoulders, Mom, unsmiling, looked up as she spread our towels before we lost more precious space. "Bernie, can you bring back a few ears of corn?"

Dad shook his head. He was trying to be obedient. "I'll see. Carrying it all will be tricky. Maybe Nathan invented a carrier. And the addition of mustard and sauerkraut on the hot dogs will make carrying everything precarious."

Mom scrounged in her purse. "Three hot dogs, corn, French fries. The sodas are free if you spend twenty-five cents." She handed him the coins. "Here you go."

"Daddy, do you want me to help?"

"Nope, it's your special day. No work for the birthday girl."

"Thanks. I love you, Dad." I hoped he'd bring back the steaming sweet corn.

I didn't mind the closeness of my blanket to the next one. After the mother cleaned up the baby's poop, the air smelled of baby oil, and everyone was trying to get a tan. Mom didn't bring any, but many people did, and my friends told me their mothers put iodine into the oil to make them tan faster and darker. Teenagers rubbed each other's backs and lay on their stomachs. Mothers

walked into the water, holding on to the hands of their little ones.

When I joined the kids busy constructing a sandcastle, they warmly welcomed me. Building with sand required meticulous planning and finding the right balance of wet and dry sand and water. Firmly patting the castle walls ensured they wouldn't collapse or wash away before the day's end.

Upon Dad's return, I settled onto my folded beach blanket, the irresistible scent of hot dogs filling the air. As he approached, the aroma became more pronounced. Dad arrived triumphantly, bearing three hot dogs adorned with toppings, a sizable bag of French fries, and three pieces of hot buttered corn in a covered box. Accompanying him was a boy, approximately my brother Jay's age, around fifteen, carrying a bunch of sodas. Dad and the boy walked over to where Mom reclined on her towel, briefly casting a shadow over me as I lay on my back, basking in the sun. The boy swiftly delivered the sodas to Mom and left. She stowed them in her bag, ready for us to enjoy.

Dad wore his dark blue bathing trunks that nearly reached his knees. I couldn't help but wonder if the water would creep into his pants and turn them into a flotation device, playfully carrying him away.

We sat together on towels and devoured all the goodies, finger-licking good. A bit of sand blew around

to remind us of this day at the beach. The corn had cooled some, and the soda had warmed. While Dad was throwing out our garbage, I stayed next to Mom. "Mom, why doesn't Daddy wear shorter pants?"

Mom's eyebrows came together. "Why do you ask?"

"I'm afraid water may fill up his pants and make him drown."

"But Dad doesn't like the water—he doesn't swim. He says the water is cold and too wet."

No matter, this birthday gift was rare indeed. I would remember my twelfth birthday forever and write about it when I was eighty-eight!

Ocean Parkway Brooklyn, NY (then & now)
The oldest bike path in America
(courtesy: www.nycgovparks.org)

Chapter Nine
Me and My Bike ~ 1948

S aturday brought rain, but Gerber's Variety Store buzzed with activity. Customers streamed in, seeking brooms, electric vacuums, hammers, pink rubber balls, yo-yos, and the Polaroid camera, the latest sensation in picture-taking. Taking charge in place of Dad, who went inside for a coffee break, I handled the diverse needs of the bustling store. One customer, contemplating the unbreakable Melmac dishes, eventually settled on a vibrant red set—a popular choice that flew off the shelves. Given the everyday mishaps of kids dropping and breaking glasses and plates, these sturdy dishes were in high demand.

Amidst the busy checkout process, a man in a dark suit and cap entered the store, cradling a large,

unwieldy package wrapped in blankets. Rainwater from the drizzle outside dripped onto our freshly washed and waxed floor, a labor of love on my part. Struggling to make out his face, I watched as he approached the cash register, the unmistakable hue of bright red metal peeking out from under the protective covering.

"Where do you want this?" the man asked.

I was suspicious. Mom always said don't look strangers in the eye and trust no one.

"Are you in the right place?" I asked.

"This is the address my boss gave me."

"Who's that?"

"Oh, sorry, Mrs. Kahane in Forest Hills."

I knew what was under that blanket and wanted to jump for joy, but I controlled myself.

"Thank you. Please put it here by the door to our apartment." He placed it and removed the wet, smelly blanket.

A gasp escaped me as the man unveiled my dream right before my eyes. It was like a heavenly vision. I couldn't resist reaching out to touch the cold, red metal, and my eyes fixed on the most beautiful bicycle I had ever seen. Standing in awe, I positioned myself in front of the bike, straddling the front tire and gripping the handlebars with sheer delight.

I smiled and looked up at the man. "Thank you for

bringing this to me. Can you take the blanket away with you?"

"No problem. Enjoy the bike. Who's it for?"

I smiled with glee, raising my shoulders and head. "Me!"

The limousine driver nodded. "I'll tell Mrs. Kahane I delivered the bike to you."

I had never seen such beauty with its chrome handlebars, polished red fenders, and gleaming metal frame. Overnight, the bike remained in our store. The following day, I rushed into the store. The bike was still there. It wasn't a dream.

As soon as I saw it, I knew I had to own it. The limo driver had found the long-forgotten bike while cleaning Aunt Anna's garage. He remembered a neighbor gave it to my cousins Lenore and Sally years ago. The cycle took the girls on countless adventures and had outgrown its use. Aunt Anna, a tall, stately woman, always impeccably dressed, was my mother's well-to-do great-aunt and my hand-me-down fairy. Aunt Anna, Uncle Roy, Lenore, and Sally lived about an hour away in Forest Hills, Queens.

I sat beside Mom on her bed while she spoke to Aunt Anna on the telephone.

"Claire," I heard her say to my mother, "I wanted to give the bike to Jay, but he's away at school, right?"

"Yes, he is."

"In that case, the bike should go to Miriam's boy, Marvin."

Mom always did Aunt Anna's bidding. And her bidding was always demanding. She had enough money to bid as much as she wanted. *Hopeless, me getting that bike.*

"I'll make sure Marvin gets the bike," Mom kowtowed.

I gasped and stood facing my mother when she hung up the phone. "Can't I have the bike? Please. It's perfect."

"The bike is for Marvin. It's too dangerous for you. What if you get into an accident?"

"What? You mean if Marvin has the bike, he won't get into an accident?"

"He's a boy. No, he won't have any accidents."

"That makes no sense."

"Stop it, Gail. Marvin gets the bike."

Mom, wearing her flowered housedress with big pockets to keep her cleaning stuff in, looked square into my eyes, speaking in a firm voice. "Aunt Anna said the boy's bike must go to Cousin Marvin, not you."

That earth-shattering statement punched me in the stomach. I knew Marvin didn't give a hoot about the bike. She might as well have dropped me into a tar pit. How could she agree with Aunt Anna? Aunt Anna had money, according to Mom. Did that make her an

expert? Mom never considered my feelings. I liked giving my opinion, but Mom decided. Why didn't she trust my judgment? Was thirteen too young to ride a bike?

I guessed grown-ups thought boys were better at handling danger than girls. We were only suitable for having babies and eating candy, unless we went to college. How could I convince Mom I must have the bike? I got an idea. I'd promise to go to college if she let me have the bike.

"Oh, come on, Mom. It's summer. There are no potholes, no whipping winds whisking my hair into my eyes, no bug bites, at least not when I'm riding."

Mom got that squeezed-mouth look and shrugged her shoulders. "Am I not getting through to you? Why do you keep arguing with me?"

"I'll go to college if you let me have the bike."

I watched Mom's face and kept quiet, hoping she wouldn't get angry. That would be the end. The bike meant freedom. If anyone knew about freedom, she did. She suffered horrors in her youth in Russia, hiding from the pogroms who would kill her if she was caught.

Mom's mantra was, "You live in a free country, so you can be anything and go anywhere." Would she be willing to give me freedom, which she treasured?

I recognized the power of her words and how they could wear down people's resistance. I saw it when she

persuaded the principal of Fort Hamilton High School to admit me as a student, even though the school was beyond my district. Everyone wondered how she pulled it off, and I had no obvious answer. I observed her negotiation skills during merchandising efforts for our store and the other local businesses she represented. I took my bargaining cues from her, witnessing how she skillfully whittled prices down in her dealings.

My mom, the biggest worrier on the planet, was taking away my bike. My bones clamored to ride and see where it took me.

"Please, Mom, let me have the bike. Here's the deal. Let me have the bike for three weeks, and then you can give it to Marvin." She called Aunt Anna to ask if that was okay, and Aunt Anna said to go ahead, but only for three weeks.

Three weeks didn't give me much time. I had to get on the bike and see where it would go.

"Will you be careful and stay close to home?"

"I'll be careful." (I didn't say I'd stay close to home.)

Brooklyn in June can get hot. Saturday was mega muggy, but it would be even hotter and muggier after school was out. I wore shorts under my skirt and my white button-down top.

I rode my bike facing the cars. Seeing the vehicle that wanted to run me over was always good. That way, I could escape, and seeing ahead for a few miles was

easier. I hoped the bike agreed. All I wanted to do was ride and not worry about anything—no basket, water, food, or even a hat to cover my short hair. I used some zinc oxide to protect me from the sun. The white zinc made me more visible, too.

Friendly waves greeted me as I pedaled along. Returning the gestures, I cruised toward Ocean Parkway. An old man seated on a bench caught my attention, motioning for me to come closer. My bike obediently rolled up to him. The wrinkles on his face radiated warmth through a broad, ear-to-ear grin. A Brooklyn Dodgers baseball cap adorned his head, with sunglasses perched on the brim. Beside him sat a young boy with curly dark hair, nodding in acknowledgment as I approached.

Curiosity got the better of the boy, and he inquired about my identity, wondering aloud if I might be the one to teach him how to ride. The man leaned down and conversed briefly with the boy, who then stood and asked, "Will you teach me to ride?"

"You forgot to say please, Mike," the old man said.

"Please."

"How old are you?" I guessed he was about eight. Age didn't matter. He just had to be the right size to fit my twenty-four-inch two-wheeler.

"Almost nine," he said, jumping up and down. He

looked tall enough to swing his leg over the bar and reach the pedals.

"I'll hold the bike. Here, climb on." I held on to the seat and the right side of the handlebars to balance him while he pedaled. He did so well that I pushed a little to send him on his way, and he rode. I ran beside him.

"I'm going to hold on now to stop the bike."

He jumped off, swinging his leg over the bar, and hugged me.

"Grandpa." He grabbed his grandpa's hand, glanced at me, jumped up and down again, and gasped. "Can I have this bike? Can I? Please, please?"

"I don't think the young lady wants to give up her bike, but after talking to your parents, we'll see about getting you your own."

Mike's grandpa turned to me. "Thank you. I'll always remember what a nice thing you did for my grandson. What's your name?"

"Gail Gerber. I live in Borough Park and am on an adventure with my bike."

"That's pretty far to go on an adventure."

"No, it's not. There were lots of cars, though. I had to be careful."

"Can you sit down for a while and visit? It's nice to meet a young lady with such a big heart."

"Yes, I would like that. Sir, how may I address you?"

"You can call me Chuck. Where are you taking your bike?"

"Oh, I'm not taking the bike anywhere. The bike is taking me. I'm not sure where we're going from here."

"You might think of telling the bike about the Park Circle Roller Rink. It's not far from Prospect Park."

"Thanks." I liked that idea, but would the bike make a stop there? I'd have to wait and see. "Do you live in one of these tall buildings? Were you a soldier in the war?"

"No, I'm too old, but I live with my son and his family. My son was a soldier in the war and lost a leg. He received medals for his bravery."

"I have to be home before dark. I'm sorry, but I must go. My bike is tugging at me to move on."

My bike stood straight up, inviting me to climb on. As the cycle picked up speed, I waved to my new friends. Mike and his grandfather stood, waved, and threw kisses.

My bike sped along, passing people on benches, other cyclists, and kids playing jump rope and potsy. I wanted my bike to stop so I could play with the girls. I loved the challenge of jumping rope with turners. It takes a unique rhythm to do it, especially double jump rope. My bike didn't stop. It continued until we saw a blue canopy over the rink's entrance emblazoned with the words PARK CIRCLE ROLLER RINK. It was one of the

grandest buildings in the area, and the windows had arches over them like a fifteenth-century castle in Scotland, as shown in one of my storybooks. The tower overlooked a wide street of cars going east and west. My bike pulled up in front of the canopy. I got off, leaned the bike against the lamppost, and went inside.

The unfamiliar organ music was rousing. The roller rink was lively and colorful, filled with upbeat music and the hum of wheels gliding over the smooth, polished floor. The rink was a large, oval-shaped area surrounded by a low barrier that skaters could grab on to for balance. Bright overhead lights cast a cheerful glow, often enhanced by colorful disco lights that danced and spun, adding to the energetic atmosphere.

Around the rink were rows of benches and tables where skaters sat and put on their roller skates. I noticed a rental skate window with all sizes and colors of skates lined up neatly in racks. The concession stand had snacks like popcorn and pretzels, and soft drinks. On a balcony, there was an organist who kept the music pumping, playing popular songs like "Harbor Lights," "It's Been a Long, Long Time," and "Peg O' My Heart." The music set the pace for skaters of all ages, from little kids wobbling on beginner skates to seasoned pros showing off their tricks.

Couples, many kids, and older people skated to the beat of the music. The gals wore itsy-bitsy skating skirts

in different colors and tops to match, like a uniform. I turned to a tap on my shoulder.

"How do you like our skating castle?" a deep voice asked above the organ's tunes. The voice belonged to a dark-haired young man sporting a smile that brightened his blue eyes and reddened his cheeks.

"I like it a lot."

"Come on, let's skate," he said.

"I don't have skates,"

"I'll rent you a pair. What size shoe do you wear?"

"Skates are shoes?"

"These are."

"I wear a size eight."

He turned and went to the skate window. I waited behind the railing surrounding the skating area. I noticed arrows pointing to men's and ladies' rooms. The soda fountain tempted me. I bet I could get a cold drink of water.

"Here, sit on the bench. I'll help put your skates on."

I slipped my foot into the skate, then the other.

"I'd like a drink of water."

"I'll get you some." He left and returned with a glass of water.

"Thanks." I guzzled it and put the glass down on the bench.

He tied the skate's laces and used a wrench to tighten the wheels. It all looked weird.

"I'll be right back." He returned the glass to the fountain window and came back.

Before I knew it, I had my arm through his, and we were skating to the music. Oh my, I loved skating in shoe skates.

Alan, a talented skater, was trim and not taller than me. His full head of curly brown hair and bright brown eyes made him look familiar. He wore black trousers and a black shirt, and his shoe skates were black, too. I liked the long line of matching blacks.

What makes an excellent indoor skater?

When Dad gave me my metal skates, I worked hard to figure out how to move without falling. I learned the skill, but not without many banged, bruised, and bloody knees. Staying upright felt good, but knowing how to dance on skates was a new challenge.

"Alan, my bike is waiting."

"Wait," he said. "Where do you live?"

"On Fort Hamilton between Forty-Fourth and Forty-Fifth."

"No kidding? I thought you looked familiar. I live in an apartment house on Forty-Fifth, up near Tenth Avenue. I hope you'll join our skating group. We come here every Saturday."

"Sure, I would love that, but it's late. I have to be home before dark."

The bike had one more stop—visiting my horse in

Prospect Park, but it was too late. His Little Gray Barn had already housed the horse. The trainer greeted me with a hug and asked me to come another day. The horse wasn't mine. I tried to ride the same one each time I went riding. It was nice when the horse knew me.

My bike turned around toward home. It picked up speed. "Where are we going?" I yelled. I hung on for dear life. We were across from the store in twenty minutes, on New Utrecht and Forty-Fifth. Then the bike made a mistake. It slid into the groove of the trolley tracks, and down we went, tumbling onto the street behind a car. I was on the ground, looking at the rear red lights of a car backing up, about to roll over me.

People passing were yelling. "Stop, stop, there's a kid in back of your car!"

I looked up and saw the red taillights flashing before my eyes. The car paused.

"Are you alright, little girl?" A voice came out of nowhere. Did my bike talk?

I looked up at the people standing around me, their faces in shadow from the sun behind them.

"Yes, I think so," I replied with hesitation.

"Here, let's get you and your bike back up," a voice said.

The crowds disbursed.

As I stood, my stomach felt like it got punched. I was okay—a little shaky and maybe bruised—but okay. It

was unnecessary to tell Mom about falling under that car. I saw goodness in the people I met and those that helped.

It was the first day of my three weeks. There were people to meet, places to go, and tales to tell. The bike gave me confidence. It opened my eyes to possibilities and gave me opportunities to share. I waited for the light to stop the traffic and walked across Fort Hamilton Parkway to the store, holding on to my bike's handlebars.

God watched. His armor had kept me safe.

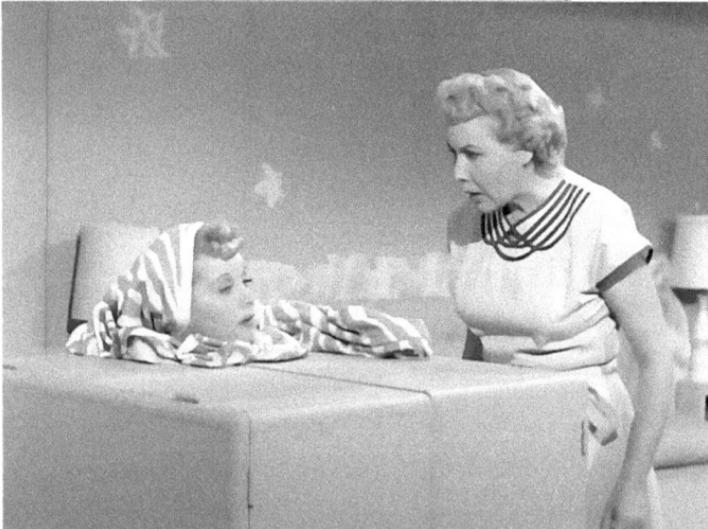

Vintage ad for MacLevy Reducing School
Lucy (Lucille Ball) in a weight reducing sauna
with Ethel Mertz (Vivian Vance)
(courtesy Wikipedia)

Chapter Ten
MacLevy's Reducing School ~ 1948

Mom signed me up for MacLevy's Reducing School. MacLevy's wasn't some institution aimed at sharpening my math subtraction skills. No, it was a place specially crafted to subtract inches from my body. When Mom decided, that was the final verdict. I didn't get a say in the matter, and Dad's stance was clear: "Do as your mother tells you to do."

On my thirteenth birthday, Mom had a makeover scheme in the works for me. I couldn't quite fathom why I needed it, but I figured every thirteen-year-old girl had to tinker with their face and body. Moms have this thing about getting their kids ready for the teenage years. The schoolboys labeled me as "zaftig" because I was five foot four and weighed 135 pounds. I thought

they appreciated my curves and my petite waist. At any rate, I wasn't sure whether it was crucial for the boys to approve of my appearance.

"Dad, am I fat?" I asked.

"No, you're just swollen. Do as your mother orders. It's good for you." I always listened to my father.

After the beauty parlor, where Sophie bleached and cut my hair, secured curl clips, and placed me under a hair dryer to unleash bouncy curls, Mom took me to MacLevy's. We ascended a flight of stairs, and I couldn't help but wonder if this was part of the reducing plan.

I toyed with the idea that maybe I could save Mom money by running up and down the stairs twenty times, but she wasn't too keen on that suggestion.

I changed into my green gym suit. The machines roughed me up, but nothing got smaller. The roller on the upper arm challenge turned and hurt my elbow bone. I had to hold my arm in a position to protect it, so I became a bit of a contortionist. I eventually gave up on that challenge and concentrated on my butt and thighs. The vigorous belt appeared to work, vibrating my flesh at lightning speed. I prayed/hoped/wished the inches would fall away and my thighs would no longer rub together.

In the end, I'm not convinced those machines changed the curve of my behind. Regardless of the mirror or how I stood to check my curves, my butt

seemed unchanged. I stopped hiding it under full skirts. Observing my classmates in the gym, I noticed none of the girls' thighs rubbed together. Thanks to the snug, itchy woolies that Mom insisted I wear, my thighs remained unacquainted with each other, free from any rubbing.

I spent six months sitting on the roller, determined to roll off those inches, standing at the vibrating belt, hoping to shake the fat away, and concluding each session by cooking in a steam box. Despite this routine, not a single percentage of my body seemed to get smaller.

Interestingly, Elizabeth Taylor and I shared the same height, but she weighed 108 pounds. Mom envisioned glamour for me, and following her lead, I believed that this was the way to achieve it. "Mom." I gazed into her eyes with anticipation. "If I get smaller, will I be like Elizabeth Taylor in her movie *National Velvet*?"

"You might be. Work harder to lose those inches."

"Should I spend more time on the vibrator?"

"Don't worry. You're doing what you need to do."

I used the vibrating belt until my legs itched like mad.

I waved my hand at the attendant, Miss Mikel. "Why are my legs so itchy?"

"The vibration moves your blood around."

I flipped the switch off and widened my eyes. "Geez, am I going to bleed out?"

She laughed. "No, the belt is stimulating your circulation. It won't hurt you."

I sighed and turned the vibrating belt back on for twenty minutes on my lower appendages.

All the other students in this school were much older than me, resembling my mom. They wore white, short-sleeve, middy blouses and black bloomers. I couldn't help but feel out of place in my distinct green school gym suit. I pondered—did everyone have to dress alike?

I submitted to the matron, who had a bulldog grin on her face. She wrapped me into a gigantic machine, pushed a button, and rubbed my fat up and down for ten minutes. I could hear my bones creak.

"Mom, do I have to keep doing this?" I asked in the car on the way home.

"You'll be trim and beautiful like the matron told you."

"But, Mom, how come all the matrons here are fat?"

"They don't have time to use the machines."

My friend Rhoda and I ate M&Ms a lot. Was that a good idea? I guessed I shouldn't have eaten an entire cake with my brother, who didn't have an ounce of fat on him. Did eating half a cake lead to this school?

As per the bulletins plastered all over the walls, the

steam cabinet, hailed as the latest hydrotherapy, was a healthy and innovative experience. But was it? I wasn't sure. The matron, her emotions concealed behind a slight sneer, or perhaps displeasure, guided me through the process. Stepping into the cabinet, I settled on a wooden bench. With the matron's help, the top of the cabinet descended over me, exposing only my blonde head, now resembling a solitary flower. She closed the doors, starting the release of steam that enveloped me like a warm blanket. After five minutes, my body felt like it had melted away. As the doors opened—first the top, then the bottom—my head flopped like a wilted dahlia. I struggled to stand on my legs, swaying from side to side.

In the 1940s, before our move to the store, thoughts about being fat or consuming fattening foods rarely crossed my mind. I relished bread, cake, and my five-cent Clark Bar, happily consuming whatever Mom placed on my plate. There was no room for waste, as children in Europe were starving. I couldn't leave the table until my plate was spotless, reminiscent of the rules enforced on the ship to America. A clean toilet, berth, and plate must have been significant in Mom's heart. Although her words seemed illogical, her attitude contributed to my enduring struggle with weight.

After settling into the store, Mom assigned me the daily task of heading to the bakery across the street to

purchase bread and cake. One day I returned with freshly made seedless rye and a tempting seven-layer cake, the enticing aroma enveloping my senses as I skipped back from the bakery. Mom, a cake-for-breakfast lover, indulged herself while slapping my hand away to prevent me from taking a piece. "Don't eat that. It'll make you fat," became Mom's lasting rebuke, an epitaph of sorts.

Frankie & Bing (courtesy Wikipedia)

Chapter Eleven
Dancing to Frankie & Bing ~ 1948

Christmas neared with Bing and Frank serenading the airwaves. My mother lingered in our cozy kitchen as she sat at our oval red Formica table, savoring her morning coffee and cake. She seemed a vision of contentment. Dad, exuding effortless charm, extended his hand to her, a wordless invitation to waltz through the beautiful routine of their lives together. It was a dance of love, compromise, and discord. I loved to dance, like Dad. Mom only had to follow along. As the famous songsters filled the room with crooning, my parents swayed to the rhythm, their steps echoing the timeless melodies of a famous era.

With his elegant flair, Dad led, while Mom, practical and grounded, followed along, her thoughts never far

from the checkbook waiting to be balanced. Frankie's smooth crooning filled the room, his voice dripping with a charisma that seemed to captivate the masses. Yet, amidst the swooning over Sinatra's swagger, Bing's refined tones held a special place in Mom's heart. It was a debate as old as time—the allure of charm versus the comfort of familiarity.

Perched on a kitchen chair, I observed this ritual, my eyes flitting between my parents with amusement and concern. Dad's attempts to whisk Mom away from her responsibilities often met with resistance.

Mom and Dad shuffled around the kitchen to the dulcet tones of Bing and Frank. I never figured out why the girls went nuts over Frankie with nary a peep for Bing. Maybe it was Frankie's swagger, code for sex appeal in the forties.

"Oh, Bernie, you know we can't afford to waste time on frivolities," Mom would chide, her face flushed with frustration, while Dad, ever the optimist, countered with a smile and a twirl, determined to coax her into his world of whimsy. In contrast, Bing's appeal was more subtle, sweeter, and more wholesome. "When Irish eyes are smiling," he bellowed as the words floated to lift them, moving them around the room. Mom preferred Bing's more refined approach. I trusted her opinion, so I picked him, too. Their dance, a delicate balance of passion and practicality, mirrored the

complexities of their relationship. Mom, with her fiery determination, and Dad, with his unwavering optimism, each bringing their unique tempo to the rhythm of their lives.

My flared blue dress made it easy for me to straddle a kitchen chair while watching my parents dance. Frankie crooned, "Isn't it romantic?" His song moved them along as they swayed like Fred Astaire and Ginger Rogers. Despite the bickering and banter, there was a quiet understanding, a shared recognition of the love that bound them together. It wasn't grand gestures or extravagant displays that defined their love, but simple moments shared in the kitchen to the popular tunes that mattered.

"Alright, let's finish this one dance, Bernie. And then I have to get back to work. That checkbook won't balance itself."

"The checkbook can wait, Claire. For once, enjoy yourself and have fun."

Uh-oh. Here comes trouble. I don't think Dad realized he pushed the wrong button.

"Oh, how can you say that to me? You know how tight money is right now." Mom's face was a red tomato.

"Money is always tight, but dancing costs nothing. We can afford that, can't we?" he asked as they shuffled. She looked up at him, sucking in a deep breath. "Maybe you can afford to do nothing, but I can't."

I wanted to put my finger under her chin, look into her eyes, and say, "Be kind and follow Dad."

How could I figure out how to stop their bickering? At least they didn't swat at each other, but Mom bossed Dad around. He didn't seem bothered by the bossing. "It's easier to agree than to argue. She's a powerhouse when deciding," Dad would say.

My mother, Claire Gerber, a brunette with a hint of red in her hair, five foot two with hazel eyes that had brown polka-dots, appeared to be sure of herself, never wishy-washy. If she had an opinion, I followed along. I don't know if I looked like Mom, but I had Dad's legs below my knees. How does God do that? Half and half, God says, like the cream in your coffee. I had Dad's green eyes. Otherwise, I followed my mother—it was too hard to disagree. No one could discourage her once she made up her mind.

Mom had baked a tray of chocolate chip cookies and left them on the stove. Those cookies always appeared out of nowhere for a woman with little time. The aroma filled the air and tickled my nose. I picked one up before Mom noticed, and stuffed the gooey, warm cookie into my mouth, not allowing the chocolate to melt in my hand.

My father, tall and slender, not a pushy guy, held on to Mom. Her two-inch platform shoes made her look taller than her five-foot-two. My father was handsome

at six feet, with those deep green eyes and a mustache. Men with mustaches are elegant, no doubt about it. Combined with a smile, they are a knockout. "Your mother's eyes beckoned me. She was a pretty thing," Daddy used to say to me.

Her cheeks reddened, and she wriggled, trying to free herself. No matter how much she pleaded, Dad wouldn't let go. I knew she felt trapped. If only I could shake her until she screamed or wept and broke loose from her lonely island.

"Give it up and enjoy yourself," Daddy said. "Come on, Claire, dance with me one more time." Mom pulled back at first, but something in Daddy's eyes made her settle into his embrace. He twirled her around as Bing Crosby's voice smoothed the way. Mom's face lit up like twinkling lights on a Christmas tree when Bing sang "White Christmas." I wished Mom would smile more often. "Enough, Bernie, stop this silliness. Look at me. I'm still in my housedress." Despite all her complaining, she kept up with Dad and the rhythm of the music.

"I'm looking. You're beautiful."

Dad broke into a wide smile. He shook his head. "Let's make time for ourselves. We're entitled to a day off. Besides, dancing is romantic."

Mom pursed her lips. "Who has time for romance when there are so many things to do?"

"Why not add dancing to that list?"

She rolled her eyes. "Dancing serves no purpose."

"Close your eyes, Claire, and listen to the music." Mom closed her eyes, and my playful father brought her hand to his lips. He held her closer, swaying to the next song. This time, Judy Garland sang "Somewhere Over the Rainbow." Mom started humming along in her lovely vibrato.

As the strains of the song filled the air, I joined my parents in their dance. Our laughter mingled with the music as we moved together in perfect harmony. At that moment, I realized that love, like music, can transcend time, bringing us together in a dance that lasts a lifetime.

Gail's mother: the flapper (seated far right);
Claire ~ wife, mother & business woman

Chapter Twelve
Echoes of Loss and Mothers ~ 1948

My home phone number was easy to memorize. I memorized everyone's phone number, but not on purpose. I still remember Gedney 2-3987. The first two letters identified our city area—Borough Park.

I loved it when the phone rang. I always ran to answer it first. It was exciting to hear who it might be. But then came a day I wished I hadn't answered it.

"Hello?"

The hollow voice on the other end of the line echoed, "Hello."

"Who is this?" I asked.

"What's the matter with you?" my friend Rhoda huffed, her voice strained with exhaustion.

I felt a pang of guilt. "Rhoda, I'm sorry. You don't sound good. Is there something wrong?"

Rhoda's voice dropped to a whisper. "There's something very wrong. We're moving."

My heart skipped a beat. "Moving? Where? How soon?"

"To Long Island, where all our friends are going," she replied, her voice cracking. "My mother has colon cancer. The doctors say she doesn't have long."

I felt a lump in my throat. "Oh, Rhoda, I'm so sorry. This is so unfair."

"Do you remember how we used to buy M&Ms from the sweet shop and sit in Old Nellie, gobbling our goodies?" Rhoda asked, a hint of nostalgia in her voice.

"Of course I do," I said, trying to smile through my tears. "Those were the best times. It's hard to imagine you not being here. We're lucky we met when we were eleven. We've had a great three years, best friends forever. Right?"

Rhoda's cries pierced my heart. "Why do I have to lose my mother and my best friend too?" she said. "I feel so lost and scared. My mother has always been there for me, She's kind and gentle. What will I do without her?"

"I wish I could be there for you," I said, my voice trembling.

"I have so many memories. I could always talk to my mother about anything. How about you?"

I hesitated. "Did she ever get mad at you and hit you or stop talking to you?"

"Why would you ask such a thing?" I could tell Rhoda was shocked by my question.

I closed my eyes, trying not to cry. "Those are the things my mom does. She can be mean and distant."

My best friend was silent for a moment. "I can't believe that. Your mom was always nice to me, especially when she asked me to convince you to cut your hair."

"That was strange," I said. "We had just gotten to know each other. My mother said right in front of me how cute you looked in your short hair. Then she asked me if I wouldn't want short hair too."

"Did you know why she wanted you to cut it?" Rhoda asked.

"I thought it was because she was too busy and didn't want to spend time curling it. You're lucky to have a mother you can depend on."

Rhoda gasped. "Don't you like your mother?"

"I used to like her, but now she seems to be angry all the time. I feel so much resentment towards her for that."

What I told Rhoda was true. Up until we moved and took over the store, my mother was kind and warm. She

would sing as she baked cookies, her laughter filling the house like sunshine. There was always time for me, playing games, telling stories, doing flash cards for spelling and arithmetic, soothing my fears, and curling my hair. I could remember many days when my mother was my hero, my soft spot to land...

"Hooray, let's play fire engine," I shouted one afternoon when I was five. My brother, Jay, nine and tough as cowhide, hopped onto the back of my red tricycle in answer to my encouragement.

Determined to go as fast as I could, even with the added weight of my sturdy brother balanced on the frame, I pushed the pedals harder, but my stubby little legs were no match for the excess weight, and gravity tipped us over right into the rosebushes.

Jay, who'd landed on top of me, suffered no ill effects from our tumble and ran hollering for Mom. My scraped arms and legs turned the color of red roses, with blood oozing from several cuts. But the thorns sticking out of my skin shocked me most. I tried not to cry, but it hurt too much. If this was what roses had to go through to look so pretty, I wanted nothing to do with them.

My mother picked up my battered little body, rushed me into the house, and fixed my wounds. There were only three thorns, but it hurt pulling them out. She poured peroxide on my arms. While fascinated by

the bubbles, I whimpered until the sting began to subside before I gave in to my curiosity.

"Mommy, what are those bubbles?" I asked, catching my breath.

"It cleans the sores to help them heal."

She put the non-burning Mercurochrome all over the cuts. I looked like I got clawed in a catfight.

"Let me look," Jay said, sounding all grown up. He took my arms one at a time. "Doesn't she need Band-Aids?"

"It's better to let the air dry them out," Mom said, kissing me on the forehead.

Her kiss did more to alleviate my pain from the cuts than any of the medicine she'd poured on them.

The apartment house had a front porch I loved because of all the hiding places it provided during the summer storms that scared me more than any ghosts lurking in the fireplace.

But every time a storm threatened, Jay would launch into brotherly teasing. "You're such a scaredy cat. What're you afraid of?"

I couldn't articulate what frightened me, but I didn't like it when Jay called me a scaredy cat. Luckily, Mom came to the rescue again.

"Jay, don't tease your sister. Storms can be scary, but it's just God trying to cool us down when it gets too hot," she explained.

"I guess God must be working hard today," I said.

Mom sat me on her lap and began to read Henny Penny.

"She said the sky is falling, Mommy. Is the sky falling?"

"No, dear, God's just getting ready to water the flowers."

"God sure has a strange way of watering," I said.

But then everything changed a few years after we moved to the store. My mother stopped believing me. I remember when one of the neighborhood gossips said she saw me smoking at the movies. I was eating my morning three-minute egg and toast when Mom came in from our store.

"Gail, I have to talk to you," she said, running her finger along the shiny chrome edging of the red oval table.

She didn't look at me while settling into the matching chair. "You were smoking." Mom accused me in a low voice tinged with a Russian accent. It was strange how her accent became more pronounced when she was angry. And she was furious.

"I was not smoking."

"Estelle stopped by the store and told me she saw you smoking with a bunch of kids at the movies." Mom's voice was cold and accusatory.

"No, she couldn't have seen me smoke. I can't

smoke. Smoking makes me cough and gives me a stom-achache," I pleaded, my heart pounding.

"Stop telling lies," Mom said, grabbing for my hair.

I ran for the cellar door, trying to evade her grasp, but she caught me. Her fingers tangled in my hair, and she yanked, pulling out a clump.

"Stop, stop, stop! You're hurting me!" I cried, my voice breaking. "I wasn't smoking. I promise. I don't even like it. I told you it makes me sick."

But Mom didn't believe me. She had already judged me guilty, and now she was delivering her punishment —beating me, pulling my hair with one hand and hitting me with the other until my father rushed in, speaking urgently in Yiddish. Mom finally let go and stopped beating me. She turned away, her face set in stony silence.

At first, I didn't care about her silence, but as the days stretched into three, her refusal to speak to me became as painful as the beating. Each day, the silent treatment cut deeper, leaving me feeling more isolated and desperate.

After a week, my dad approached me, his expression weary. "Apologize to your mother."

"What for? She called me a liar and accused me of smoking."

"Were you smoking?"

I shook my head, tears welling up. "How could you

ask me that? No, I don't smoke. I'm not apologizing. Mom needs to apologize to me."

"You know she won't do that."

"She owes me lots of apologies."

"This is not helpful. You must say you're sorry to make life bearable."

I caved. When you're a kid, you must be the one to apologize. I did it for my dad, choking on every word. My apology was a lie, and it broke my spirit.

My mother's actions and the change in how she treated me were confusing and heartbreaking. How had she transformed from the loving mommy who kissed away my scrapes? The stories she read to me soothed away my fears. What happened to turn her into this virtual stranger who refused to believe me and treated me like a rabid dog? The question haunted me, leaving a deep, aching wound that never truly healed.

One day, I asked my mother about her childhood and what it was like coming to America. She raised her chin, stared at the ceiling, and left the room. But I persisted, trying to speak to her when she was in a good mood. She finally revealed that her father beat her and that she didn't like him. Was this why we rarely visited my grandparents? But my cousin Sheva said that her mother, Aunt Miriam, Mom's sister, loved their father. This made no sense. My mother's relation- ship with her family remained a mystery for years

until, one day, after she was gone, I found an antique photograph.

I hadn't seen the photo in decades. But as I gazed at it, I realized the woman in the picture, my mother, wore a dress reflecting the day's fashions, unlike the rest of her family's modest clothes. The picture was a few months before my parents married. She wore a dress typical of the flapper era, and her bobbed hair was a dazzling relic of the Roaring Twenties. The dress, adorned with intricate beadwork and sequins, cascaded to just above her knees. Over her bare shoulders, she'd draped a delicate sheer shawl. I was sure it would catch the light with each movement, creating an enchanting dance with shadows and sparkles. My mother was a great dancer, Dad told me. Her clothes were daring; perhaps her father berated her for that.

Flappers of the 1920s were young women known for their energetic freedom, embracing a lifestyle many viewed as outrageous. Considered the first generation of independent women, flappers pushed barriers of economic, political, and sexual freedom. This era was a decade of significant transformation, with young women like my mother at the forefront of cultural evolution.

But rather than achieving a better understanding of me, her own experience made her harsher. Was it because she worried about me? Or was it because she

had lost touch with that spirited girl she used to be—a wife, mother, and businesswoman?

Then, in her old age, when she was ill, she told me there were things she wanted to say to me. Unfortunately, she passed away before we could have that talk. Perhaps my mother told me what was on her mind and heart when I came across that picture, long after she was gone. A flash of awareness and understanding came over me as I gazed upon the image of my mother in the photograph when she was lovely and full of the flapper spirit.

Was my mother a rebel?

In the days following our phone call, I spent as much time with Rhoda as possible. We revisited our favorite spots in Sunset Park, made new memories, and laughed, despite the looming sadness. I assured her that distance wouldn't change our friendship. We planned to write letters and call each other regularly. On her last night in Brooklyn, I gave her a scrapbook filled with photos and mementos of our time together. We hugged tightly, tears streaming down our faces, knowing our bond would endure. And then one day, I was married with three kids, living in Hicksville, and she called to say hello.

"Hi, Gail, what's happening?" Rhoda's cheerful voice rang through the phone.

"Bob just passed his CPA exam, and all's right with the world," I replied, my heart light with pride.

"That's wonderful! I'm so happy for you both," she said warmly. And then, just like that, she said goodbye.

I never heard from Rhoda again. She didn't give me a chance to ask how she was doing, to share in her life as she had in mine. That fleeting conversation was our last, leaving me with a sense of loss and unanswered questions.

Best friends and teenage temptations...
(courtesy CANVA)

Chapter Thirteen
Friends ~ 1951

As the story goes, my folks had no spare money after marriage in 1929, but Mom had a wealthy friend, George. She found him when he placed an ad for a bookkeeper. His generosity came from his heart and his Key Foods supermarket in Brooklyn. His kindness spilled over to the best meats to buy with the groceries, filling my mother and father's empty pantry. Mom spoke highly of George through the years. She did not form a friendship with his wife, Lilly, who acted strangely. She had dementia, unknown in those years. Most likely, the dementia began in her youth, because she never remembered who I was. On each visit, she spoke like she'd never met me.

"Gail, it's nice to meet you. You are tall for a five-year-old."

Her daughter Anita and I were best friends. Best friends last forever, don't they? When I was five, we went to ballet and tap classes together, paid for by her dad. (I used the taps for my clogging 65 years later). Mom always told me, "If it weren't for George, you'd never have these classes." I remember the hand positions and the pirouette, where I had to spin on one foot. It was almost impossible, but I persevered and came close. Anita and I practiced the five barefoot and hand positions. (Now, 75 years later, I use the hand positions in my ballroom dancing).

Anita lived on ritzy Avenue J in the Midwood section of Flatbush in Brooklyn. With a standing invitation from George, my family spent almost every Sunday at their house. They welcomed family and friends to drop into their three-story Victorian. The side door by the kitchen was always open. Fresh-cut green grass, pink azaleas, and cherry tree blossoms scented the lush spring garden on the property. Anita's mom gave me fragrant branches to take home, and their scent was a delightful reminder of her kindness. Amidst the familiar aroma of gasoline at the station and the pungent smell of airplane glue from my brother's hobby, I found comfort in those everyday scents. Meanwhile, Jay stayed home, immersed in the joy of flying model planes with his friends.

Anita's house was dreamy. The kitchen, which was

more significant than two of ours, had a rolling butcher-block island and marble counter space for food preparation. A bread basket filled with fresh bread and muffins waiting for a smear of marmalade sat beside bagels, lox, and cream cheese. Our fathers sat at the table for eight in the kitchen breakfast nook, drinking coffee and watching a twelve-inch television tuned to Sunday baseball games.

Anita's mother occasionally served us treats while we sat at the breakfast bar. At other times, we helped ourselves to goodies in the refrigerator, overflowing with leftovers like chocolate pudding, lemon meringue pie, and chocolate brownies. My mouth watered from the smell of chocolate in the kitchen.

On a particular Sunday in May 1951, when I was sixteen, and we'd been friends for ten years, Anita grabbed my arm and dragged me up to her bedroom on the second floor. The servants lived on the third floor, but I never saw them. Anita said they were off on Sundays.

Anita's room made mine look like a closet. She had everything I'd ever wanted or dreamed of—a phone, privacy, and pretty pictures of people on her walls. Old toys languished in a corner, and her closet was full of clothes and some of her mother's clothes, makeup, and perfume to play dress-up. I tried on a dress and strutted around in her mother's high heels with my hands on

my hips. Her makeup made us look like magazine models. I sniffed the French perfumes, but they tickled my throat, making me cough. Anita's mother, who insisted I call her Lilly, never said a word about the mess we made of her things.

"I love when you come over, Gail," Anita said.

"Me too. Why are you wearing dungarees?"

"They're Arnie's. See, I rolled up the cuffs so they fit."

"How come? Your closet is bulging with all kinds of clothes and shoes."

She grinned. "I like to wear dungarees. Boys are so lucky—they wear pants all the time. Why can't we?"

Anita looked glamorous in Arnie's dungarees—her lips matched her red turtleneck sweater. She always prettied up to go on adventures with her friends.

I spun her around. "I have to admit, you look adorable."

"This is what I wore last Saturday when I went to New York with my boyfriend, Dave. You met him at his house party last month."

I sat on the small chair at her vanity table. "Yeah, I remember, but I can't keep up with your boyfriends. What did you two do in New York?"

"We played the machines at the penny arcade. We met some friends, went for ice cream, and ordered the

Kitchen Sink." Anita plopped onto her bed, sinking into her pillow.

"Is that the one where you get every flavor in the ice cream store?"

"Every single flavor, syrup, nuts, sprinkles, and whipped cream, too." We each got a spoon and kept eating until we were so full we fell over."

"That sounds like lots of fun." I got stung by the jealousy bug. "Please, take me on your next adventure."

"If I let you come, you have to promise to keep where we go a secret."

I hugged my friend, but I had no idea what I was getting into. I threw my arms up. "Yay, I promise," I said in a singsong voice.

"Meet me at Coney Island next Saturday," she said, pressing her finger against her lips to silence me. "Remember, it's a secret, so don't tell your mother."

The week had to be the longest in forever, but that Saturday in May arrived sunny, warm, and bright. What should I wear? I narrowed my decision to two dresses—a red pinafore or a black felt swing skirt that made my waist look tiny. The skirt also had a poodle applique on the front. I picked that one. I added my black bolero jacket with pockets. White socks with my brown and white saddle shoes looked pretty good. I strutted back and forth in front of my tall mirror in the back of my bedroom door.

THE F-TRAIN in Flatbush took Anita a half hour to get to Coney Island, while the BMT (Brooklyn Manhattan Transit) took fifteen minutes from my stop at Fort Hamilton Parkway. At the first stop on Sixty-Fourth Street, the sight of two kids fighting in front of the Angel Guardian Orphanage wasn't unusual, and, like always, I hoped the winner righted the wrong. I turned to the woman sitting beside me with a little girl.

"What do you think those kids were fighting about?" I asked.

"Maybe one of them stole something?" the little girl guessed.

"You think so? That's awful." My stomach felt squishy thinking about that. It stirred me up. Should I be doing something I couldn't tell my parents about? I had never kept a secret from them. What if they found out?

We made a couple more stops. Folks got on and off. We passed New Utrecht High, loaded with gangs. Everyone called it the tough school. That wasn't my school. I played handball there and rarely knew my opponents, but it didn't matter; playing handball had a

competitive challenge I prized, like racing the boys. I loved the win.

The train stopped on Eighty-Sixth, a busy shopping district. I sat on the rattan seat and, from the train's open window, watched people walking, shopping, pushing baby carriages, and couples holding hands. The aroma of pizza and knishes from the luncheonettes made me feel hungry, until the stink of garbage filtered into the blend.

The sign on the tiled station wall read CONEY ISLAND—STILLWELL AVENUE. When I got off the train, the air permeated my nostrils with the smells of the ocean, and I heard the seagulls calling to each other. Anita stood waiting for me on the platform. She had dressed in Arnie's dungarees, a red turtleneck sweater, and a plaid jacket with leather buttons. She turned up the collar, and of course, she looked perfect.

"You aren't wearing dungarees," she said, her painted-red lips twisted into a frown. "You look ridiculous in that outfit. At least it's a full skirt. Otherwise, I don't know if you can ride." Anita smelled like an entire field of lilies. I bet she poured her mother's perfume on the top of her head and let it trickle down to her shoes.

"I-I'm sorry. I didn't know what to wear. The only dungarees I have are for horseback riding anyway, and they're yucky." Disappointed by her disapproval, I

wanted to turn around and get back on the train. But curiosity nailed me in place. "Ride what?"

"You'll see." She glanced over the railing. "Let's go down. Everyone's waiting underneath the trestle."

"Everyone" was boys with slick-backed hair and wearing black leather jackets on motorbikes—some with scruff on their baby faces—and a gaggle of giggly girls with painted lips and ponytails, all wearing dungarees with rolled-up cuffs. It was a look-alike club, and I was not a member. What did Anita see in these girls?

Although the day was bright and sunny, it was creepy, dark, and dirty under the trestle. Passengers had to pass through to reach the stairs to the trains. Iron stanchions, spaced like notes in my piano music, held up the trestle. The air was damp, and it stank of mold. Crumpled candy wrappers blew around us, and cigarette butts covered the ground. The oncoming train rumbled above us and added to the din. I wanted out of there. My skin crawled, but I wanted to see what would happen next—my big chance for adventure.

Anita pulled a slip of paper from her dungarees pocket and paired each girl with a boy and his motorcycle. Sam was my ride. He had green eyes and blond hair, and we were nose-to-nose in height. He wasn't the cutest, but sparkling white teeth enhanced his smile.

Sam stood beside his bike, looking at me. "Hey, girl. Sit here," he said to me as he patted the seat.

I was trapped. I couldn't believe I was going to do this.

"How do I get my leg over?"

"Put ya foot on this here peg behind the kickstand," he said as he pulled it down with his foot.

Sam held out his hand. I put my hand in his, stepped on the peg with my left foot, and swung my right leg over the seat. I tucked my skirt under my thighs.

"There's another peg on the other side to rest your right foot. With your feet on both pegs, you'll be secure."

"It'll be okay," I said.

Sam cocked his head. "Why didn't you wear dungarees?"

"Anita didn't tell me what we were doing."

Sam snapped his fingers. "Well, she should have."

My itchy woolies covered my thighs pretty well, keeping my legs warm. I double-checked my tucked skirt.

Sam mounted the bike. "Put your arms around my waist."

My stomach churned. "Why?"

He laughed. "Keeps you on the seat."

The revving engines made a robust, throaty growl, but it didn't block out Sam's laugh. I hoped the fumes' odor, which I didn't like, wouldn't choke me. I patted my

jacket pockets to ensure my little purse with my just-in-case money and tissues was there.

"Ready?" He grinned over his shoulder.

I grinned back at him. "Go, go, go."

Sam took off so quickly that it felt like the bike had lifted off the ground. My head snapped back, whipping the wind against my face.

Sam made a left turn and hollered, "Lean with me." I understood now why Anita liked these kids—riding was a thrill. I felt like Alice in Wonderland following the white rabbit down the hole. Sam drove up Brighton Beach, back to Coney Island on Surf Avenue, and turned on Stillwell to the boardwalk. A few bikes had parked there, but we didn't get off. Sam circled, and we returned to the dark, secluded elevated train station. Sam got off and held his hand out. I wasn't sure what he expected, but I slipped my hand in his and got off the bike. We were alone. The other kids were not back yet. The crowds on the boardwalk hummed. Echoes of voices exploded as strangers with fresh cotton candy ran into the tunneled pathway to the stairwell to catch the next train out.

Sam pushed me against a support column and pressed his lips to mine. He slobbered all over me. I had no idea what to do. He invaded my privacy—and didn't ask my permission. This was nothing like the kissing games we used to play. Perhaps kissing Sam was

making the best of things. But my brother shouted in the back of my head: Always. Be. A. Good. Girl.

I pushed Sam away and looked him in the eyes. He looked straight back into mine. I wiped my mouth with my jacket sleeve. "Ugh, you're disgusting."

Sam took my hand. I jerked away. "I'm sorry, it just happened. You're so pretty."

I felt a blush bloom on my cheeks. I shook my head and wiped my mouth again. "Creep, you had no right to kiss me."

The sun had set, and the clouds had rolled in. It was dark and eerie. The kids, mothers, babies, drunks, and musicians had disappeared. I wished I had never asked Anita to take me along. My muscles tightened, and I shivered.

"Look, you don't belong here," Sam said. "You're a good girl. Let's call your parents to come get you."

I didn't argue.

"Gimme your phone number." Sam ran across the street to the phone booth. I watched him drop coins in the box and dial. Sam smiled while talking. He hung up the receiver and ran back to me. "Your father's on his way." Sam busied himself polishing his bike with a rag from a black saddlebag. He looked up from his dallying. "Hey, Gail, I'm sorry this experience wasn't good, but I hope you liked the ride."

I nodded while my heart beat in my ears. My father

arrived fifteen minutes later. I was grateful to see him alone at the wheel. Anita hadn't returned yet, and neither had anyone else. Oh my God, my mother was going to kill me. Anita was going to be so mad at me. What if the boy she was with tried to kiss her, too?

My father rolled down his window. Sam waved, hopped on his motorcycle, and sped away, dust billowing behind him. I guessed Sam spoke with my father—person to person. I lucked out. Sam was a good guy.

I stood beside the car and watched my father's eyes follow the boy until he and his bike disappeared.

Dad shook his head. "Are you alright?"

"I'm fine, Daddy." I got into the car, pulled out my tissue, and buried my head in my hands. I tried to be stoic, but the tears rolled down my cheeks.

"It's okay to cry, Tootsie," he said, using the endearing name he gave me.

"I'm sorry. This experience hurt. I don't know why I listened to Anita. But honestly, nothing bad happened until the kiss. That kiss said lots about the group." I shifted back in my seat. "I won't ever go again."

"Who was that boy? How old is he?" my father asked.

I shook my head. "I don't know."

"When he asked me to pick you up, he said you didn't belong with these kids. What did he mean?"

"The boy tried to kiss me. I pushed him away and told him he was disgusting. He was nice about it, though. He said I was a good girl and asked for my phone number so he could call you."

When we got home, my father told my mother the story. With each sentence, my mother's hazel eyes darkened.

My mother's lips tightened. "Who was the boy you rode with?" she asked, snarling at me. "And where's Anita?"

I shrugged. "Sam, I rode with Sam. He was a nice boy, but I can't tell you anything." A groan sliced through the fog in my brain.

My mother shook her finger at me like always. "Lilly called when it got dark." My mother was getting angrier by the minute. "She asked where you and Anita were. I asked her why she thought you two were together, and she said Anita told her you both were going to Prospect Park. It's unsafe to be in Prospect Park after dark," my mother said. She paused and took a breath. "And now Dad says he picked you up under a trestle with a strange boy in Coney Island, and you tell me you can't say anything? Where's Anita? What if she's in danger?"

Guilt clawed at my gut, and sweat beaded on my forehead. How could I break my promise to Anita? I couldn't tell my mother that Anita was with boys in black, with bikes and giggly girls. But what if Anita was

in trouble? What if the boy Anita rode with wasn't like Sam? Nausea climbed in my throat.

"I promised Anita I wouldn't tell."

Mother drew a sharp breath, her face turning red. "You tell me where she is right now," she shouted.

Panic welled up inside me, and tears rolled down my cheeks. "I can't tell, Mom. I just can't."

"Who is she with? Did she ride a motorcycle, too? Is she in danger?"

"I'm not sure."

"Then what are you sure about?"

"She'll be okay."

My mother shook her head. "I'll tell Lilly not to worry; let's hope she'll be home soon."

I nodded, but inside, my stomach churned.

Anita called me that night. "You promised you wouldn't tell," she said before slamming the receiver down.

The next day was Sunday, and, as usual, we visited Anita's family. Anita was nowhere to be found. Afraid to ask where she was, I stayed in the kitchen with my mother and Lilly and helped them make brownies. My father and his friends watched baseball on the television in the kitchen's breakfast nook. It was my mother who finally asked where Anita was.

"She's in her room, where she will remain all week except for school," Lilly said.

I never saw Lilly angry or sad, so it was unusual to see her unhappy. I rubbed my eyes with the base of my palms. "Lilly, can I go to talk with Anita?"

"Yes, but say what you must and come back down."

"Thank you." I raced upstairs and knocked on Anita's door.

Footsteps came closer from behind the door. It opened slowly. Anita stepped back, permitting me entry. Her eyes were red and half-closed. I held my friend and cried with her.

"I'm so sorry, Anita."

She pushed me away. "You didn't keep your promise. You told."

"I didn't tell. They figured it out."

"Our parents aren't that smart. You told, so they figured it out."

I shook my head. "I can't make you believe me, but I'm telling the truth."

"You can go, Gail. You aren't a true friend."

With tears streaming down my face, I left Anita, my heart in pieces.

I thought it was the end of our friendship. We still visited on Sundays because our parents were good friends.

Anita would never discuss that day with me. She wouldn't believe me and didn't give me a chance to say

that all I had told my mother was that she'd be alright. Personal stories no longer passed between us.

Lilly gave me a brownie upon my return to the kitchen. There was nothing to say.

Days later, I spoke about it with my mother. "Anita doesn't tell me anything in confidence anymore."

"I'm sorry it didn't end well between you and Anita, but you don't need a friend who encourages you to be less than honest."

I couldn't blame anyone for my lack of honesty. I knew our parents would disapprove of the day's adventure, and I did nothing. Anita believed nothing I said, so I can't blame her.

I will never again promise to keep a secret. Secrets lead to lies. They make me vulnerable and put me into compromising positions, like Sam almost taking advantage of me and mixing up with a questionable crowd. Best friends aren't always forever, are they?

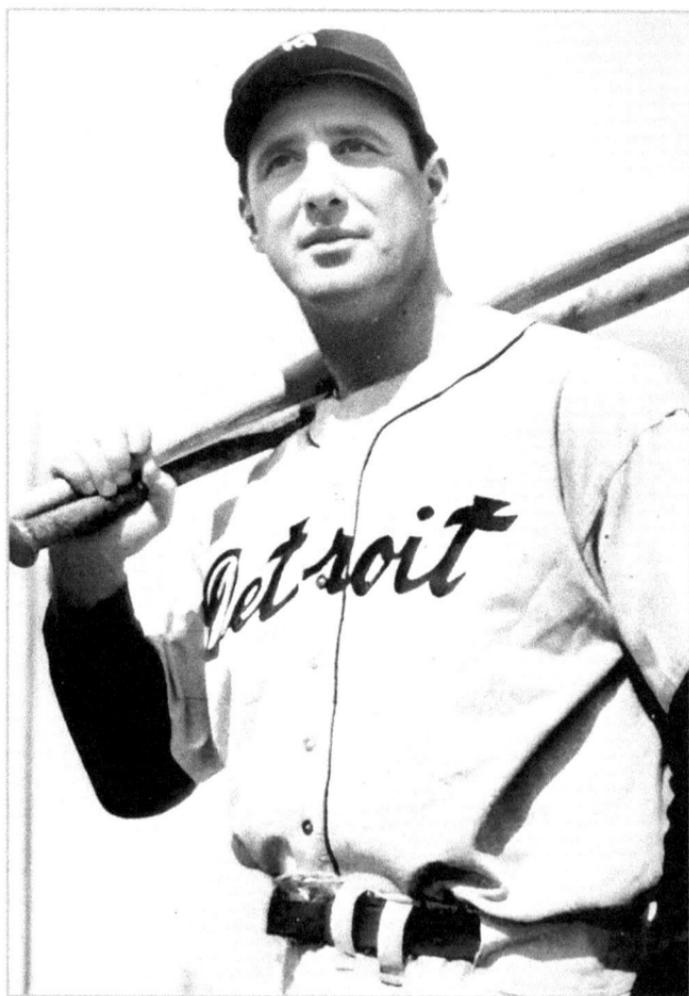

Hank Greenberg
(courtesy Wikipedia)

Chapter Fourteen
Meeting Hank Greenberg ~ 1951

My parents maintained an Orthodox Jewish lifestyle in my childhood home and spoke Yiddish when they didn't want me to understand what they were talking about. While writing this, I realized they could have an entire conversation in Yiddish—my parents spoke two languages. Imagine that? Naturally, Mom pushed me to Hebrew school when we moved to Jackson Heights. She insisted I learn my haftorah for my Bat Mitzvah, like my brother for his Bar Mitzvah.

This was not good news for me. I had enough trouble passing grammar, and now I must learn Hebrew, which would only be helpful if I lived in Israel. Learning Hebrew was only for my Bat Mitzvah. I was almost nine and not interested in this process. I

stamped my foot, my hands on my hips, and gave Mom a piece of my mind.

"Yuk. The boys run around, hollering and scribbling on the blackboard. The teacher can't control them, plus I'm the only girl." Much to Mom's dismay, I refused to go. That was that.

When we moved to the store, those Jewish traditions were impossible to keep with Mom working. As required for a Jewish home, we had two sets of dishes, one for meat and one for dairy. Imagine what it was like shopping for food. Soon after, one set of dishes disappeared, and Mom never said the word *kosher* again.

Mom had no time to worry about me.

"Cover your behind," she would say. So, I figured it was too big. Did that mean I was fat? What was fat, anyway? What does fat look like? I thought my mother was fat.

As I explained earlier, she took me to a reducing school, where I lost nothing except time. I looked the same at the end as I did at the beginning. Pardon the pun. I was sure she didn't like my hair, because she took me to her hairdresser to bleach it to a lighter shade of blonde. I imagined Mom always wanted to be a blonde. In that case, I was her dream. Why didn't she bleach her hair? All this was before TV makeovers.

My mother reigned over me. I tried to tell her that hand-me-downs had run their course. It didn't matter if

they were high-fashion, expensive clothes, dresses, and pretties in assorted colors. I'd had enough already, squeezing into my glamorous cousins' skinny clothes. Hmm, maybe I *was* getting fat. Their clothes used to fit. Were rich people thinner than poor people?

Buy my own clothes? All I need is money. On Wednesday, November 1, I turned sixteen and got my working papers. Yay! Was I excited? You bet! It meant freedom—the end of my fifty cents allowance and the beginning of a paycheck. Mr. Stern, my guidance counselor, helped me fill out the papers. My bosses in the school's bio lab and guidance office gave me referrals that praised my attitude and abilities. I applied for a paid job as a pantry girl at Maimonides Hospital, a short four-block walk to Tenth and Forty-Eighth from our store on Fort Hamilton Parkway.

The summer of 1951 was the best. Working early morning was a great way to start the day. You could smell the heat coming off the sidewalks. As I passed, the dew lifted from the lawns and flowered gardens. It was quiet except for the elevated train's typical steel wheel and rail squeak, taking people to work.

I had to punch a time clock at six a.m. and serve breakfast at seven. Then I met up with the chef. The sun was rising and peeking in the clerestory window in the kitchen. The stainless-steel surfaces bounced the sunlight back, creating fun shadows on the walls. I

reviewed the menu of the day pinned to the shadowy wall. The chef lined the counters with platters of scrambled eggs, bacon, toast, oatmeal, and orange juice for me to put on serving trays. As I wheeled the tray through the halls, the coffee filled the air with its aroma. I entered my patient's room with a smile and a different song daily. Rosemary Clooney's "Come On-a My House" made the patients smile.

A famous baseball player, Hank Greenberg, greeted me with a big smile, bunches of thanks, and a compliment. "Here comes my pretty pantry girl."

"Thank you, Mr. Greenberg."

We ended up having an exchange about food and how it tasted better when I served him.

"Do you know anything about baseball?" he asked.

"Only that if you live in Brooklyn, you better like the Dodgers."

"I played for the Detroit Tigers. Will you like me, please?"

"I've never met a baseball player, and you are so nice. Yes, I like you."

"Whew, thanks. I've played for a long time and hit lots of home runs. Do you know what a home run is?"

"Hitting a ball out of the park. Is that a home run?"

"Yes, that made lots of people happy."

"The kids in my neighborhood played stickball in the gutter. They didn't seem to mind when a car came.

They stopped playing, stood aside, and went right back playing after the car passed. No one mentioned baseball."

Hank smiled. "No one played baseball when I was a kid. Like your friends, we played stickball in the street. Nobody thought about baseball. Kids thought the entertainment was beating up kids of other nationalities. It's like beating up Jewish kids. Are you Jewish, Gail?"

"Yes, I am. I haven't had problems like that, but my Jewish friends aren't nice to Catholic kids. I hang out with Greeks, Catholics, and Italians. We don't fight. I even have one friend who is a fairy. (In the 1950s, that's what people called a gay guy). He's nice. I met him at Park Circle Roller Rink. It was a surprise to see him there. I almost didn't recognize him. We all liked him— he was part of our group, taking walks to Sunset Park and the movies."

"Good for you, Gail. Always remember kindness. Please come by before you leave for the day so I can see your pretty face again."

"I will, thank you."

His words felt good, and I always remembered them.

With my first paycheck, I went to the shop across the street from the store and bought a pair of stockings and a black skirt. It made me look skinny, with a belted

waist and a flared skirted bottom that hid my behind like Mom wanted.

When I got home, I grabbed my stuff, said bye to Mom, and headed for Washington Baths, a private club in Coney Island. The club had a couple of small beaches, one near the pool and one near the handball courts. Already in my bathing suit, I dived into the pool to cool off, did a few handstands, and headed for the handball courts. Some older guys played handball using a hard rubber black ball, nothing like the squeezable pink one I used. They invited me to go one round with them. I won a few points with my partner. This place was great for finding friends, socializing, and swimming.

Every Tuesday in summer, my friends and I went to the public beach, sat on our blankets, and watched the fireworks and people making out under the boardwalk. I wanted summer to go on forever. Then came the summer of all summers. A polio pandemic in the '50s shut everything down. The baths emptied, but some dedicated kids like me hung around. We all waited for the promised vaccine. Mom came to the baths that summer to make sure I stayed safe. They had drained the pool, so sitting on the beach was it. Mom sat in her favorite peach-colored beach chair and wore her pink bathing suit, covering herself with a matching beach

robe. There was no mingling, only the sun, shower, and leave.

One chilly day, long after the baths closed for the season and the leaves changed to buttery yellow and scarlet, Mom called me into the kitchen for a talk. She hadn't given one in a while. I couldn't imagine what it was this time. Earlier, she had urged me to study hard for college in my senior year, which was coming soon. My high school looked over the vast Hudson River in the shadow of the Verrazano Bridge. I didn't have a boyfriend because none interested me. They all wanted the same thing—to go to the movies or Sunset Park and make out. I sang in the choir with tall, cute Harold, the guy with the baby face. My friends always gave me advice and told me how much he liked me. He didn't send my heart fluttering. Should he? Larry, Anthony, and Marty were interested in me. That's all I remember at the moment. I went to the movies with them as long as they didn't kiss me.

Anthony was younger than me and a little too babyish with his pleading. "Oh, please, Gail, take a walk with me." He didn't dance and forgot to tuck in his shirt. No, not for me. Marty was a nice Jewish boy; he liked the big boat on Dad's dresser. I think he wanted the ship more than he wanted me. The beautifully scaled model got lost when my parents took it to a bar for safekeeping until we moved to Flatbush. Stolen, they said.

Rumors said Larry was the best soccer player on his team. I liked Larry a lot—as a friend. He advised me about all my boyfriends and clamored to get me as his girl, but I wasn't interested. He was too short. When I met Bob, the guy I married, he made me stop being friends with Larry. "You can't have boys for friends," Bob said. It broke my heart.

Back to reality and the talk in the kitchen. Mom told me the polio vaccine was available at the doctor's office.

"I'm ready, let's go." We hastened up the hill on Forty-Fourth Street to Ninth Avenue. My classmate Arnold lived on this street. A few years before, gangs had killed his brother. I heard he'd witnessed a crime. I knew no more and wasn't interested in learning more.

I remember when my brother picked up his books to leave for school one day. He went outside and then came screaming back into the house.

"Oh my God, Dad. What do we do? Look out front. There's a dead man in a car all full of bullet holes. There's blood everywhere."

Dad told Mom to stay put while he hustled to check it out. He came back, puffing like he had moved a barrel of cement. He picked up the phone and babbled words about talking to someone at the police station. I'm not sure if there was a police station nearby to come and clean up the mess. Dad turned to my brother while still on the phone, waiting to tell the police what he found.

"Sit tight, Jay. After they take that car away, I'll take you to school, and you too, Gail."

I had a lump in my throat. "I was glad I didn't see that man die," I said in a squeaky whisper. After that, I suspected every customer who came into the store. My dreams were never the same, nor did I feel safe and trusting again.

Dr. Evers took us right in when we arrived. I didn't feel the shot. I danced around as we walked down Forty-Fifth Street, singing Judy Garland's "Somewhere Over the Rainbow." There were tall buildings on this street. Some had tiny gardens filled with red roses. I had friends on this street that I grew up with playing stoop ball on the brownstone's steps. You would stand about ten feet from the stoop and throw the ball at the crack. When the ball returned, you had to catch it on one bounce worth five points or a fly worth ten points. We also played double-Dutch jump rope with a used clothesline. I had to time jumping between two ropes twirling in opposite directions. My friends were excellent turners, and we all took turns turning. When we weren't playing games, we sat on the steps, watching everyone go by.

Dad came out to greet us. "Well?" He put his arm around my shoulder. "Is my girl safe from polio?"

"Yes, Dad, I'm safe. Nothing can hurt me now."

His hair caught a sliver of sunlight, and his eyes

sparkled. Dad hugged me and followed a customer into the store. He looked back and gave me a wink and a smile.

I spent three years at Fort Hamilton High, sang in the choir, learned French, took modern dance, did well in algebra but struggled in geometry, and failed American history.

I lucked out when I saw the bulletin board request for a volunteer job for my guidance counselor, Mr. Stern, in his office. I grabbed the index card and raced there.

Out of breath, I knocked.

At the welcome, I opened the door. "Am I too late, Mr. Stern? Is the job still open?"

"Your timing is perfect. I have gigantic piles that need to be sorted and filed ASAP. Can you handle that? If so, the job is yours."

My heart beat like a drum, and I wiped my sweaty hands on my skirt.

"Yes, yes, yes! I'm sure I can be an asset. When can I start?"

"Right now, if you can."

My friends, Arlene and Ethel, who lived on Fifty-Fifth Street, already worked in the school's business office. Mr. Stern offered to drive us to and from school for the rest of our senior year. What a treat! Working for Mr. Stern was a plus.

Two months before graduation, I met my first true love, Bob. It was instant-like. He didn't pick on me like Mom. Being with him felt comfortable unless he wanted to be familiar. I hoped he enjoyed me, even when I refused his advances. We hung out at his house. The apartment in the back of the store was a less-than-desirable location to hang out, especially if Mom was around.

Bob had agreed to be my prom date. Now I needed a dress. We were in our 1950 Plymouth, with Mom at the wheel, passing the typical Saturday traffic on the way to downtown Brooklyn. You'd think everyone was going to the beach, with the big rush. What could be more important than the beach? But we were shopping for a prom dress. My mother kept her eyes on the road, an elbow resting on the open window, her other hand on the wheel. "We're going to a warehouse on Bedford and Sterling, where we'll find a gown for your prom. It's unlike any clothing store you've seen with Cousin Katy."

Mom and I wove through racks of slacks, skirts, shirts, underwear, and an unimpressive men's section.

After a long walk, we reached the back room, an enigma for most, where designer clothes were at meager prices. We found a sleeveless, scooped-neck, sky-blue, tiered, cocktail-length dress in layers of tulle. I undressed in the open space with no private dressing room and tried on the dress. A couple of rotund ladies stopped hogging the one mirror and stared at me. "Young lady, you look gorgeous in that cocktail dress. Is it for your prom?"

"Thank you." I smiled and nodded, feeling like the lead ballerina in a Russian ballet. However, shopping with Mom gave me pause. In the past, Cousin Katy had been my shopping companion. My mother's toughness left me bewildered. She pulled my hair with no apparent reason, and her sudden temper tantrums transformed her into a monster. The lack of control was her nemesis. I struggled to comprehend and appreciate her, especially in those rare moments like this, when she was generous and kind. Why couldn't she be that way all the time? I wished I understood my mother's motivation and what made her sad. It was difficult to respect her, get along with her, and not fear her. On prom night, Bob showed up in a neat and clean tux, his shirt tucked in. He wore shiny black dress shoes with a white wrist corsage for me. His dad's car made him look grown up. He was a superb dancer and a gentleman, bringing me punch and appetizers. When the evening

ended, he took me home and kissed me goodnight on my cheek. Mom waited in the kitchen for my report.

"Oh, Mom. The evening turned out beautifully. My boyfriend treated me well, dancing and dining, snacks, and lots of cold, fresh punch that made the air smell good. The band played all the top songs, and we danced the whole time. He treated me like a princess."

That summer, I took history at Erasmus High and failed again. I had to memorize uninteresting things. I easily memorized songs and scripts, but couldn't learn history. I wondered if I failed to spite Mom. She wanted me to pass and get an academic diploma. I didn't care if I passed, and in the end, it didn't matter. I attended Brooklyn College for a year, learning the latest business machines, and then I left to get a job and marry my fiancé, the young man who took me to my prom.

G B

Mr. and Mrs. Bernard Gerber

request the honor of your presence

at the marriage of their daughter

Gail

to

Mr. Robert L. Ingis

on Sunday, the fourth of September

Nineteen hundred and fifty-five

at twelve noon

Menora Temple

14th Avenue and 50th Street

Brooklyn, New York

Wedding Invitation

Chapter Fifteen
Gail and Bob ~ 1952

At a sweet sixteen party in Flatbush on a Friday night, a handsome young man, fair-haired, dressed in casual trousers, his white shirt slackly tucked in, looked adorable standing by the beverage table. He appeared collegiate and elegant at the same time. My heart thumped in my chest. The liquid in the giant vessel was no doubt disguised as punch but drowning in whiskey. If, perchance, I was to meet this young man, the bus trip with rain threatening would've been worthwhile.

It was April 17, 1953 when Mickey Mantle hit a 565-foot home run at Griffith Stadium in Washington, D.C. Mantle's home run was the longest in baseball history, according to many historians. As baseball fans celebrated the home run, I was on the local bus as it wound

through the center of the Flatbush Avenue shopping area, my favorite. This was where I bought classy shoes from at the famous A.S. Beck shoe store.

The bus drove through a side street, passing brick houses built after WWII. Picket fences were typical of the neighborhood, although a few badly needed mending. Some had porches, and overgrown gardens were typical. The bus dropped me off close to the party house. The weather was clear but a little foggy. I picked up my pace, shivering, as the barking wild hounds with bulging eyes would surely eat me if they got loose from the trees they were chained to. I had to hurry and run faster, hoping my Shalimar scent wouldn't rile them up. My mother bought me the perfume, which smelled like jasmine florals and vanilla-filled cookies and made me feel French.

I followed the street, searching for the address of a party celebrating another teen's sixteenth birthday.

Alan, my roller rink skating friend, had invited me to this bash—an excuse to party and meet new friends. Music floated out of the windows of a four-story brick apartment house. I walked up the stairs into a front hall with a locked interior glass door. If a thief wanted access, he would smash the glass, but I didn't think any robbers were around in this neighborhood. When the buzzer sounded, I pushed the door open, walked to a set of beige marble stairs, and climbed to a second-

floor hallway with brown walls and doors. It was like walking through Agatha Christie's novel, *The Mousetrap*. I pushed the door open to an apartment with high ceilings typical of turn-of-the-century buildings. The walls were light beige in contrast to the dark hallways. The living room was smoke-filled. Kids my age imbibed and danced. Twosomes groped each other, not waiting for the kissing games. Where were the adults?

Jeepers creepers. Where could I hide? A tall boy by the beverage table carried himself with an air of self-possession. He held a glass, winked at me, and sat on a clear plastic-covered wing chair. He patted his lap—an invitation if I ever saw one. The plastic cover where he sat matched the plastic-covered couch. The fashion of the times was a sad state of affairs. The plastic was sticky, especially if you wore a dress or shorts. I sat where the young man patted his knees and hoped I didn't send him the wrong message. "Good girls don't sit on a boy's lap," my brother reminded me. But the boy's green eyes pulled me to him. I sat on the edge of his knees, uncomfortable but respectful, I hoped. I was glad not to sit and get stuck to the plastic covering the chair.

He put his arm around my shoulders, securing me.

"Hallelujah, you saved me from the kissing games. I'm indebted forever," I said.

He smiled. "I'm Bob Ingis. My buddy, Herb, asked me to come to this underage party."

I smiled back. "I'm Gail Gerber, shocked and so over those kissing games. What's wrong with these kids? Can't they think of anything else?"

A floor lamp topped with a red jewel-fringed lampshade provided a dim glow, reflected in the fringe. The light was a relic from someone's grandmother, no doubt. Hmm, the dull light must have been like this before Thomas Edison.

"Where do you live?" Bob asked.

"In Brooklyn," I said, trying to be cute.

"Come on, silly. Where in Brooklyn?"

"Borough Park, and you? Where do you live?"

"My family has a private house in Bensonhurst."

He didn't ask me my age. I thought that odd. He asked what school I attended.

"Fort Hamilton High." I offered him the information, unsure he wouldn't think I was the same age as the kissing kids.

"I go to NYU, studying accounting."

He was brilliant, no doubt!

He lived in a private house with his family, which was impressive. When he asked for my number, I was more than willing to give it to him.

Bob called me the next day, and we made a date for two weeks later on a Saturday afternoon. He was

quick, as in my "just do it" philosophy. Did we think alike?

The first Saturday in May, a sunny spring day, was my first date with Bob. I suppressed a sigh, searching through the small closet I shared with Mom for an outfit to look my best. There was slim pickings—the best I could do was my black skirt and white blouse with a round collar and puffy sleeves. While I waited, I sat down at the piano to play my favorite piece, "Grieg's Piano Concerto in A Minor," which I'd recently played in Brooklyn's Town Hall. Footsteps sounded outside my door. It opened, and Dad and Mom poked in their smiling faces.

"There's a boy out there. Come for you. Says he's your movie date," Dad said with a grin. He extended his hand to me. I stood and took it.

"He's my new boyfriend. What do you think?" I said as we walked to where Bob waited.

Dad shrugged. "He looks nice," he said in a pleasant tone.

Mom grimaced. "I'm not sure yet. Outward appearances mean nothing."

I giggled, covering my lips with my fingers. Then I ran them through my hair, fluffing it up. "Am I okay? I didn't expect him so early."

Mom turned me around and looked me up and down. "You look fine."

Bob waited by the store's cash register counter. He wore tan chinos and a striped knit shirt casually tucked into his belted pants. He had combed his wavy blond hair, but not every hair was in place. "Mom, Dad, meet Bob Ingis. We met at a party two weeks ago."

Dad shook Bob's hand.

He charmed Mom with his smile. "Nice to meet you, Bob," she said. "Take care of our daughter, and please bring her home early."

Bob reached for my hand and held it in his. "Would you mind if we go for an ice cream soda after the movie?"

Mom hesitated. "If it's early and before supper."

We headed to the afternoon movie at Loew's near the store. They were showing *Never Let Me Go*, a British adventure romance with Clark Gable and Gene Tierney. Bob took us to the balcony after grabbing popcorn. Couples were already getting cozy. I thought about suggesting sitting in the orchestra where it was less private, but we were already on the balcony, so I didn't say anything.

Nothing on the screen caught my eye; I couldn't stop thinking about Bob. He didn't seem interested in the movie either. He focused more on holding my hand with his arm around my shoulders. Was he thinking about romance? It felt uncomfortable and made me uneasy. He was just a boy, and I wasn't sure if he saw me

for who I was or just as someone who would go along with whatever.

I should have stood and said let's go, but I didn't. Uh-oh, was Bob going to kiss me? I hoped not, but that's what boys did.

He took a deep breath and let it out. "Let's go steady."

Whew, no kiss, but that statement came out of nowhere. It was way too soon, and we didn't know each other. I turned to him. "Do you think maybe it's too soon? Can I let you know?"

Before this, I had had steady boyfriends, starting way back during a three-week summer camp when I was eleven. After swimming in the lake, a boy and I decided we were in love and pretended to get married. I made a wedding dress out of sheets. One of his friends married us before supper. We divorced after supper.

But I wasn't a child any longer, and I knew that all boys wanted the same thing. I always broke up with those boys. I hoped Bob wasn't one of them.

Graduation was coming at the end of June. "Will you take me to my prom?"

He asked all the right questions. "Do I need a tux? Can I get you a wrist corsage? Do we need a car?"

"Those are great questions. I'll let you know," I said.

"Have you given thought to my question?"

"You mean about going steady?"

"That's what I mean. Have you?" Bob asked.

"Tell you what. I'll let you know when you figure out those prom questions."

Bob rolled his eyes. "Sure."

In the meantime, I asked Mom what she thought about his proposal. "If you're comfortable saying yes to going steady, it's okay with me. He seems like a nice young man. Time will tell."

A week later, Bob asked again. "My request is still open. Will you go steady with me?"

"Have you found out the answers to the prom questions?"

"Yes, I have. You'll be happy to know I have a car. It's blue, has four doors, four tires, a radio, and a motor."

I laughed. "You're funny."

"My mom said she'd help me with the tux and accessories. She told me where to go for the wrist corsage, but she said to ask you about the color of your dress. I need to know to order the right color corsage."

"Wow, you're fast. I'll relent if you promise not to take advantage of me."

He took a deep breath. "It's a deal."

Pumped up by his reaction, I ignored the cramp in my jaw. "Okay, I'll go steady with you," I said sweetly, with a little laugh. It wasn't funny, but OMG, what was I doing? He was good-looking, but I began to notice that maybe he was a little sloppy, like his shirt wasn't tucked

so it didn't hang over his belt, but that wouldn't affect going steady. Stuff like that was trivial. He didn't think it essential, so why should I?

I wanted my brother to be supportive, but he looked at me as if I had palsy when I told him I was going steady with Bob. He said, "I want to meet him. And remember, no matter what, steady or not, be a good girl. That means don't let a boy touch you. Boys are always looking to satisfy their egos. Maybe holding hands is okay." I trusted my brother's steadiness. He would never allow Bob to take advantage of me. If he did, Jay would teach him a thing or two. "No worries, you're stronger than you know. No one can hurt you with me watching," he emphasized as he hugged me.

Bob invited me to a Sunday roast beef dinner to meet his parents and seven-year-old brother. They greeted me with smiles and open arms.

"It's nice to meet you, Gail. Bob has told us how pretty you are. Indeed!" his mother, Beatrice, said in a pleasant voice.

"Thank you so much, Mrs. Ingis."

Wow, what a fantastic way for Bob's mom to greet me. It was so special. I loved it.

Mrs. Ingis served mashed potatoes, peas, and gravy on my meat. Did she know that bloody meat would make me gag? My mother explained I must be polite and eat what she served. I didn't know what to do when

Mrs. Ingis put that plate of bloody meat in front of me, except to eat it. I hoped no one would notice me gag. But, surprise, the smell made my mouth water, and the meat tasted as good as it smelled. I enjoyed the unusual flavor and tenderness. Never had I had meat like that. "Mrs. Ingis, what do you call this meat?"

"Rare roast beef."

"Mom cooks all our meat crispy. Your rare roast beef is a first for me. I also love your pineapple tart dessert. Thank you for a lovely dinner and the warm welcome."

"Thank you." She blushed. Maybe no one had ever told her that before.

Bob's father's name was Isadore. His patients called him Doc, and so did everybody else. He was rotund. The bit of hair on his head was gray, and he wore suits. I think he only had two, one gray and one black. I remember no suits in the hot summer, shirt sleeves only, but he was always ready for his patients. His shoes had a brilliant shine, and the cigar in his mouth smelled like old books, worn-out leather, and mold. The house smelled like that unless Mrs. Ingis was cooking or baking.

He smoked a cigar daily and often sat at the kitchen table with a cup of coffee. The cigar smelled yukky. He frequently had an unlit one in his mouth. I liked Doc so much that I wanted to enjoy the smell of his stinky cigar, but it was hard.

Bob's brother, Ted, preoccupied himself with things he liked most of the time. It wasn't easy to have a little brother, eleven years between them. When his parents went out, Bob had his friends over. Ted got in the middle of us dancing. On my visits there, Ted hung around with his mom and Aunt Pearl, Doc's sister. He was nice enough when his parents were there, but when Bob and I were with him without his parents, he enjoyed irking his big brother. I always liked Ted and thought he was smart and had good ideas, but Bob was not on the same page. I thought having a little brother —especially a bright and fun one—was great.

All this sounded promising, but I wasn't sure going steady was right. What did we know at such young ages? We needed time to get to know each other, and then maybe we could go steady.

Were our parents doing their due diligence?

Ted told me later that his parents told Bob we were too young to commit. But Bob rebelled and insisted he wanted this relationship.

I don't remember my parents ever objecting to our liaison.

After six months, Bob and I talked about getting married. Bob's father sat us down to elicit a promise from us. "Be diligent as Bob goes through his accounting education at NYU. You can work on a wedding date after graduation."

While we waited, Bob's mom told us that his uncle Mac was a diamond dealer. After getting educated in diamond investments, we chose a perfect color J diamond with one imperfection not visible to the naked eye, 1.90 short of two karats, with six nine-point side diamonds enhancing the center glittering round stone in a high-set Tiffany setting. The diamond caught the light, making it sparkle.

I didn't want to spoil our wedding night by being intimate before marriage, but Bob was impatient. I refused to allow him to touch me. He tried to put that ring on my finger to get his way. Bob was always plotting ways to get me alone for reasons I don't enjoy writing about. Sigh. I wouldn't say I liked the idea of intimacy before marriage, but he saw nothing wrong with it. I finally caved.

I didn't know it was wrong in God's eyes, but I always had a relationship with God, and He did not give me a positive sign about promiscuity. I shared how I felt and what I believed with Bob.

"Hogwash," he said, shaking his head. "That's the most ridiculous thing I ever heard. I don't believe in God. I'm agnostic, not sure there is a God."

I should have broken up with him when I heard that, but he was Jewish, and according to my mother, that was most important for marriage. But you know what? We had twenty-three years together. I was inno-

cent of any improper activities Bob pursued outside of our marriage. He supported my going to design school, gave me a graduation party (after many requests), and gifted me a backyard tennis court. Our life was a masterpiece, painted with hues of joy, love, three exceptional children, and a melody composed of laughter and shared dreams. Yet, its final chapter closed with a poignant sadness, casting a shadow over our once-vibrant world.

Miss Independence

Chapter Sixteen
My Independence Day ~ 1953

After I graduated from high school, we moved to a quiet Flatbush neighborhood. I had trouble falling asleep without the hum of the traffic and trains. Dad and Mom found an apartment around the corner from Brooklyn College, where I took business courses. See, Mom, you were wrong. An academic diploma wasn't necessary. They took me as is.

The streets were clean. It differed from the busy store location, with the BMT trains across the street and the trolley cars on New Utrecht. There, the roads were always dirty from traffic, with candy wrappers, newspapers, and cigarettes blowing everywhere. Apparently, no one noticed the trash cans on every street corner.

This apartment only needed paint to move in.

Mom's decorating style made me appreciate the decorating classes she took at NYU. School can teach you something.

Mom never asked if I wanted a pink bedroom. She bought pink patterned wallpaper and installed it. I never understood why she didn't ask me. I hated pink, but mosquitos must love it; my room always had a couple. Catching them was impossible. I waited till they bit me and then, when they were resting from their feast, I plastered the dang things, splattering my blood all over my walls.

The rest of the apartment looked nice. Only when I finished training at the New York School of Interior Design (NYSID) did I appreciate my mother's decorating. The living room sofa had green silk upholstery and a different shade of green on the chairs across the room (No wonder I created green décor when Bob and I moved to New Jersey). I remember her glass-and-brass coffee table with tchotchkes on the top and her porcelain collection of little dogs: Saint Bernard, schnauzer, corgi, and others. They fit in my hand. I still have those adorable dogs. The Persian rug wasn't to my taste, but her friends said the carpet and furnishings looked beautiful. So who was I to say anything?

Dad drove me to school every day and picked me up. If he couldn't get me, I took the local bus that stopped right at my corner.

"How's college?" Dad asked with a smile.

"It's a piece of cake."

"What's the subject?"

"Business machines, all different kinds. The teacher said this will give me office skills."

It was the forty-fourth Sunday of the year, and Mom and Dad were home. Even though it was my birthday, I wanted to make breakfast for us. I was an early riser and never needed alarms. At seven in the morning, the sky lightened far into the horizon. I leaped out of bed and ran into Mom and Dad's bedroom.

"Good morning. It's my birthday. How about I make scrambled eggs and toast for us?"

"We were going to take you out for breakfast. Which would you rather do?" Mom asked.

"Are we going to do our Sunday friends visit today?"

"Later," Mom said.

"Then let's eat at home. You put on the coffee, Mom, and I'll take care of the eggs."

I started cracking eggs into a large bowl. Crack! Four eggs. Crack! Six eggs and whisk till fluffy. I removed the Velveeta from the fridge, diced some, and plopped it into the eggs. "Dad, can you cut up a few potatoes for home fries?"

His mustache moved as he smiled. "I can."

I heated cooking oil for the potatoes, and Dad

browned them, the aroma filling all the spaces in the kitchen.

I'd turned eighteen and had my permit.

"I hired a driving company to take you out for lessons next week," Dad announced.

We were all enjoying our delicious breakfast. I put my fork down and looked up at Dad.

"After all you've taught me about driving a car, why do I need driving school? How come you passed me off to a stranger?"

"An instructor will give you a better perspective than I can. But before you go, remember to drive like everyone behind the wheel is stupid."

"You told me that before. Is everyone stupid?" Another one of my masterful questions.

Dad had his serious face on. "It takes thinking and coordination to drive well, you'll see. Drivers make uneducated decisions."

Dad told me he had set a date for the coming Saturday for my test. When the day came, I got into the driver's seat. My instructor sat next to me. "Which would you prefer to drive, automatic or shift?"

"I have a choice?" Strange. Not having driven behind the wheel before, I figured my best bet was automatic.

"Excellent decision," my instructor said.

For the driving test, belly butterflies didn't interfere

with the skills I had learned from Dad. The tester asked me to parallel park, which I did by coming about nine inches away beside a parked car, using a side view, and aligning the mirrors. I began backing up, turning the steering wheel to the right until my car was at a forty-five-degree angle to the parked car. Then I turned my steering wheel to the left and continued to back in, straightening the vehicle.

"What if there's no car to align with?" I asked.

"It won't matter. You can park with no other car in the way."

I treasured what Dad taught me in the car, sitting beside him all those years. Being in the driver's seat felt different. I had to watch the road, other vehicles, people, traffic lights, signs, and more, amazed at this new experience. The instructor smiled when the test ended. I smiled back, went home, and waited for the results.

Two weeks passed. I felt like my life was on hold. Would I have to retake the test? Was the mailman sick? The license should show up soon. There may have been a flood at the post office, and my new license drowned. One day, I was sitting at our red Formica table, having lunch in the kitchen. The flap on our letterbox in the front door made its usual plunk when the mailman slipped in the mail. I dropped my fork into my salad and ran to the top of the stairs to check. All the white

envelopes lay on the floor below. I raced down the wood stairs on my bare feet. In one minute, I had the official envelope in my hand. I ripped it open. There it was— my driver's license with my name, Gail L. Gerber, the year my license would expire, and other characteristics about me that a police officer would have to know if (or when) I went through a red light or stop sign. No one was home to share the good news.

I sat at my secretary in my pink bedroom and called Dad at the store to share my excitement. "I passed," I shouted into the phone with my hand against my heart, which was pounding like I was on amphetamines.

I could feel Dad smiling. "Great! Now hop on the bus and come to the store. I have a job for you."

I pulled out my black slacks and beige sweater. As soon as I arrived, Dad hugged me. "Good news." He handed me the keys to our 1950 Plymouth automatic. "Pick Mom up at work. She'll be in front of the building."

My palms were sweating. I looked down at my outfit. "How do I look?"

"It's fine. It'll be fine when she sees you driving. You don't even have to get out of the car."

"Are you sure? It's my first time alone."

"Of course I'm sure."

He plopped the car keys in my palm and touched my shoulder. "You can do this."

He walked me to the car parked in front of the store. His 1950 pale green, four-door Plymouth was waiting for me.

"The automatic is the wave of the future," the instructor had told me.

The future was here. My driver's license meant freedom and independence. At eighteen, I'd be in charge of my life. I unlocked the driver's side door and slid into the seat.

"Okay, Dad." I took a deep breath, adjusted my seat and mirrors, turned the key, and the car purred to life. I wrapped my fingers around the steering wheel. I pulled from the curb and headed into New York to get Mom from work. She was the bookkeeper at Blue Bell Dungarees in the garment district on Forty-Seventh and Broadway. I'd driven this route millions of times with her; it was all familiar. My sweaty palms disappeared.

It was a fifteen-minute drive down Fourth Avenue, Jay, and Sands Streets. Yellow cabs blasted their horns as they zigzagged past various vehicles and people crossing those busy downtown streets. As usual, garbage and paper of all kinds littered the streets. I passed Flatbush and DeKalb Avenues, Macy's department store, Paramount Theater, and Stuyvesant High School on Chambers, where my smarty pants future brother-in-law Ted Ingis went. I passed May's department store, where I recalled my salesgirl job at sixteen

causing tired and swollen feet by the end of the day. As I crossed the Manhattan Bridge, my eye caught the water below with sprays of foam dancing off the rolling waves. The metal of the bridge caught the sunrays bouncing back onto my windshield. I plucked my mother's sunglasses from the visor, put them on, and drove off the bridge and into Chinatown.

I drove up to Forty-Seventh and Broadway, skirting around slowpokes, and turned onto the street where my mother waited in front of the Blue Bell Dungarees building. Sunlit skyscrapers pierced the deep blue sky dotted with fluffy white clouds drifting by.

"Well, aren't you something, Daughter? This is your first big trip driving into the city. How does it feel?" She got into the car. "Where's your father? Although I appreciate you coming."

"Dad was busy in the store. I'd be happy to pick you up when you need me."

"I'm only here when they call with bookkeeping issues. Dad brings me in and picks me up, leaving Rose to watch the store."

"I loved driving and noticed aggressive drivers, but that's fine. There's a rhythm to driving. I just joined the other drivers. I can go anywhere if I follow the rules, right, Mom?"

She nodded. "That's an astute observation. This is special mother-daughter time. Don't you think so?"

Oh no, did she want to talk about boys? It was hard for me to trust that she truly wanted mother-daughter time. Besides, we didn't have to discuss boys anymore. My relationship with Bob had turned into an engagement.

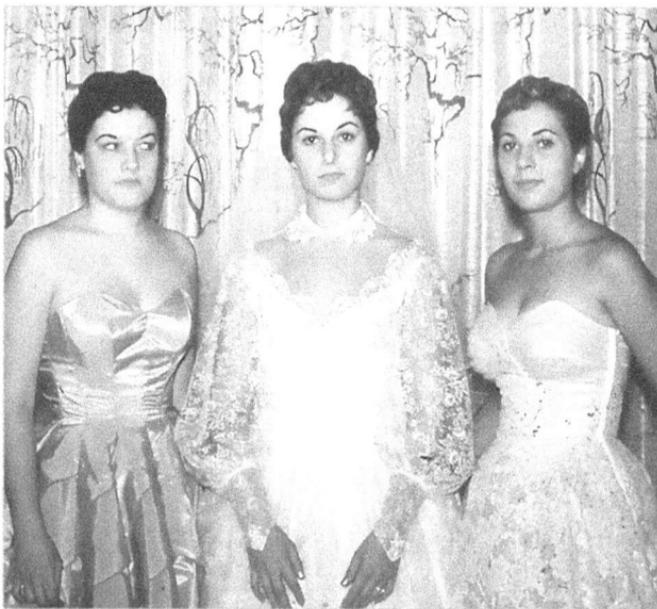

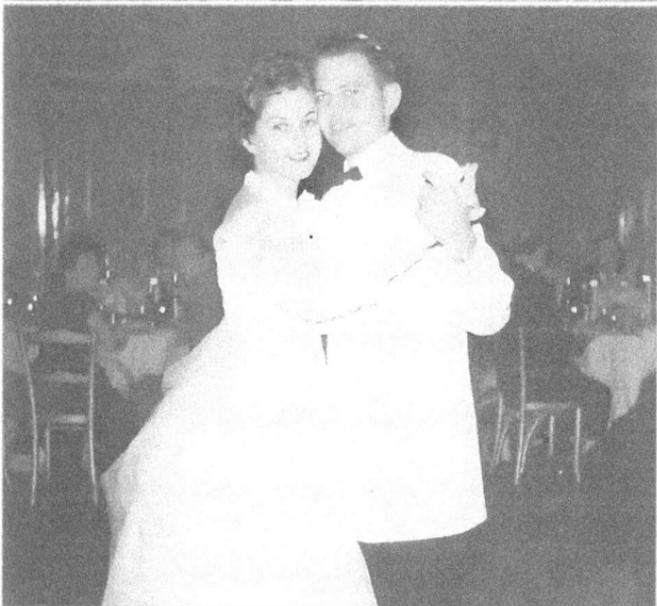

Wedding day jitters (top left) cousin Sheva,
Gail (bride-to-be) & best friend Anita;
Bride and groom's first dance (Gail and Bob)

Chapter Seventeen
A Wedding & A Honeymoon ~ 1955

My mother went on and on about the wedding. Before deciding where to hold the celebration, she explored hundreds of places, including Eastern Parkway Jewish Center, Ocean Parkway Jewish Center, and Prospect Park Hall, where I occasionally rode my horse. Well, maybe not a hundred places, but close. Mom chose Menorah Temple in Borough Park. She planned and executed my wedding celebration single-handedly, showing off her abilities. She trusted no one to do the job.

"More shopping, Mom?"

"I'll know when it's right," Mother said.

We shopped in the New York district for wedding gowns—there were districts for everything in the city. The Garment District sported the Fontana sisters.

Everyone wanted a wedding dress designed by Sorelle Fontana in Cascais, Portugal. A dress like Linda Christian wore marrying Tyrone Power. I gasped at the price. We tried on wedding gowns in store after store. "My hair is messy, and I feel greasy and gross. Can we please decide?" I begged.

I was weary and worn out, and my arms and legs were sore from climbing in and out of monstrous satin beaded dresses. The store proprietors seated Mom in front of a three-way mirror for an all-angle observation. I got to check it out, too. Would you believe Mom had to approve first, and then she asked how I felt?

"I like all of them."

"That's not helpful."

She chose a handmade lace and silk design with pearls and rhinestones—long, bouffant, jeweled sleeves and a jeweled Peter Pan collar. I liked the one she chose, which was unusual for me. Finally, it was not a hand-me-down. She also perused the dresses for my maids of honor and one for herself in the mother-of-the-bride dresses.

Another day, we took my two maids of honor to the same store for a fitting: Sheva, my best cousin, who had wavy, mahogany-brown hair and velvety, brown, sparkly eyes, and Anita, my best friend, who had curly raven hair stressing her deep, luminous, green eyes.

After what happened between Anita and me, I had

given up on repairing the friendship. But then a year after the incident, I called Anita to tell her I was getting engaged. That was when she gave me an opportunity to explain more fully that I had never said a word about the day, only that she would be alright. We spent time together and enjoyed double and triple dates with Sheva.

Both girls would exude elegance in their pou-de-soie dresses—Sheva adorned in blue and Anita in pink. My mother, clad in a sparkling blue cocktail dress, radiated elegance. The men wore traditional black tuxedos rented from a local Thirteenth Avenue store a few blocks from home. Dad sported a classy white blazer with a bowtie and striped, black tuxedo trousers.

There was an intoxicating fragrance from an abundance of white flowers—garden hydrangeas, white lily of the valley, and phalaenopsis adorning the huppah (wedding canopy) and lining the aisles, infusing the air with an enchanting allure fit for royalty. The fragrance of my bouquet was a delicate dance of floral elegance, with the white roses lending their sweet notes while the wisteria added a subtle hint of fresh spring air. My maids of honor held bouquets of pink roses and white wisteria, filling the air with a blend of romance and purity.

Every step resonated with anticipation and love as we approached the platform. Bob's little cousin, Judy,

graced us as the flower girl. With my parents by my side, as I gazed into my father's eyes, I felt an unfamiliar peace. His kiss on my cheek sealed his trust in Bob as he placed my hand in his. Bob and I exchanged vows under the huppah, sealing our union with a kiss that echoed with promises of forever. Bob's symbolic act of shattering the glass ignited a chorus of cheers, marking the fusion of our families.

In a whirlwind of emotions, I turned away from the future I had committed to, swiftly descending the platform stairs ahead of Bob. Then I noticed he was not beside me. What was I thinking? I don't know why I left the platform without him. What in the world was I running from or to? I waited for him at the bottom of the stairs, and no one said anything.

Amidst the whirlwind, questions flooded my mind. Did Bob truly understand the vows we exchanged? Would he be there when I needed him most? And what had I promised in return? One emotion stood out: relief from my mother—no more apologies, no more explanations.

Following our enchanting waltz, I shared dances with my father and more with Bob, cherishing moments of connection with our families. The lively hora embraced us, and the circle of dancers lifted us on chairs, laughter echoing around us. Afterward, we wandered between the tables, conversing with our

guests. Embracing our roles as husband and wife, we were responsible for expressing gratitude to our guests for sharing our day. While the event was undeniably beautiful, I felt detached, failing to appreciate the effort behind orchestrating such a momentous occasion. The entire affair felt like an out-of-body experience, with my mother ensuring that everything unfolded according to her vision. I engaged with guests and posed for photos, with no time to taste the delectable appetizers or the succulent steak and chicken dinners. A river of whiskey flowed, fueling the enthusiasm of the festivities.

The party was over, and Bob graciously accepted the well-wishes of the guests, their envelopes filling his pockets. I secured a few in my beaded bridal handbag, a tangible reminder of the love and support surrounding us on this special day.

We spent our first night in our apartment at the back of the garage. Our first night together didn't surprise me—Bob had taken care of that before our marriage. I was nineteen years old and had no one to talk to, no one to ask my questions, no one to share with. Still, I'm grateful for the growth and resilience those experiences fostered. It is a part of my journey that I have come to terms with, understanding the complexities without assigning blame or embarrassment to anyone involved.

In a moment of emotional turmoil, back home in

our little apartment, I altered my wedding dress, symbolically shedding the layers of control and manipulation that had clouded my relationship with my mother. I cut the hem, shortening the dress to cocktail length, and felt relieved of my mother's overshadowing influence. I was learning the lesson of the strength gained by meeting adversity with grace and resilience.

The next day, my parents stood waiting outside, ready to whisk us away to the airport for our Bermuda honeymoon. Their beaming smiles filled me with emotions—excitement for the trip ahead and a gnawing fear of the questions they might ask about our first night as a married couple. I couldn't shake the anxiety bubbling in my chest. What would I say if they brought it up? How could I possibly explain what had happened, the truth about my past with Bob? As we approached them, I couldn't help but wonder how strange it would be to confess to my parents that my wedding night wasn't the first time I had been intimate. That moment was stolen from me by Bob a year before, a truth I hadn't found the courage to share with them.

"Hello, how are you? Are you excited to be going on your honeymoon?" They kept the conversation general. I mean, really? Why was intimacy such a deep, dark secret? Was it such a shameful subject? Everyone knows what a married couple does on their first night. How come no one says anything? Aren't parents supposed to

share their wisdom? Did Bob's father talk with his son? Given Bob's behavior when we were dating, and now, after our first night, would it have made a difference if Doc had talked with him? My mother never had that talk with me about what to expect that first night. I missed that massive piece of the marriage puzzle. The subject of intimacy was still awkward to discuss with anyone.

Then my mom asked, "Where's your wedding dress? Did you give it to the cleaners?"

"I shortened the hem and removed the sleeves, styling it into a cocktail dress."

She shook her head and mumbled, "That's too bad. What a shame."

She never asked to see it. She chose not to. It would be too upsetting. We never discussed the dress again. I worried how she would get back at me for destroying her dress. She didn't stop talking to me. She couldn't send me to my room. I noticed nothing unusual. The dress and what it represented were gone, but I felt sad and glad at the same time. My father never said a word, and neither did my new husband. But I was sure my guilt was apparent on my face and in my eyes, even if they weren't aware.

During the honeymoon, my innocence about certain aspects of intimacy became apparent when Bernice, also on her honeymoon, asked me about a

climax. The word itself was entirely foreign to me, highlighting my lack of exposure to such discussions before that moment. The conversation left me feeling uncertain and exposed, realizing there were gaps in my knowledge that I hadn't expected.

"Did you have a climax?"

"What's that?" I asked.

Bernice explained, but her words meant nothing to me. "It's a tension releaser during intimacy, and it feels good."

I didn't understand and don't remember discussing it with Bob.

Bob asked me one day while on our honeymoon if I had felt anything extra special. My husband's question surprised me. I shook my head, clamped my lips, and my throat felt dry.

"I don't know what you mean," I squeaked out. Was it the climax he asked about? Maybe he didn't know how to ask. I asked Bernice what to do. I did not want to do this climax thing. Perhaps I could fake it, but how? I don't remember when I figured it out. Years later?

We had fun sightseeing on motorized bikes. The pink sand at the beaches felt warm and soft between my toes. I swam with the fish inhabiting the shallower waters and the visible coral reefs in the warm, turquoise sea. We enjoyed discovering purple passion flowers

growing on a vine along the ground. Birds of paradise were everywhere.

Forgetting the climax, I enjoyed foods like pasta, desserts, and ice cream with no guilt. I dared to weigh myself in the tennis club's locker room. Gasping, I looked twice at the scale's numbers. I'd gained ten pounds in a week. It was a good thing I'd brought my big clothes along. I'd bought my Jones black slacks and T-shirts in three assorted colors with my paycheck from Beneficial Finance, where I worked on Eighty-Sixth Street as their bookkeeper. I also had two pairs of Bermuda shorts for variety. Like most brides, I lost weight to look thin on my wedding day. I guess that was the end of that. The weight gain ended the relationship with my converted wedding dress. Back home, I ripped it into shreds and threw it into the garbage because the lightweight fabric would never be good rags like my father's old T-shirts.

My folks picked us up from the airport. I hoped they would ask how the honeymoon was, but they didn't, and I wasn't bringing it up. What was wrong with this

picture? I needed to understand how to be a wife, but who would teach me?

Our first apartment in the back of a garage wasn't too awful, I convinced myself. When someone started the car, the smell of oil crept under the door, making me feel dizzy and light-headed. I worried we would die from the crude oil stink. Then our first electric bill came. We both worked and were home at night and on weekends, but the bill was over one hundred dollars for the two tiny rooms. When I approached the landlady, she denied the bill was for the entire house. We paid and planned our getaway.

Shortly after the wedding, my folks sold the store and moved to Florida. For me, it meant no pushy mother around. I had no idea what losing one set of grandparents would mean for our yet-unborn children. Neither did they, and neither did Bob's parents.

Baby on board

Chapter Eighteen
We're Pregnant ~ 1956-1957

O ne sunny morning, in our tiny apartment in Brooklyn, I awoke suddenly and leaped out of bed. To my surprise, an unsettling wave of nausea washed over me. Assuming it was the aftermath of a questionable Italian meal from the previous night, I prepared a hearty breakfast of cereal, eggs, and bacon, but the sight and smell of the food made my stomach turn. Not wanting to let the meal go to waste, I told Bob, blissfully unaware of the unusual start to the day, to enjoy the food.

Our kitchen seamlessly flowed into our bedroom, melding functionality with simplicity. In this distinctive setup, our bedroom served a dual purpose. When the Castro Convertible sofabed was closed, the space became a living room.

"Why are you up and dressed already?" Bob asked, crawling out of the sofabed. His wavy blonde hair was a cute mess. I loved running my fingers through his hair, connecting me with him. I married the most handsome man in the world with his green eyes and blond hair. His eyes and hair matched mine. Even our Grecian noses matched. Most folks thought we were brother and sister. My brother, with his dark brown hair like our father's and hazel eyes like our mother's, looked nothing like me. I found it odd that I married a man who looked like he could be my brother.

My go-to was my usual black skirt. "What did we eat last night? I just threw it all up," I said while tucking in my white blouse.

"That's strange. I feel fine," Bob said, peering out of the tiny bathroom and brushing his teeth.

While standing, he downed his breakfast. "I'll get a cup of coffee at the office. Your mother makes a good cup. Maybe she'll bring her layer cake, too."

As the week progressed, my morning routine became increasingly challenging. Being late for the bus had become a recurring theme, and I sprinted to catch it. The exertion proved too much, and I soon realized that my sickness was not just a passing stomach bug.

When I threw up again the following day and the next, I worried I suffered from some unknown disease. The clock ticked away, and I was late for work again. In

a frantic dash, I grabbed my bag, threw on my coat, and sprinted for the bus stop. I felt a relentless fatigue settling in, making each step more arduous than the last. The run for my bus felt like I was carrying a sack of potatoes, and I was late again. My boss threatened to fire me.

"The bus is always five minutes late," I said.

"Catch an earlier bus," my boss said.

Brilliant. That was a life lesson. I've never been late again, even at eighty-eight.

Day after day, the routine continued—the mad dash for the bus, the relentless nausea, and the overwhelming fatigue. Amid it all, I remained oblivious to the possibility that I might be expecting. When I couldn't shake the nausea and fatigue, I realized Bob's doctor dad could help.

"Hi, Dad. I hope it's not too early, but we're concerned about Gail throwing up the last few mornings."

"Don't forget to tell him I'm nauseous, too."

Bob smirked. "Oh, yeah, she feels nauseous."

"Wait a minute. I'll give you a phone number to call my friend, Dr. Schantz."

"Okay."

Doc returned to the phone and gave Bob the number for his friend, who, he explained, was an obstetrician. This raised questions about my ailment.

I scheduled an appointment with him, notified my office for the morning off, and went to see him. After arriving at his office, I faced the discomfort of my first internal examination, an embarrassing and emotionally challenging medical experience. Bob waited patiently in the outer room.

As the examination concluded, Dr. Schantz maintained professionalism, instructing me to get dressed before ushering Bob into his office for a discussion. Despite the discomfort, it became evident the doctor respected the emotional and psychological aspects of the examination process.

Once we settled in his office, he sat at his desk and invited us to sit opposite in the two chairs. "Are you ready to hear what I have to say?"

"Yes, please," I said with worried anticipation.

"I'm ready. What's going on?" Bob said.

"Looks like we're pregnant. We'll know for sure after you miss your upcoming period," the doctor said, looking at me.

"But how? It's not possible," I said.

Bob drummed his fingers on the arm of the chair. "How did this happen?"

"If you don't use protection when your wife is ovulating, pregnancy usually results."

"How are we supposed to know when she's ovulating?"

"Gail keeps a record of her periods. Most women ovulate within seven days of a period."

"So now what?" Bob asked.

"Gail, we'll put you on vitamins during the pregnancy. Make sure you get plenty of sleep and exercise. You'll be new parents in nine months, including these couple of weeks."

"What do we do with this situation? How do we tell your parents, Bob?"

Bob scratched his head. "I don't think they'll be happy."

The situation caused me to gasp a few times a day. How did we allow this to happen?

Bob toiled away at Edgar Tichy's accounting firm, where my mother held the esteemed position of head bookkeeper. Through her recommendation, Bob had secured a position as an in-house accountant, a strategic move to gain the experience required for the CPA boards. The hours were demanding as he delved into his professional pursuits. His father's pat on the back echoed pride and anticipation for Bob's journey toward becoming a certified public accountant.

The money from my work at Beneficial Finance was also part of our budget. Would I keep working until the baby was born? I was unfamiliar with parenting. How was I supposed to behave? I was only twenty-one, too young to raise a child. Who would be my role model?

Certainly not my mother. I didn't know Bob's mom well, so I had no one to go to for advice about raising a baby.

We called my in-laws.

"We need to talk to you. Can we come over?" Bob asked his mother.

I didn't know what to expect. Bob's dad had told us when it was time to get married. I felt relieved when he sat us down and explained a budget so we understood how to spend and how not to. He told us not to let the sun go down on our anger and to clear up disagreements before bedtime. But no one talked to us about babies—when we could have one, how to have one, and how to care for one. My dad was my hero, but he explained nothing about babies, and my mother was always angry. I didn't trust her answers.

In the heart of Bob's parents' home, amidst the familiar scents and warmth of the kitchen, we faced a pivotal moment. Standing before them, nerves taut like bowstrings, I struggled to find my voice. Sleep had been scarce since our doctor's visit, anxiety gnawing at my insides. Despite following the doctor's advice, sickness still plagued me. With a heavy heart and trembling knees, I finally uttered the words: "We're pregnant."

Bob's mother's immediate reprimand cut deep. Her words pierced through me, directed solely at my perceived shortcomings. I was stunned, unable to comprehend why the blame fell exclusively on my

shoulders. Through tear-filled eyes, I tried to explain, grasping for understanding. She was my second mother, a figure of authority and wisdom, the matriarch of a family where I sought my place. But her response remained firm, resigned to the reality of the situation. "It is what it is," she said finally, a phrase heavy with acceptance yet devoid of consolation.

A new chapter of my life unfolded like a faded photograph in the quiet recesses of memory. It was a time when youth and marriage entwined, and the mysteries of life were yet to reveal themselves. As a young bride, I stepped into the intricate dance of marriage, oblivious to the nuances ahead. Ovulation was unfamiliar to my youthful innocence, and the consequences of this ignorance cast a shadow over my early days of matrimony.

In those days, discussions about reproductive health were primarily unheard of, and crucial information often eluded the eager minds of young wives. The concept of family planning remained obscured, and as the inevitable consequence of our love manifested itself, so did the disapproval of my second mother.

Her scolding cut through the air like a sharp gust of wind, leaving behind the wreckage of my naïve expectations. The weight of her displeasure eclipsed the joy of impending motherhood. She, a woman of experience, saw my unintentional oversight as a grave mistake, a

failure to uphold the unspoken expectations. Her disappointment echoed in the kitchen, and the warmth I hoped to find within those walls turned cold. The ache of her disapproval lingered, a constant companion as I navigated the uncharted waters of impending motherhood.

During this sensitive time, we found a one-bedroom apartment in Alley Pond Park, Queens. The living room, beyond the front door, was one big room with two windows. The view looked out onto lawns, gardens and circulative paths to neighbors. The Castro convertible sofabed easily fit, leaving space for more seating. Tucked into a corner was a small eating area before reaching the working kitchen with cabinets not worth mentioning. It had the usual: sink and one long counter against the wall, a small refrigerator, gas stove, and enough space for a baby's highchair. To the right of the living room was a small bathroom—opposite the one big bedroom that housed a crib, baby changing table, and later a youth bed for Linda and the existing crib for our new baby, Richard. Now, it might not have been the Ritz, but it was brimming with charm, particularly if you were a new mother.

The neighborhood was practically a stroller parade, with young moms from every corner converging to trade baby tips and sleepless stories. We had dear cousin Marilyn to thank for leading us to this little gem,

a convenient place for our new adventure as parents. Our upstairs neighbors were a delight—fellow rookies parenting with their own little one. The only downside? The nocturnal entourage of roaches (not the waterbug size, thank goodness) that loved to crash Linda's 2 a.m. feeding. Flick on the light, and they'd scatter like they were late for a meeting. But those little pests couldn't dim the warmth of the community that was more than just a place to live. It was a lively, endearing hub where friendships bloomed as quickly as our babies.

As I pen these words, the sting of Bob's mom's anger resurfaces, a testament to the lasting impact of that moment. In the retelling, I confronted the vulnerability of my youth and the harsh lessons that accompanied the transition into adulthood. The passage of time has afforded me the wisdom to revisit that juncture with compassion. I recognize the limitations of that era and the gaps that fueled misunderstanding. The story transforms into a journey of resilience and self-discovery and the intricate layers of family, love, and the unstoppable march of time.

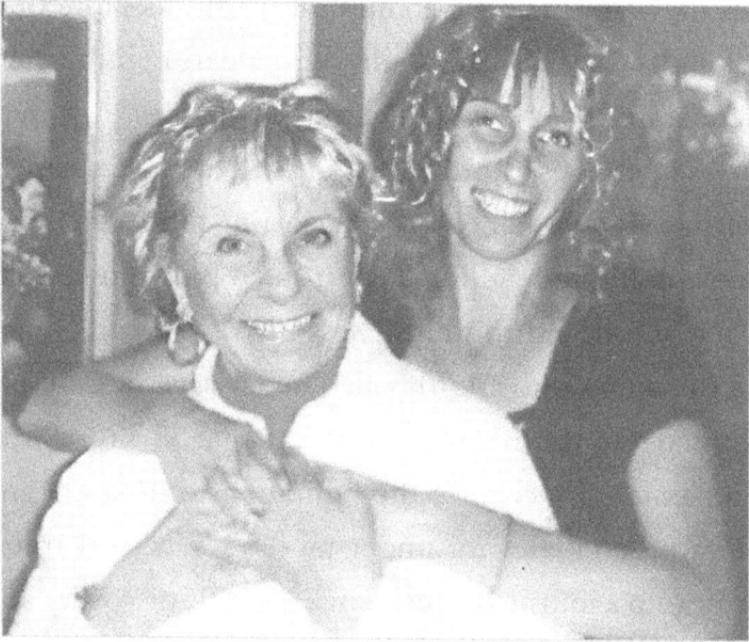

Gail with her lovely daughter Linda

Chapter Nineteen

Mothers and Daughters ~ 1957-2014

It was a breezy afternoon in the middle of May when Mom, who had flown in from Florida for the birth, decided to treat me to a visit to the beauty parlor. My pregnant self, dressed in maternity clothes, a pair of black slacks and a white top, barely fit into the chair. I'm quite certain they hadn't anticipated accommodating a client on the brink of delivery. Nevertheless, relaxation washed over me as skilled hands shampooed, curled, and styled my short hair.

Little did I know that the first pangs of labor would intrude on this moment of indulgence. As the stylist expertly teased and twisted my hair into a fashionable flip, early contractions began to make their presence known. At first, I waved them off as the usual discomforts of pregnancy. But as they persisted, a realization

dawned: labor had commenced right there, amidst the gentle hum of the beauty parlor. A new rhythm emerged, hilariously synchronized with each tug and twist of my hairstyle.

"Gail, you're amazing, getting your hair done while in labor," the hairdresser said. I laughed with a mixture of excitement and trepidation. "Got to look good for the baby," I said. She shared a knowing smile, completing the finishing touches on my hair.

My in-laws ushered us into the house and sat me down on the green velvet sofa in the living room. By this time, labor made me feel like I wanted to push the baby out. Then my water broke, soaking the sofa. Mother Bea, with nary a complaint, gave me a dry housedress. My mother, Doc, and I bid her farewell, while she stayed home with Ted and called Bob. Doc, who was an old-time city doctor, had birthed a few, making me feel secure.

"Bob will meet us at the hospital. By the time we arrive, you might be ready to deliver," Doc said.

Doc drove his car, and my mother and I followed in my car. As we sped through the early evening, passing streetlamps marking a step closer to the momentous event, the city lights blurred into streaks of color. Mom, her hands steady on the wheel, wore a determined expression, hinting at a mixture of excitement and apprehension.

I glanced at my new hairdo in the rearview mirror. It was a pleasant addition to my physical and emotional preparation for this day and promised a beautiful beginning.

The labor room became a stage where the last act of this unique drama would unfold. The doctor on duty delayed the birth of my firstborn, waiting for Dr. Schantz to arrive. The epidural soothed the labor pains until the wee morning hours when Dr. Schantz told me to push a few times, and our daughter cooperated as he helped her slip into the world. Linda's first cries echoed through the delivery room, with her grandfather watching the miracle of his ancestry. The styled hair, once a symbol of preparation, now tangled and tousled, reflected the raw, unfiltered beauty of the moment.

I gazed at my beautiful baby when the nurse placed her on my chest. After a few moments she took her away to clean her. Doc held his swaddled granddaughter while I delivered the afterbirth and Dr. Schantz finished the stitching. I had a remarkable feeling of buoyancy and joy as the nurse placed her in my arms. They took us to my room, where Bob waited to see me and his daughter. None of us could take our eyes off her. She was a sunbeam, bringing warmth and light to every corner of our world.

THIS CHAPTER HOLDS a tender place in my heart—a chapter dedicated to supporting my sixty-seven-year-old daughter through profound physical and psychological adversity. Her suffering began with unsuccessful back and knee surgery in her thirties, and the loss of her twenty-three-year-old daughter to a seizure in 2014 devastated her emotionally. As a parent, my instinct to protect and care for my child has never waned. In the face of Linda's challenges, my commitment to being her unwavering source of strength has only deepened.

When I first understood my daughter's dual battles, I stood at the crossroads of concern. As a parent, how could I best support her? How could I respect her independence and ensure she felt the warmth of a supportive embrace?

The journey began with open communication. We talked not just about the symptoms and diagnoses of her ailments, but also about her emotional burden. I needed to create a safe space where she felt understood and free from judgment. These conversations taught me about her fears, hopes, and seemingly impossible challenges.

The next step involved collaborative decision-making. Together, we explored medical options, sought the guidance of professionals, who didn't help, and created a plan to address the aspects of her well-being. I needed to empower her to make choices about her health while offering unwavering support. I discovered the delicate art of balance—knowing when to offer advice and when to step back, allowing her to navigate her path.

After Linda graduated high school, she spent a year at SUNY Upstate. Not interested in higher education, she gave up and came home. She had an active social life and met Michael Sklar at a tennis party. They dated, and she moved in with him, asking Bob and me what we thought. Honestly, we didn't know how to advise her. What were the reasons to move in? It didn't matter, and we were at a loss. This was not unusual for the mid-1970s.

"Everyone is doing it, living with their boyfriends."

Would she move in without our blessing if we said she shouldn't? She already had moved in, so we gave her an affirmation of our support, but I was scared. Would Linda be happy? Was it really the right thing to do just because everyone was doing it? She told me recently if we had said no, she would have moved in regardless. So, we guessed right,

LINDA AND MICHAEL had built a life with their two sons, David and Josh, and daughter, Rebecca, when a sudden storm of grief descended. It was a storm that no weather forecast could predict, an upheaval that shattered the calm of our existence. An unexpected and devastating seizure took Linda's daughter, Rebecca, from us at twenty-three. As the news echoed through our family, the world outside seemed to come to a standstill. With her infectious laughter and dreams still in the bloom of youth, Rebecca had left life too soon. The house that once resonated with her life's melodies now echoed with the haunting silence of absence.

Linda, at fifty-seven, bore the weight of a mother's grief, a burden that no parent should ever have to carry. The days following were a blur of tears, hugs, and aching hearts. The community rallied around us, offering condolences like delicate flowers in the storm, providing a semblance of support in our collective sorrow.

Amid the mourning, Linda, her eyes clouded by tears, would recall the milestones—the first steps, the school graduations, the shared laughter over family

dinners. Her daughter's sudden departure left a void that seemed impossible to fill.

The funeral was a bittersweet gathering. Friends and family united in grief, sharing stories vividly portraying Rebecca's life. It was a painful acknowledgment of a future unrealized, dreams left hanging like delicate threads in the wind.

As the days turned into weeks, Linda grappled with the grief. It was a journey that no roadmap could navigate with precision. Life's routine became a series of challenging steps, each heavy with the weight of loss. Once the strength for her family, Linda leaned on the support of those who shared the pain. When I visited, Linda sat in Rebecca's room, surrounded by the echoes of a life that had been—clothes in the closet, posters on the wall—each item a poignant reminder of the void. While letting go, Linda faced the challenge of rebuilding a life without her daughter's physical presence.

As the seasons changed, so did the landscape of grief. Linda, forever changed by the loss of her daughter, navigated a path toward healing. It was a journey marked by minor victories—the ability to smile at a cherished memory and the courage to face the ache without crumbling. The storm of grief, though never fully abating, relented, making space for a bittersweet acceptance of the new reality.

In the aftermath of Rebecca's untimely departure, a gentle and unexpected ray of light emerged from Nikki, one of Rebecca's closest friends. Their bond, forged through shared laughter and secrets, transformed into a lifeline for Linda. As the weeks passed and the shock of loss settled, Nikki took it upon herself to step into the void Rebecca had left behind. Every Friday, without fail, she visited Linda, bringing a smile and sometimes a small token of affection. It created a routine not out of duty but from a sincere longing to comfort a woman grieving for her daughter.

On their Friday afternoons, Nikki and Linda would embark on small adventures—a visit to a favorite café or a mall where the aroma of soft pretzels mingled with the bittersweet trace of loss. In these simple acts, Linda found not just a friend but a second daughter who filled the emptiness left by Rebecca's departure.

Nikki, wise beyond her years, navigated the delicate dance of comforting without replacing. She understood no one could replace the irreplaceable, yet she was a comforting presence, a reminder that life, in its altered state, could still hold moments of joy and connection.

Nikki became a confidante, a source of strength, and a living reminder that love, though altered, could still find expression.

As the weeks turned into months, Linda and Nikki's connection deepened. Their Fridays became a ritual of

healing, an acknowledgment that life could still be beautiful. Nikki's gestures, once intended to console, now spoke of an enduring friendship, a connection born from shared tears and laughter.

Like a guardian angel, Nikki remained steadfast in Linda's life. And so, every Friday, they found solace in their shared moments, a testament to the extraordinary bond that emerged, acting as the family that fate had rearranged.

Throughout Linda's trials, her husband, Michael, stood by her unconditionally. Not only did he shoulder the responsibilities of running their household, cooking, and managing the kitchen, but he also dedicated himself to his full-time job in the food industry. Despite their challenges, Michael's love and care extended beyond his marriage to Linda. He embraced Nikki with open arms, treating her as his own and welcoming her into their family as a second daughter. His commitment to supporting Linda and nurturing their extended family exemplifies his compassion, strength, and boundless capacity for love.

Dangerous Diets
(courtesy CANVA)

Chapter Twenty
Dangerous Diet Pills ~ 1958

Fattened up and turning thirtysomething around I engaged in my last do-or-die attempt to reduce. I'd lost weight many times but always gained it back. I'd tried diet pills, lost the weight, and gained it back. Maintaining my weight proved impossible. I tried vibrating inches off my thick thighs, my waist, and my hips. The basement walk-in closet was a hiding place for the electric belt and my sweatpants. No one knew my plan—not my husband, best friend, or children. I convinced myself I'd reveal how I achieved magical success when I reached my goal. I used the belt after the kids left for school and Bob left for work. Then again in the early afternoon, before my crew came home. Despite my determination, not a single inch of my body vanished.

"Mom? What is this thing?" Paul, my nine-year-old son, one day asked after he discovered the device. "What does this do?" he asked, climbing onto the machine's belt and wrapping the wide strap around his skinny butt.

"It's supposed to vibrate my inches away."

He flipped the switch on. "This is silly," he said after three minutes. He flipped the switch off, untangling himself from the strap. "It tickles my butt."

Eventually, the useless vibrating machine ended up in a storage unit. In 1993, after collecting dust for over two decades, my new husband, Tom, who couldn't care less what I weigh, helped me toss it into the giant compactor at the town dumping station. Regrettably, I couldn't get rid of what I had ingrained in me as a teenager. Thanks to Mom and MacLevy's Reducing School, I would always be *zaftig*—a plump girl—in my head.

Possessed with a passion for losing weight from reducing school many moons ago, I approached Doc, my best advisor and caring father-in-law, who supplied me with a lifetime of diet pill samples. I was so excited and felt special about getting those pills.

Earlier, before the pills, Doc's friend, Dr. Schantz, in Borough Park, proved to be a godsend for my pregnancy journeys. He outlined what to expect, provided

essential vitamins, and emphasized regular checkups once a month. Brooklyn's Maimonides Hospital would see my babies delivered. As my pregnancy with Linda progressed, my love for pasta and treats led to a gradual weight gain of fifty pounds by the time she entered the world. The struggle with constant heartburn and sleeping sitting up became all too familiar.

Determined to avoid a repeat, I must admit that I enjoyed my second pregnancy snacking on diet pills (amphetamines). They were my tasty tidbits with my Ricky, who claimed he owed his addictive personality to my habit. I only gained fifteen pounds, felt remarkably better, and was skinny after I birthed him.

Navigating my third pregnancy, I attempted to curb overeating, though it proved to be challenging. Opting to forgo the diet pills this time, I limited my weight gain to twenty-five pounds. Pregnancy wasn't my favorite state; unfortunately, Bob wasn't the most helpful companion. His typical male disposition failed to summon much sympathy for my frequent bathroom visits.

One-a-day amphetamines did nothing for my weight, but I cleaned the entire house in record time. I was sure we had the cleanest house in the neighborhood, thanks to those diet pills. But my weight, well, that's another subject.

My Mom's epitaph: "Don't eat that, it'll make you fat."

Despite my father-in-law saying my hips were perfect for making babies, carrying and birthing was challenging. Who was I kidding? Impossible was more like it. Some women, I've heard, like being pregnant. Doc was a guy, the male species. What did he know? Ask a woman. She knows about carrying a baby—the heartburn, not sleeping, feeling like a duck, and walking like a duck. Doc knew about allergies and healthy eating. During my first and third pregnancies, I felt fat, couldn't move well, couldn't bend easily, and couldn't touch my toes without hurting my back.

My father-in-law cared. He spouted Dr. Carlton Fredericks, a health food guru, on the radio for thirty years. His syndicated *Design for Living* program aired six days a week. Considered "American's Foremost Nutritionist," he explained how to eat and not get fat. The then-popular diet doctor, Dr. Atkins, laughed at him as a promoter and food faddist. Fredericks made fun of junk food. When callers asked about white bread, he answered, "It is a wonderful thing to use when cleaning your countertops or dusting your furniture."

"*My Poem of Reflections on the Amphetamine Routine*"
 Eat, eat, eat.

Hide the food, no cheat.
Take the pill and skip the treat.
Take the pill, clean up the mess.
No more food, that's the stress.
Take the pill, pay the bills.
Walk the dog, no more frills.
Feeling tired, moving slow?
Take the pill, and off you go.
Fingers cold, fingers blue,
Can't take the pill, eat anew.

I OWED my Raynaud's syndrome to the diet pills; my fingers turned blue, then white. The cold hurt, and so did warm water soaks. Nothing warmed my fingers. I had to wait for the blanching to pass. It took twenty years for my fingers to heal. No one had a clue about the effects of amphetamines back then. The manufacturers handed out samples to doctors like candy.

Between my speedy behavior and my caffeinated coffee, I was a master at getting things done—cleaning, refinishing furniture and walls, dressing the kids, cooking. I did it all at the speed of light. I had to hurry before the pills wore off by four in the afternoon when I collapsed.

No one noticed—I looked normal. My feast was a beast, the pills my addiction. I had to take them to func-

tion. I'm shocked that after taking those pills for twenty-one years, I survived. Funny—the pills lost their effectiveness and no longer reduced my appetite, but I got hooked. I discovered the dangers and dumped them all in the garbage for the raccoons, who raced around looking for more.

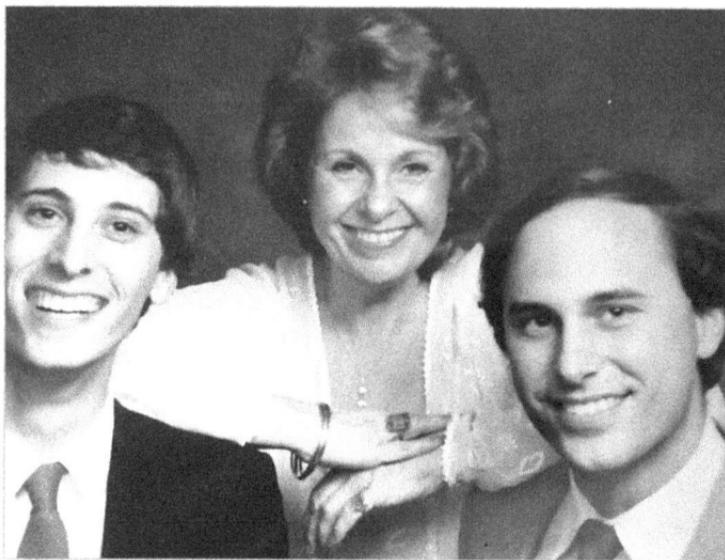

Gail with her handsome sons Paul & Rick
(then and now)

Chapter Twenty-one
My Two Sons ~ 1959-1963

The traffic crawl into Brooklyn from Alley Pond Park, Queens, to see Bob's folks was worth every lost minute. Spending time with Mother Bea taught me a thing or two. She was the role model I needed. My training in the daughter department lacked life with mother. My working mom was not exactly Miss Manners material. Mother Bea, the household matriarch, ran the kitchen and family. Learning to be a daughter from her was like finding the missing piece of the puzzle.

I yearned for the memories of my first mother before our lives turned upside down. Transported back to a time when she stood as a beacon of nurturing wisdom, teaching us with tenderness, and her chocolate chip cookies danced on our taste buds. I lived in a

sanctuary of tenderness, where harsh discipline had no place, and understanding, empathy, and gentle guidance reigned supreme. But as fate would have it, our lives took an abrupt turn with the opening of the variety store, thrusting her into the relentless whirlwind of business ownership. The metamorphosis was profound. She traded the apron of a homemaker for the cloak of a wise entrepreneur, entrusting the care of our home and hearth to my father and me.

Bob's mom took me shopping and asked for a discount from the butcher. I loved her tenacity. She taught me to cook and bake, and especially how to make a flaky piecrust. I still have her old pastry wheel. She gifted me a Singer sewing machine and signed me up for a course on how to sew. That taught me the properties of fabric and tailoring. I didn't know then how important learning about fabric would be. Surprisingly, I found more fulfillment in having a sewing machine than a husband. Creating clothes for my family was a passion, and I made a cherished lined sports coat for Bob. I still use the machine and care for it like it's one of my children.

I loved and admired my second mother, but the difficulty, distance, and traveling with young children kept us apart. In 1959, our son Rick was born right on schedule, by appointment—a total game-changer. No stress about labor pains—induce labor, and let the

meds do their magic. This second bundle of joy was a happy baby from the get-go. After a week in the hospital, he slept through the night. Rick was a little ball of sunshine, spreading joy everywhere. He adored his sister, shared toys like a champ, and the two were inseparable playmates. With his insatiable curiosity, Rick's laughter echoed through the house. Pure innocence sparkled in his big, bright blue eyes. I kept him content —fed, dry, and drowning in love. Those were days full of joy and laughter.

My in-laws encouraged us to find a house and gave us $5000 as a down payment. We found a charming 1950 ranch house for $16,000 on a cul-de-sac next to a playground in Hicksville, Long Island. We assumed the previous owner's VA mortgage. The house received a facelift courtesy of some savvy refinishing on my part. I stripped, sanded, and transformed the yellowed pine kitchen cabinets and tired beadboard wainscot in the dining room. A satin water-based finish was the final touch, ensuring a timeless look.

We carefully planned our third child's birth. Paul was born by appointment on February 6, 1963, because of the unpredictability of labor and the long drive from Hicksville. His birth brought overwhelming joy, and I embraced motherhood with a newfound experience and love. Unlike his siblings, I nursed Paul, despite my father-in-law's reservations, cherishing the closeness it

brought. Paul brought our family a unique sense of contentment with his tender nature and curiosity. His love for his siblings was evident. Our family grew closer, with my parents moving to Hicksville and our home becoming a haven filled with love and cherished memories.

While the nearby playground was a bonus, our backyard swing set provided peace of mind as we watched our children play. Our backyard, adorned with hydrangeas and rhododendrons, was where I learned to garden. Badminton games and swims in our above-ground pool added to the fun. I taught my children the essential swimming skills I learned in my youth. Our finished basement became a secret play haven filled with toys and Legos. It was there, with my eight-month-old Paul, that we heard the tragic news of President John F. Kennedy's shooting, leaving a lasting mark on our family's memory.

Bob sought better opportunities through interviews and landed a job with a pharmaceutical company in New Jersey, which led to a pay increase and a need to move. This caused my parents to move back to Florida because of my father's intolerance for cold winters. Our yearly visits were a joy.

During the Vietnam War protests, underscored by songs like Bob Dylan's "Blowin' in the Wind," we moved to Woodcliff Lake, New Jersey, in '66. Our new home

boasted three bedrooms, two and a half baths, a circular driveway, and a large backyard suitable for a tennis court. I hadn't yet discovered my passion for tennis, little knowing it would lead me down an unexpected path, shaping my future.

The kitchen was my dream. Bob, caught up with the dishwasher's novelty, played with the buttons. Despite the absence of dirty dishes, the dishwasher filled with water—a detail that didn't deter his pleasure in pushing those buttons. It was strange to watch his fascination, because he never washed a dish. The prospect of not having to handwash dishes gave me a thrill.

Linda, 9, had her own room, while Rick, 7, and Paul, 3, shared. I worried about challenging sibling dynamics, especially between Linda and Rick, which continued into adulthood. Encouraging their interests helped, like Girl Scouts and Boy Scouts

Balancing time for the kids and myself was tough, especially with Bob's frequent travels. Joining a local book club with professional women provided connection and validation. I was the only member without a college degree. I asked why they invited me; they said I had an innocent point of view. I loved taking part.

When Bob was home, family time often centered on TV's *Star Trek* or sports, though his fatigue interfered with bonding. Rick enjoyed his martial arts at his dojo. Meanwhile, Paul's passion for Legos forged a strong

bond with Rick, showcasing their collaborative synergy despite their age gap. Linda took up with Michael and eventually moved in with him.

Decorating the large living room was a task I took on alone. I perused design magazines, but I needed clearer guidance. How was I to know? Unfortunately, I hired an incompetent furniture company. The extravagant silk drapery tiebacks took up the thirty-foot span of the dining area and living room wall. I had yet to learn our new living room was dreadful. I'd sell all in the future, but Mother Bea supported me when she pointed out that the moss-green color scheme worked. Everything was moss green (popular in the sixties): moss-green carpet, matching ceramic tiles in the entry, the tufted silk sofa, and tiebacks on the long wall. Gold velvet tufted chairs complemented the green. I embraced my mom-in-law, finding solace in her caring. Her approval meant the world. Bea was the epitome of the mother I longed for, a true gem in my life.

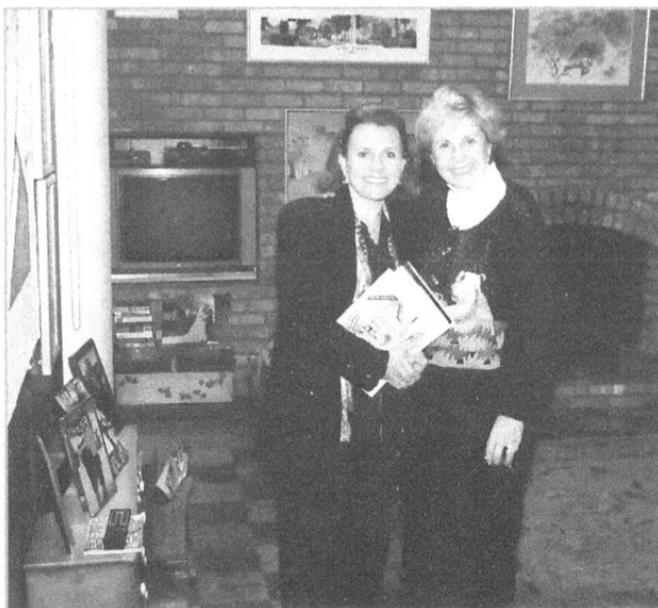

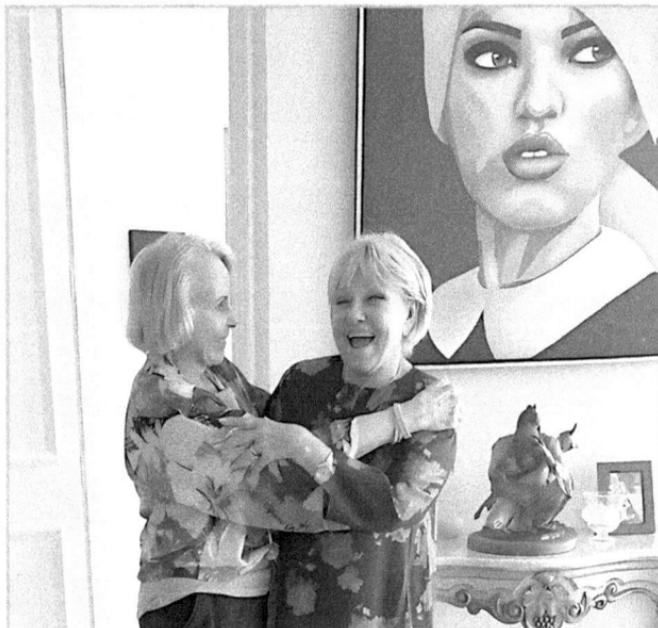

Gail and Gigi (then & now)
Painting by Christina (Gigi's granddaughter)

Chapter Twenty-two
Meeting Gigi ~ 1967

T his story begins on a tennis court in the summer of '67.

The average cost of a new car was $2,750, and a gallon of gas was 33 cents. The Beatles negotiated a nine-year worldwide contract with EMI Records.

Steam rose from the ground underfoot after the early rain in July. The green surface snuck up, grabbing my white sneakers as a tennis ball demanded my attention. I pulled my racquet back and ran to the ball. My short white tennis skirt swished as I avoided slippery spots from the rain. I kept my eye on the ball, stopped short, and returned it cross-court.

Outside the chain-link fence, a playpen harbored five babies, their babbling forming a chorus reminis-

cent of a bustling mob of monkeys. The cacophony momentarily whisked me away, drawing parallels between their lively chatter and the animated scenes I'd seen at the Bronx Zoo. My concentration returned in time to see my opponent, Renee, fumble with the ball, leading to my win.

The brood and their mothers caught my attention. Observing our game, the two ladies had stood at the high chain-link fencing, their fingers wrapped around the links. Now the brunette-haired woman in a white skirt and T-shirt leaned over the playpen. The other woman, in shorts and a T-shirt, who looked like she might be her sister, did the same. Crying ceased with cookies, trucks, and teddy bears.

The gal closest to me smiled, her enthusiasm evident.

"Would you and your friend like to play?" I asked, injecting a sense of friendship into the moment.

Meanwhile, Renee, positioned at the far end of the court, responded with a casual wave of her hand. "That's a great idea, Gail—it's alright with me." Her willingness to embrace the impromptu change in plans added a touch of camaraderie to the court to merge our worlds and share in the joy of a collective game. The prospect of including the onlookers from beyond the fence promised to transform the game into a shared experience.

When we'd rolled into the park earlier, we were eager to hit the court, only to find it occupied by a quartet of tennis enthusiasts engaged in fierce doubles action. Tennis was the hottest thing since the invention of the tennis racket, so finding an unclaimed court in this tennis-crazed town took effort.

With its sprawling greenery, Wood Dale Park had this solitary tennis court, swallowed by the vastness of nature—trees, ponds, and winding paths conspiring like an elusive treasure hidden in the wilderness. Renee and I stood there, twiddling our rackets, patiently waiting our turn. We strolled along the paths, taking detours to watch ducks leading their fluffy ducklings in a parade across the lawns, performing synchronized swimming routines as they hit the water.

When we thought we could audition for a part in a duck documentary, a majestic swan swooped in, maintaining an elegant distance from the quacking chaos. We found a vacant bench to pass the time, armed with a humble batch of breadcrumbs I'd smuggled from home.

As we tossed morsels to our feathered audience, my patience for waiting for a court waned. It was time to end the avian sideshow and claim our territory. Finally, after an eternity of ducks getting more attention than our tennis balls, the fab four from the tennis court packed up. Renee and I seized the opportunity with

triumphant grins—the court was now ours for the next couple of hours to unleash our version of a tennis drama. Game on!

I smiled at the woman across the fence. "Please join us. That'll be fun, but what about your kids?"

"They'll be fine. They have their toys and can't jump out of the playpen."

"My name is Gigi Duarte," the brunette said, still holding her racquet. "My sister, Mete, has two children. The other three over there are mine."

Renee and I introduced ourselves.

I partnered with Renee. The ladies seemed amenable and smiled the whole time we played. We had a jolly time. Renee and I won more points simply because we'd played a few times and our new friends said they hadn't.

"I must run," Renee said. "The kids are coming home from camp soon."

I nodded. "Thanks for the game. Let's do this again."

"Good idea. We'll talk later. Ta-ta for now," Renee said, wiggling her fingers. She held her racquet bag in her other hand and trekked out the gate.

Gigi's eyes sparkled with enthusiasm, and she asked, "Would you like to play again, Gail?"

We made the most of the summer by frequently engaging in spirited matches, and the camaraderie we forged on the tennis court blossomed into a genuine

friendship. Our tennis escapades extended beyond the court, intertwining with parenthood's shared joys and chaos.

My energetic four-year-old son, Paul, found a playmate in Gigi's daughter, Liz, also four. With our little ones happily occupied, we entrusted them to the capable hands of Gigi's extended family—her sister Mete, the ever-patient Donna Emilia (Gigi's mother), and occasionally her younger sister, Lili.

In the precious moments of kid-free bliss, Gigi and I seized the opportunity to socialize after our tennis bouts. Gigi hosted some of our get-togethers at her place, and the spotlight shifted to my humble abode on other occasions.

Gigi followed me and parked in the circular driveway the first time she came to my house. I shouted from my car, "I'll be right there." Swiftly maneuvering to the side of my home, I tucked my vehicle into the garage and hurried inside to throw open the front double doors.

As Gigi stepped onto the columned portico and into my expansive foyer leading to the open, airy living room, her reaction was priceless. Gasping with delight, she placed a hand over her heart. "Did you decorate yourself?" she marveled, gesturing toward the fusion of green and gold adorning the space.

I wasn't familiar with good decorating, so Gigi's

unexpected question caught me off guard, prompting a reflection on my mother's innate talent for decorating. Until then, I hadn't considered her flair might have influenced my sensibilities. As I was growing up, my mother took charge of decorating, and I took the compliments she received from friends for granted. My parents moved from the back of the store to a second-floor apartment in Flatbush, a spacious abode practically around the corner from Brooklyn College. The décor was a hit, with friends singing praises for the elegant touch my mother added to every corner. The centerpiece, an antique Persian rug in the living room, held aesthetic and financial value, worth several thousand dollars, as my mother proudly declared.

However, after my mother's passing, I uncovered a secret—a 1929 certificate made out to her, Claire Gerber, for completing a decorating course in the Economics Department at New York University. The revelation shed light on her meticulous choices in turning our home into a haven of style and warmth.

In hindsight, that Persian rug would have been a wise keepsake. Regrettably, my younger self, oblivious to its value and not drawn to Asian styles, didn't grasp its significance. Who thinks about investments when you're still navigating the maze of adolescence?

As I grappled with remorse for not recognizing the

rug's worth, life was about to throw a curveball, ushering in changes I couldn't have foreseen.

Gigi's question took me aback. Perhaps my mother's knack for decorating rubbed off on me after all. "Thank you. I'm glad you like the decor, but I must tell you I didn't do this alone. I read through decorating magazines, which didn't help. The magazines left me frustrated, so I hired a furniture company, which was also no help."

I gazed at my friend and smiled. "Do you like it?"

"I do," Gigi said. "Can you do my living room?"

She looked serious, as if her life depended on my answer.

My face felt flushed. "I wouldn't know how to begin."

For a moment, her expression remained blank. Then she said, "You've seen my house. Come again with redecorating in mind."

The next time I visited, I stood facing her living room. She was right—it needed help, but I didn't know how. I knew nothing, and she knew less.

"Alright." I sighed. "Let's review *House Beautiful* magazine and maybe some others." My living room didn't make me swoon. My only idea was to do the same decorating for her. Oh Lord, what to do? We perused stores for furniture and lighting and poured through

more magazines. We bought a chandelier to test our options and opinions.

"Let's install this and review it with the rest of the room to see if we like it."

Gigi called two days later. "The electrician just left. He installed the chandelier. Can you come?"

"That was fast. I'm on my way." I said, elated.

"I think I like it, but I'm not sure. What do you think?" Gigi said when I arrived.

The style of the chandelier caused pressure to build in my chest. Even I knew it was too much glitter. "I'm so sorry, but it doesn't work—too big, too bright, too gauche." I frowned, and turned to Gigi, hoping she was still my friend.

Gigi tilted her head, acknowledging my effort. "You've worked hard. I appreciate the time you've invested. What's next? Do you have a recommendation?"

Fired by our talk, I shared a spontaneous idea that felt invigorating and freeing. "Here's the plan: You babysit Paul, and I'll to go to design school, just like my father-in-law once suggested I do."

"What did he say, exactly?"

"We discussed my return to school, and he mentioned my knack for decorating."

"See? I've been saying that."

Her eyes sparkled with enthusiasm as she eagerly accepted the proposition. "It's a deal."

In that simple agreement, a pact formed that promised a new chapter—me pursuing my passion for design and Gigi providing the support needed to make it happen. Little did we know it would set in motion a series of events that would not only transform my career but also strengthen our bond of friendship.

Chapter Twenty-three
NYSID Design School ~ 1969

I found discussing my design school dream with Bob challenging.

He screwed up his face. "There's no exact formula or rules to interior decorating, are there? What will they teach you?"

"I'm not sure, but what I am sure of, based on the catalog curriculum, is that I'll learn color, business, space planning, and the history of interior decorating. The New York School of Interior Design (NYSID) is the most convenient place and has a glowing reputation. I read about their success, philosophy, and popularity."

He looked around the kitchen, taking a drag of his cigarette. "How come you finished supper? Did you save me any?"

"Your secretary called to say you'd be late."

"I wasn't too late. You should have waited."

"Oh, I'm sorry," I said.

"Get on with your schooling."

My face felt hot. "I signed up for Section A."

"Then there's section B and C?"

I nodded. "It'll take fall and spring to finish."

"Then what? Is D next?"

I shook my head. "No, then there's a three-hour exam and portfolio review."

"Do they find jobs for you?"

"No, uh, I don't know. I'm trying to help my friend Gigi. That's my job."

"All this money for tuition, and you're just helping your friend?"

"She's babysitting Paul. I wouldn't be doing this if not for her."

I put a plate with an ample slice of cherry pie on the table.

He put his cigarette in the ashtray, sat on the historic plastic swivel Eames chair, and dug into his cherry pie.

He took a bite of the pie. "Entenmanns?" he asked, chewing on a mouthful.

"No, homemade."

"I thought you forgot how to do homemade. This pie is good."

"Are you listening? I'm trying to tell you about registering for design school."

"Let's see how much this will cost me."

"Does it matter? It'll give me a career, and I'll be able to contribute to our budget."

"We'll see."

BOB HEADED to the office on a bright Monday in September '69, and the kids were off to school. Now, it was my turn. Excitement and nervous anticipation fluttered in my stomach. I hopped into my car, cruised down the FDR into New York, and enrolled in the Practical Training Course at NYSID, covering history, business, and color.

Armed with a fresh textbook, research guide, and bibliography, I drove downtown to the Strand and bought thirty-three books from the recommended list, determined to absorb as much knowledge as possible. In the following months, I immersed myself in reading the Sherrill Whiton textbook and answering the questions in the back. My book collection expanded to cover design history, architecture, interiors, color, fabric, and

more. I dedicated my evenings to studying after classes, creating a personal Library of Congress.

Before the final exam and the fall semester drew to a close, I approached my advisor, Robert Murray, in the lecture hall. I stuck my head in.

"Come in, please, What's on your mind?" he asked while erasing the board.

"Thank you, Mr. Murray. I'm Gail Ingis."

He nodded. "Good to meet you."

Little did I know how good it would be. This tall man with a smile that could move mountains was an outstanding teacher and became my confidant and mentor.

"I'm finishing up the certificate program, and I love it. I want to build a career in interior design, but how?" My stomach churned as I spoke, but I squared my shoulders and focused on the gracious, patient man who would become my first-year instructor. With a track record of Bs and Cs in high school and never passing American History, I couldn't help but wonder what kind of student I would be. I put my hand up to my throat and hoped I wouldn't throw up.

"Sounds like you have an interest in our three-year program."

I shrugged. "Maybe. Isn't it tough to get in?"

He raised his brow. "Can I ask you a couple of questions?"

I gulped. Oh my God, was I in trouble? Was this a test? I don't do well on tests.

I gazed at the blackboard for a moment. "Yes, please," I said.

"How are you doing in your classes?" he asked, looking into my eyes before returning to cleaning the blackboard.

My lips turned up. "A in color and business."

"Good," he said, looking at me again. "What about Section A?"

"I won't know until the exam. However, after every lecture, I studied the text, answered the questions in the back of the book, and tested myself. If I got anything wrong, I reread the chapter. I think I memorized the entire book."

"I can't make any promises, but what have you got to lose? Fill out the application—you might get in," was the encouraging advice I received from Mr. Murray. Four months later, I passed the courses, completing the three-hour final exam in twenty minutes and achieving an unexpected A. My grade surprised me, boosting my confidence. Encouraged by this success, I took the next step and applied to the three-year professional full-time program. The competition was intense, with 400 applicants battling it out for only sixty-five available spots.

To my delight, I got in!

Gigi will be thrilled I'm all registered for the professional degree. I couldn't wait to get home to tell her.

I asked Miss Chaplin in the office to see Mr. Murray. He came out to greet me, smiling.

I, too, was all smiles, trying not to jump up and down.

"Well, Gail, you got in, as I knew you would. What can I do for you?"

"I'm so excited. Can you advise me how to schedule classes?"

"I'll be your first-year instructor. Here's what I suggest you do. Begin the three-year program in the fall of '70. For the upcoming spring semester, take Practical Elements of Design, which will give you a heads-up for the first year. Take Mrs. Antek's Sketching and Michael Greer's History of Antiques."

Mr. Greer always wore a cashmere tan jacket with tweed trousers. He played with his silk bowtie as he spoke about antiques. When a concerned student asked Mr. Greer about antiques while showing Hepplewhite chairs on the screen, he said, "Don't worry about antiques, darling—just don't lean back." That humorous clip stayed with me. I've quoted it many times.

When I got home, I was about to call Gigi with my news when the phone rang. "Gail, I have good news."

"Me too. You first."

"Graciano (Gigi's husband) purchased a lot on Blueberry Drive in Woodcliff Lake and hired an architect. Will you work with us?"

"Of course, you know I will." I tingled all over. "The professional degree program at NYSID accepted my application for the fall of '70."

"There was no doubt you would get in. It's what we both wished for. Congratulations. I'm happy for us."

"Thanks. I can't wait to meet your architect."

"We're meeting with him soon. But first, we'd like to look at pictures for house designs with you. Can we get together on-site?"

"When is good for you?" I asked.

"You tell me. Your schedule must be full."

"An early evening, around six, when it's still light?" I asked.

The advice from design school lecturers was clear: collaborate with an architect and client to create optimal designs. I had already asked Bob Murray if he would work with us. He gave me a yes.

"Sounds good," Gigi said.

I never minimized the importance of planning a residence. It's more than mere matters of taste. The emphasis needs to be on prioritizing space planning and function before delving into aesthetics. The space must work for the client's lifestyle and needs. It's essen-

tial to see the site's topography and how the house will be situated.

Gigi and I sat at my drafting table in my family room. The kids were out with friends. The windows were ground level but permitted sunlight to enliven the room, with its black-and-white tile floor, wood dado, and well-used fireplace.

We unrolled the architect's basic plan and designed each room. Placing the beds in the three bedrooms, considering optimal window placement, noting sunlight exposure, and ensuring beds were not against window walls.

My instructor, Mr. Murray, also contributed his expertise to Gigi's project. We convened after class and worked at my drafting table at the school. Earlier, I gathered information from the architect, known for his contemporary designs and expertise in architectural history.

"Here are the architect's final plans," I announced, unrolling the drawings onto my drafting table in my classroom, light pouring into the space from the tall windows, with Bob Murray looking over my shoulder. Collaborating with professionals was a valuable experience that enriched my knowledge base.

Eager for his insights, I held my breath as my instructor rubbed his chin, examining the plans,

sections, and elevations. "What do you think of the exterior?" I asked.

He smiled and said, "Do you recognize the roofline? The French architecture lecture was a couple of weeks ago." His deep voice resonated loud enough for anyone passing to hear.

My eyes widened. "It's sort of out of context, but now that you mention it, yes," I said, hoping not to come across as ignorant. "We're talking about a Mansard roof here, a hip roof, right?" I asked, seeking confirmation.

"You're correct. The roofline is a unique design element. Did you know you have extra attic space with that roof? And extra light by the window placements," Bob said.

"I had no idea, and the architect didn't mention the extra space. Gigi would love that space in her sewing room. She's a talented seamstress."

Mr. Murray surveyed the plans while I peered over his shoulder. I had much to learn about reading architectural plans, but I knew the right questions to ask. As I learned to draft and draw up my plans for designing the space, I couldn't help but appreciate how essential my instructor was at this early stage of my training. Working alongside Mr. Murray, an experienced interior designer, was a blessing—he was the best.

As we delved into planning the master bedroom, my

instructor's gratis advice and dedication warmed my heart. Gigi's willingness to allow me to learn to work with the experts designing and building a new house was invaluable.

It was the perfect time to explore the Decoration & Design (D&D) building. I went to see Gigi and asked if she wanted to join me to become familiar with what the design and decorating showrooms have to offer. It was open to design professionals. Welcome to my new world, Gigi.

"Yes, that sounds good, let's make a date, but I have more big news, Gail. Graciano purchased a New York apartment on East Fifty-Third and Third."

My jaw dropped. "That's wonderful. We'll need a place to hang out."

"And you'll have more work," Gigi said.

I wrapped my arms around my friend. "Thank you for the opportunities."

FOR OUR HOME, I sold all my tasteless furnishings. I learned what an interior designer must do to create a functional and aesthetic interior. Capitalizing on the market, I profited from those uninformed prior choices

of furnishings and reinvested the money into new, well-designed purchases. Refined interior design is aesthetic, functional, and practical.

I saved the profit from selling everything I bought from that furniture store, including the drapery tie-backs, keeping only the sheer white under curtains. I used the money to redesign our house, transforming the great room with a sleek stainless-steel surround fireplace for a modern touch. I updated the seating, complemented by a glass and steel coffee table, and designed a built-in olive ash burl-wood cabinet in the dining room to store our serving pieces. A fifty-four-inch square lucite table on a pedestal created an illusion of a spacious room. The interior had iconic pieces like Barcelona chairs, Eames furnishings, and Bauhaus elements. An antique oak pedestal kitchen table added a touch of tradition amidst the contemporary designs. The walls showcased artwork from artists like Nesbit, Greco, and Warhol, and Currier and Ives prints, creating a vibrant and eclectic ambiance.

Bob grimaced and asked, "Are you sure about this?"

"You bet. It's a mix of the nineteenth and twentieth centuries. Do you like it?"

"If you say so," Bob said.

I reminisced about when I had no design knowledge and wasn't about to explain it to Bob, who was uninterested in design trivia.

I called Gigi, inviting her to come over and see the new look. "Oh, my goodness, Gail. Your new designs are a before-and-after miracle, but I didn't know what it could be. It's beautiful. I'm happy for you, and me, too," Gigi said, expressing her delight. She put her arm around my shoulders, adding, "I'm proud of you. More than ever, I'm enjoying working with you."

"Thanks. I'm on a career path," I said, feeling a sense of accomplishment and newfound confidence.

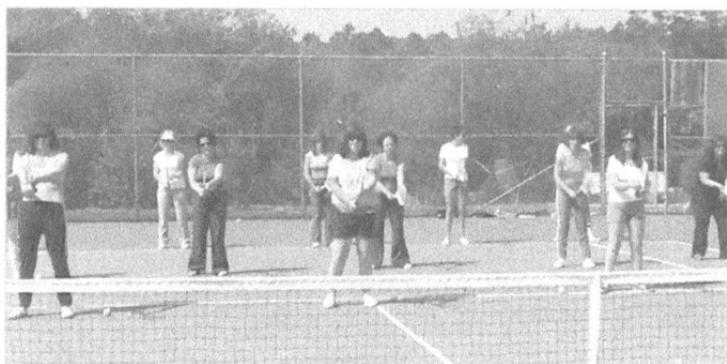

Gail teaching tennis;
Gail and Tom (30 Love);
USPTA 75th Anniversary commissioned a watercolor painting by Gail
Ingis (featuring top tennis players)

Chapter Twenty-four
Tennis Anyone? ~ 1969

A t the start of the three-year program at NYSID in the fall, as each of the sixty-five students introduced themselves, one gal said, "I'm Jane from Rivervale, New Jersey."

I raised my hand and said, "Hey Jane, I'm from Woodcliff Lake. Would you like to drive in together?" Our camaraderie blossomed amid the notorious FDR traffic, a symbol of our shared experiences and the challenges we overcame, where we exchanged ambitions, life, and dreams. Little did I know this simple offer would lead to a lifelong friendship, a bond that would shape my journey in ways I never imagined.

I shared the beginning of my venture into interior design—with school and travel buddy, Jane, who said that if I would like to learn tennis, she would teach me.

She ignited a passion in me when I began taking lessons from her the summer of '70. This unexpected connection between my two passions, tennis and design, would shape my professional path in ways I never imagined. Meanwhile, Jane was also pursuing her United States Professional Tennis Association (USPTA) certification for teaching tennis.

She aced her tennis certification and continued to be my summer coach. Under her tutelage, I navigated the nuances of proper strokes, mastering the mysterious art of serving, which initially felt like a dance move gone wrong. After overcoming the head-rubbing-stomach-patting confusion, I found my rhythm.

With my newfound skills, I joined a local tennis club. This decision not only allowed me to play spirited doubles matches with fellow enthusiasts but also had a significant impact on my personal and professional life. Bursting with pride, I couldn't wait to showcase my progress to Bob. We went to Wood Dale Park to mark where I first met Gigi.

Excitement filled the air as I rallied with Bob. His return shot swerved away, leaving me determined to refine my game further. Curiosity burning, I asked Bob about the mysterious swerve of the tennis ball. With a chuckle, he confessed, "Honestly, I just hit it like I do in ping-pong. My friends like the challenge, even though they can't quite beat me. It's become a thing."

Eager to unravel the enigma, I turned to Jane for insights. She revealed the secret—Bob was adding spin by flicking his wrist, making it a tricky feat for amateurs to return. His unconventional technique baffled his friends and made him a local champion, a revelation that explained why my attempts to dethrone him were in vain. In tennis, I had to accept my amateur status, realizing that defeating Bob was a feat reserved for more seasoned players. My tennis dreams of triumphing over the spin master remained a dream.

Years of dedicated serving practice tore my right rotator cuff. Dr. Alan Reznik, the unsung hero, armed me with two pins and mended my shoulder, but he suggested I bid farewell to the days of overhead serving.

In a twist of fate, Jane's tennis teachings became my newfound strength. Little did I know the changes that were coming. Gigi, the ever-generous friend, sent me Odette, a Portuguese marvel who doubled as a cook and housekeeper. My hopes soared, and I imagined having enough time to assist Gigi and indulge in tennis coaching when our hands weren't busy transforming her home.

However, a culinary curveball emerged—my kids weren't fans of Portuguese cooking. Yet, a silver lining surfaced: my boys learned to cook. Now, they share cooking duties with their wives. This unexpected turn of events only strengthened my resolve and taught me

the power of adaptability in the face of challenges. It's these moments of resilience that truly define us.

It was my cherished goal to arrive home before my kids, but in the hustle of daily life, the FDR traffic often turned a thirty-minute journey into a two-hour odyssey. Bob, who worked late, left us with fatherless meals. Amid homework sessions in our family room, shadows danced on the pine wainscot as the day's last light filtered through ground-level windows. Chilly nights saw us gathered around the fireplace, toasting marshmallows over its roaring flames—a haven amid the chaos. These moments, filled with warmth and laughter, are etched in my memory as some of the most precious times of my life

Balancing my school studies with family time became a juggling act. Working on intricate drawings, plans, elevations, and models demanded relentless focus. Never did I anticipate the rigorous demands of becoming a certified interior designer. During my early years in design school, I joined professional societies as a student in the National Society of Interior Designers and AID (later ASID). My fellow designers voted me in to serve on the New Jersey Chapter board of directors. Subsequently, I developed programs for students and developed review courses for my fellow designers for the National Council for Interior Design Qualification (NCIDQ) boards. I kept the ball rolling in that court,

pleased to help grow our profession. I attended meetings and traveled to our yearly seminars in various cities across America while supporting industry foundation members who let the world know ASID professional members go through impeccable training. We worked in hospitals, hospices, schools, offices, and residences. After graduating from design school in '73, I continued working in design, although my love for tennis intensified. Frequently traveling with Bob was an opportunity to rub shoulders with the tennis elite. I got pointers from the legendary Dave Applebaum at the posh Beverly Hills Hotel, picked up tips from Pancho Segura (yep, Jimmy Connor's coach) at La Costa Spa, and even had a hitting good time with the great Althea Gibson at a tennis club in New Jersey. Althea became my mentor for three years, guiding me through the ins and outs of the game. And let me tell you, when Althea hit the ball, she hit hard—even accidentally tagging me in the face once. Ouch! But there was no lasting damage; it was just a reminder to always to keep your eye on the ball, especially when Althea's ball was on its way.

In 1977, I tackled the formidable NCIDQ exam—the gateway to interior design licensing. This comprehensive test delved into building systems, codes, construction standards, contract administration, design application, professional practice, and the history of

interiors and architecture. Armed with a packed lunch, drinks for hydration, and a stomach full of butterflies, I embarked on this nerve-wracking journey held in a New York City school.

The scene felt eerily reminiscent of past school exams, with two stern exam proctors overseeing the process. The familiar refrain echoed: "Don't touch the paper until the proctor says, 'Go.'" They scheduled bathroom breaks, and the no-eating policy persisted until the hallowed lunch break. The self-imposed torture left me wondering why I subjected myself to this.

Once the ordeal concluded, exhaustion set in. I emerged victorious on my first attempt at the exam. Gratitude to the heavens!

Amid the whirlwind of interior design projects, I found an oasis of tranquility on the tennis court. And as I indulged my passion for the game, my thoughts often drifted to my role as a parent. Despite my fervent participation in the tennis activities at the Englewood Tennis Academy back in '73, my children showed no signs of disappointment or concern over my occasional absences. But as life marched on, the tug-of-war between personal pursuits and parenthood became ever more apparent. There's a wealth of joy I missed. Perhaps Linda would have stayed in college had I been there to cheer her on. Then again, I provided her an

example of the possibilities that come with an education. I'm grateful for my education at NYSID because it taught me that anything was possible. I am ever the eager student—enrolling in workshops on art and design, building, writing, tennis, even voice, guitar, piano, and more. I'm always clamoring after knowledge.

Teaching tennis became more than a profession—tennis paved the way for an unexpected turn in my career. Under the expert guidance of the USPTA teaching pro at the Bogota Racquet Club in 1977, he suggested I pursue certification, offering to sponsor my journey. With confidence in my teaching abilities, I embraced the challenge of a two-day exam, spanning written and on-court assessments. The written segment delved into business aspects of programming, sports science, and tennis operations, while the stroke exam tested my knowledge on the court. I demonstrated teaching private and group lessons, showcasing proficiency in the five elements of stroke production—forehand, backhand, volley, serve, and overhead. With determination, I passed my two-day tennis on-court and written exam and received my teaching certification.

While immersed in my role as an interior designer, my love for tennis intertwined with my professional endeavors. I undertook projects to update the lobbies of

a couple of local tennis clubs and design a shop show-casing tennis clothes and accessories.

Diving deeper into tennis, I purchased a machine for my son Paul to string tennis racquets. As the strings hummed with precision, I learned the skill myself—after all, why not? The marriage of my professional flair and tennis passion created a dynamic synergy.

Transitioning to teaching interior design may seem like an odd turn, but my career trajectory has always been a series of purposeful steps. Here's where the plot twist comes—from coaching tennis to teaching interior design. I know it sounds like a lob gone wrong, but life serves up surprises. The switch happened when the head of the New Jersey ASID caught wind of my tennis teaching credentials. The next thing I knew, Dean Kettler at Kean College was ushering me into the world of design education and introducing me to my first class of students.

I couldn't help but smile at the dean's introduction and announced, "If all else fails, I can always teach you a forehand." The students chuckled, and we set sail on this unexpected adventure lightheartedly. Teaching interior design at Kean College became a fulfilling opportunity to share my knowledge and passion for eager minds.

Building on this unexpected beginning, I expanded my role by creating a specialized review course for

designers aiming for professional affiliation with ASID. This unique course played a pivotal role within NCIDQ, providing comprehensive insights and preparation for those navigating the demanding standards of professional interior design.

NYSID-New York School of Interior Design

ASID-American Society of Interior Designers

NCIDQ-National Council for Interior Design Qualification

USPTA-United States Professional Tennis Association

Baked dreams
(courtesy CANVA)

Chapter Twenty-Five
The Bakery ~ 1974

The shocking news from Bob's office arrived. Bob, the company's CFO, discovered the president had double-billed the company. I supported Bob's decision to present the theft to the board. The board's reaction disheartened both of us. They threw Bob out. It was all over the Wall Street Journal, front-page news. A scandal reverberated around Bob, who, as comptroller, had to report any dishonesty within the ranks.

I told Bob not to worry. I'd get a job in the interim.

A week later, darkness clung to the world as I jumped from my bed, blanket in tow, the clock glaring four thirty a.m. in defiant silence. My husband, wrapped in sleep's grasp, grumbled at my disturbance. "A man's trying to get some sleep here."

I shrugged and looked at my jobless husband.

"Sorry. It's my first day, first shift at Walter's."

"Almost forgot," Bob mumbled.

The birch tree outside our window provided privacy, shielding us from the prying eyes of neighbors. The quiet street offered solace, devoid of the usual hum of passing cars. Clothes lay on the red armchair, arranged for the day ahead. The summer-scented breeze wafted through the open window of our master bedroom on the second floor. I dressed, leaving my pajamas on the chair, and slipped into white bell-bottom jeans and a bolero shirt. Socks and sneakers completed my outfit. My husband, still facing away, muttered his farewell.

"See you later, honey. Good luck job hunting today."

"Thanks," he said, pulling the blanket over his head.

I navigated past the bedrooms of our sleeping children. Paul, now eleven, peeked out, his brother Rick and sister Linda lost in their dreams. "Good luck, Mom," Paul whispered, wrapping me in a hug.

"Thanks, go back to sleep. I'll see you later," I whispered and hugged Paul back. He was a sweet kid.

On Chestnut Ridge Road, in Montvale, NJ, cruising in my car, eager to get to this new adventure, my stomach felt upside down as I ventured into this unfamiliar working world. My radio blared, and my fingers tapped my steering wheel as I sang to John Denver's

"Take Me Home, Country Road," his most popular album. I could listen to him all day. His voice warmed my soul, settling me down.

I parked my blue four-door BMW and floated on the baked bread aroma into Walter's Bakery.

"Good morning, Gail," Emma, the owner's wife, said, grinning behind the showcases filled with morning pastries and fresh bread.

"Good morning."

"Look at you, skinny in your white pants and shirt. Enjoy it while it lasts. You won't look like that when you leave here. Your uniform and apron are in the back."

I walked into the bakery's rear—the aroma fastened to my senses, my mouth watering. I donned the white apron and placed a hairnet on my head, completing my transformation. Skills honed in my parent's store as a teenager served me well: taking money, giving change, meeting people, and assisting customers in choosing the renowned buttercream cakes gracing the shelves of Walter's Bakery.

Little did I know the new job Bob secured would destroy our marriage.

Dances with Wolves by Gail Ingis

Chapter Twenty-six
Open Marriage & the End ~ 1975

W hile Bob kept his work to himself, I focused on my vibrant world—design projects, tennis, chic clothes, and shopping. Places like Hartley's of Westwood and A&S were my go-to spots. In '75, with no Nordstrom or Bloomingdales, I found high-class fashions in local boutiques.

Despite the joy my kids brought, Bob's frequent absence left a void. I threw him a surprise fortieth birthday bash nine months before mine. The Saturday before his big day was the perfect occasion, adding spice to the chilly February days with a shindig that illuminated the dark half-moon nights.

I whipped up a killer centerpiece: a rigatoni pasta platter decked with delicate fresh mozzarella that oozed

creamy perfection. I topped it off with a Parmesan breadcrumb crunch.

But, oh no, I didn't stop there. I got all fancy with eggplant parmesan and lasagna, layering them with my meat sauce, ricotta, and mozzarella and baking them in my new oven. When it was showtime, I strutted to the table with a fancy bowl filled with a vodka sauce that simmered for hours. A steamy, tempting aroma wafted through the air as I placed the bowl on the table. And, of course, meatballs on the side completed the feast.

The spread for my guy, surrounded by his crew of friends and family, brought me pure joy. We decked out our fifty-four-inch dining room table with salads, sauces, and a mix of mouthwatering entrees, all laid out on vibrant tablecloths with lively geometric patterns.

To cap off the celebration, I ordered a double-layered birthday sheet cake from Walter's Bakery, which added the perfect sweet note to the festive occasion.

The morose expression on Bob's face upon coming into the house shocked me.

"What's going on here?" he asked, bewildered, his voice echoing for everyone to hear. But then a grin spread across his face as all shouted, "Happy birthday!"

Bob's reaction after the party was a stark contrast to the joyous celebration. He spoke to me accusingly once the party dust settled and our guests departed. "Thanks,

I guess, but I didn't need a party. What am I supposed to do with all these gifts?" His words hit me like a punch to the face, stinging and crushing. At that moment, I couldn't stand him. His words hurt too much.

IRONICALLY, I had just finished responding to Mom's letter from Florida, where she hinted at Bob's infidelity. I dismissed the accusation with a gasp, treating it like dust on my piano. His work often kept him in the office, and when he came home, there was no trace of perfume or lipstick on his collar. I couldn't fathom where such notions could come from—indeed, there would be evidence if he had another woman. The very thought was unfathomable to me.

The garage door rumbled open, shattering the silence. My husband was home.

The pen slipped from my fingers, the half-written letter forgotten. Nothing took precedence over welcoming the father of my children, the man I pledged to love forever, the one who shared my bed. His coming home brought a sense of security and reassurance, grounding me in our home's sanctuary. Even though he

had limited time with the children, I did not harbor any resentment.

Bob entered through the garage's side door, letting his briefcase thud to the floor in the laundry room. He stepped into the kitchen, and in anticipation, I rose from the white, fiberglass swivel chair. The pen tumbled to the floor as I pushed the half-written letter away from the edge of the oak Stickley pedestal table. I longed for his attention, for a moment of connection in our shared space.

He brushed past me, removing his tie—no hello kiss, no eye contact, no touch—and pulled his Camels from his jacket pocket. With one in his mouth, he took a long drag while leaning against the small Formica counter next to the latest GE four-burner slide-in. He took another drag, blew it out, and took the cigarette from his mouth.

"Listen," he demanded, putting his cigarette in the ashtray I had given him a few minutes before. Bob spoke in a low voice, a tone I had never heard. I knew he had something to say I wouldn't want to hear. His eyes were dark and wide, and his lips turned down. My heart beat in my ears, and my dry mouth made me queasy.

I took his plate of food from the oven and placed it on the table. I had turned the oven off hours ago. I

wanted to push it into his face to obliterate his expression, which filled me with dread.

He removed his jacket and dropped it onto one of the kitchen chairs. I sat down across from him.

"Your dinner got cold." My voice was flat. It had been a long day. I was tired and wanted it to end. It was annoying when Bob came home late and smelled of his beloved cigarettes. How come I never noticed before?

"I was busy," Bob said.

Yeah, right. He was always busy.

He dragged on his cigarette again. "You could've called my secretary and asked her if I would be late. She would have told you."

"Now it's my fault you're late?"

My feet rooted to the spot beneath the chair on the ceramic tile floor. My ears burned, and I wiped tears from my eyes. Showing weakness to my husband made me uncomfortable. At least I could try to handle what he was about to say, couldn't I? Pulling myself together, I pushed my shoulders back, wiped the tears, and took a slow breath before speaking again. There was no hurry to hear what I believed would be bad news. His dull eyes, turned-down mouth, and gruff voice gave him away.

"I'm listening," I said, crossing my arms over my chest, mirroring Bob's stance. He took another long drag of his Camel and blew a puff of smoke from the

corner of his mouth. I coughed, watching the smoke dissipate around the ceiling light fixture. Oh God, he was so disgusting. At least he considered my smoke allergy.

Bob took another drag. "I feel trapped."

My thoughts scrambled, not understanding what he was saying. "What do you mean, trapped?"

"I want to be free," Bob declared, his words echoing in the kitchen. I couldn't believe what I was hearing. How could he want to be free from our life, our family, our love?

"Have I stopped you from anything?" I swallowed and almost choked on my saliva. "Tennis? Is it splitting us up? Is it me? What's the real problem?"

"You can play your tennis—that's your outlet. I want to be free to date, do other things, and not be home-bound. I'm sorry, but that's the truth. I still love you."

"Love? Did you ever love me?" I reached out to touch him and bit my lip.

He took my hand.

"I'm sorry," he said.

My world collapsed as he let my hand drop.

"Tell me what you mean. How can you still love me and say you want to be free? I don't understand that kind of love. Do you want a divorce?"

"No, I don't want a divorce. I want to be happy—I want joy in my life."

My husband startled me with his following pronouncement. "I want an open marriage."

Stunned, I compressed my lips. "An open marriage?" He might as well have punched me in the stomach. The waistband on my black slacks constricted, and I gasped for breath. In haste, I unbuttoned the top and sighed. Tears welled up and ran down my cheeks like an implanted water faucet running behind my eyes. No matter how much I brushed the tears away, they kept coming. The faucet wouldn't turn off.

"You're being ridiculous. Stop crying. You understand what that means, right?"

I stared at him through the blur of tears and raised my brow. "Swinging? Is that what you're suggesting?" I asked, sobbing.

"Having relationships outside your marriage. You can get a boyfriend."

He said it like a boyfriend was a candy bar.

My God, this man was crazy. "I don't want a boyfriend," I said.

The thought of intimate involvement with a stranger sent chills down my spine, making it difficult to catch my breath. If only I could turn back time by ten minutes to halt the clock before those five words shattered the life I knew.

Bob's request for an open marriage overshadowed the memory of that day. If I had sensed his thoughts, I

could have greeted him with a loving hug, expressing, "I love you so much. I'm lucky to be your wife." Although it wasn't the usual greeting, it might have changed his mind. It all felt like a dream, except for the stark reality of his request.

My throat constricted, my eyes swollen from tears, and I thought, how would Bob break the news to the kids?

I held on to hope that our three children would be okay. Linda, at nineteen, had completed a year of college and was in a committed relationship.

Rick, at seventeen, was going through a challenging phase and veering off course. While his father's intervention might have been beneficial, that wasn't Bob's approach. I recall a bitter winter day when Rick asked his father for a ride to a friend's house. Bob refused, insisting he ride his motorcycle as usual. Despite my plea to intervene, Bob remained resolute, denying us the chance to give Rick a ride. I can't forget watching Rick bundle himself in dish towels and scarves, trying to ward off the cold. It was a heartbreaking scene.

I couldn't grasp what Bob was trying to prove. After ignoring Rick, he became involved in this attempt to teach him a lesson. When I inquired about his reason, he remained silent, never answering.

Paul, at thirteen, would struggle to cope with this

situation as a kid whose world centered on Legos, his bike, and his admiration for his father.

The prospect of an open marriage raised unsettling questions about its impact on the family, me, and us. It seemed like a facade with a concealed darkness. Ironically, an open marriage isn't open at all—it's suffocating and demoralizing, and pushes relationships toward disintegration. If I consented, it would be tantamount to permitting his infidelity and relieving his conscience. I had no interest in such an arrangement. Bob, unwilling to endure the challenges and costs of a divorce, seemed more focused on enjoying freedom without the responsibilities of being a husband and father at the potential expense of our children, my life, and my career.

"How do you propose to work out this new arrangement?" The words *open* and *marriage* were oxymorons.

"I'll come home on Mondays, Wednesdays, and Fridays. Paul can visit my apartment in Queens every other weekend, and Rick is welcome, too, if he chooses."

Bob's words cut through my heart. "Have I failed somehow? Am I not the wife you expected?"

Was our home too small, too cold, too empty? We once believed it was the most enchanted place on earth —watching snowflakes gather in the trees, branches bending to the howling winds, the beauty of winter clouds scraping across the sky, listening to bird songs in

spring, enjoying tennis in our backyard with friends scrambling to play. Summers at the Old Mill held precious memories. Why couldn't he have shared his feelings sooner? I had heard of married couples seeking therapy. Was it too late for us?

Bob shook his head. "I'm not pointing a finger. It's about fresh air, freedom, and joy. I still want you. I love you." He stubbed out the butt of his cigarette. "You're my wife and the mother of my children. I don't want to lose that."

Bob doesn't want to lose that. Lose what? What does he mean? Sounds hokey to me. All those nights in the city, working late, wasn't he a family man?

"Why can't you try this? Maybe it'll work, and we'll both be happy."

"Happy? This isn't happy."

"I think you should try it."

Bob wanted permission to cheat on me. I placed my hand over my heart. It was hard to catch my breath. Another cigarette dangled from his lips, the tip blooming red as he sucked on his habit. Bob leaned his six-foot frame against the kitchen counter. He planted his arms across his chest, and his green gaze narrowed.

I didn't smile. How could I make it right? How could I make him hold me?

His mouth twisted as he removed his cigarette.

I lowered my head and placed my fingers against my

lips. "You're never home. What do you do all night? Where do you go?" My nails dug into my palms. I detested my trembling voice.

"Stop having a tantrum."

I longed for the man I thought I knew. Was he struggling to balance work and his personal life? Giving in to his request might be the only option. I'd never be enough for him. If this mystery woman hadn't caused him to make this request, he would find someone else.

I caved.

"I'm moving out today," he said. He took my heart and went to the bedroom to gather his belongings.

I got his attention while sitting in our red velvet armchair for two, wearing jeans and a T-shirt and folding his clothes. "Bob, can I ask you a question?"

He continued with his task. "What is it?" he asked, looking up at me.

I took a deep breath. "You did lots of traveling for your company. Whenever you traveled, did Barry in Atlantic City fix you up with hookers?"

"Yes," was all he said. I walked out, leaving him to his packing.

We lived in an open marriage for a month, but it became too painful, thinking about another woman in my husband's arms. I suggested Bob pursue a divorce. He went to the Dominican Republic, got a quick divorce, and then asked me for a Jewish divorce, a "Get,"

for his new partner, his Jewish mistress. It's distressing to recall and recount this experience, as she intruded into our marriage, slept with my husband, and then demanded I approve dissolving our marriage to validate hers within Jewish matrimonial laws She didn't align with my concept of a fine person, but who was I to stand in Bob's way if he no longer wanted to be with me or his family? If he desired to build a new life with this woman, why not let him have whatever he wanted? And in the end, that's exactly what he did—he created a new family with her.

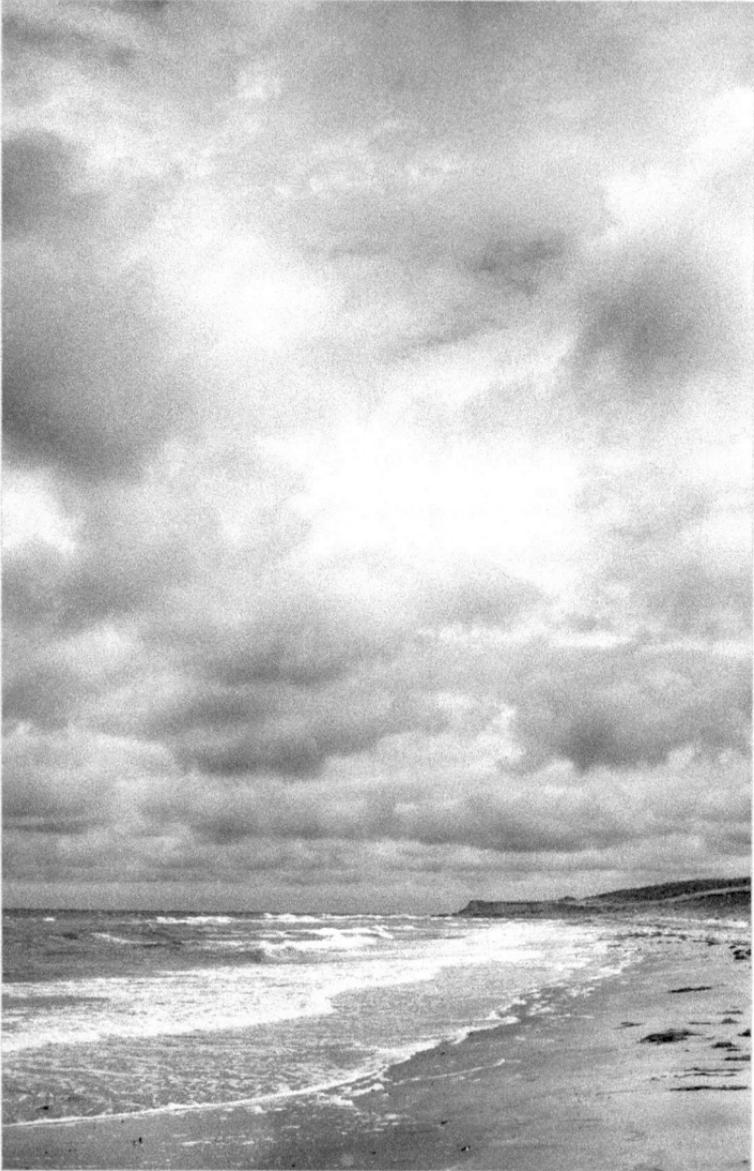

Coming Storm...

Chapter Twenty-seven
The Dark Cloud ~ 1976

Paul stood before the mirror and adjusted his suit jacket, buttoning the one button, unbuttoning, and buttoning again. Today marked his Bar Mitzvah, a day he had longed for and dreaded. I knew a mixture of excitement and apprehension churned within him, the latter gnawing at his stomach.

I saw him glance around the room, taking in the decorations and the meticulously arranged preparations, and I knew he couldn't shake the heaviness in his heart. His parents' strained relationship overshadowed what should have been a joyous occasion. He must have been longing for the days when we all laughed together and the tension was absent from our home.

Amid the sadness, a beacon of pride shone. Paul

understood the weight of this day, not just in the eyes of his family and community, but also in his journey toward adulthood. He knew the responsibilities of a Bar Mitzvah and embraced his heritage.

As the ceremony drew closer, Paul, enveloped in a cocoon of love—found his grandparents, aunts, uncles, and friends all offering encouragement and support. Their presence buoyed his spirits, reminding him he was not alone, even in uncertainty.

I took a deep breath, surveying the bustling activity in our home. It was a day of joy and celebration. But for me, there was a heavy weight of sorrow and uncertainty. I moved from room to room, overseeing the final preparations for the celebration. I couldn't shake the feeling of isolation that clung to me like a stubborn shadow. The strain in my marriage to Bob had reached a breaking point in recent months, casting a cloud over our family life. But I would not let our struggles overshadow Paul's special day. I poured my heart and soul into planning every detail of the Bar Mitzvah, wanting it to be a memorable occasion for Paul despite family challenges.

Amid the chaos, I found comfort in the preparation rituals—the careful arrangement of flowers, the setting of tables, the lighting of candles. Each task provided a temporary respite from the turmoil threatening to engulf me.

But as the hours passed, and the time drew nearer for the ceremony and celebration to begin, my facade of composure cracked. I felt the weight of duty pressing down on my shoulders, threatening to crush me beneath the burden. As I observed this poignant moment in the ritual between Paul and his father, my heart couldn't help but shatter into pieces. The juxtaposition of the celebratory occasion and the underlying tumult in our personal lives created a profound emotional dissonance, leaving an indelible mark on my soul. Despite the issues that Bob and I were navigating in our relationship, we had set aside our differences to celebrate this extraordinary day in Paul's life.

Stepping into the synagogue, the weight of the Torah scroll in Paul's arms must have been comforting and daunting. It symbolized the traditions he was about to uphold. But as Paul chanted the familiar words, I heard his nerves gave way to a sense of purpose.

He was here, standing on the threshold of adulthood, ready to embrace the journey ahead. The Bar Mitzvah marks a boy's transition to manhood at thirteen in Jewish tradition. During this ritual, the young man may read a section called the haftorah from the Five Books of Moses. Rick had experienced this cherished tradition four years prior—a fond memory still etched in our hearts.

Despite the tasks, Paul stood tall on the bimah,

accompanied by the cantor. His father stood beside him, supporting his son's crucial passage and honoring the sacred act of reading from the Torah.

Only when I saw Paul, resplendent in his suit, his face radiant with anticipation, did I find the strength to carry on. Paul's joy was a beacon of light in the darkness, reminding me of the preparations and purpose.

As I sat in the congregation watching Paul, hearing him confidently chant the ancient words of the Torah, I felt a swell of pride and admiration. Despite his challenges, Paul had risen to the occasion with courage.

As the ceremony closed, he made it through with grace and determination. Looking out at the smiling faces of his family and friends, he knew that no matter what the future held, he would always have this moment to carry with him—a moment of pride, strength, and hope for the days to come.

I watched Paul laughing with his friends and mingling with guests and family in our home, allowing myself to bask in his warmth and happiness, if only for a fleeting moment—and a glimmer of hope stirred within my heart. Perhaps, despite the darkness that threatened to consume us, there was still a chance for light to break through, for joy to triumph over sorrow, for love to conquer all. In that moment, I knew that despite the hardships Paul and his father faced, they

would always have each other to lean on, celebrate with, and find solace in the face of adversity.

I embraced Paul tightly, tears streaming down my cheeks. I whispered a silent prayer of gratitude—for this moment, for this day, for the precious gift of family that would carry us through even the darkest time.

Threads of Wisdom by Gail Ingis

Chapter Twenty-eight
Forgiveness ~ 1976

In the heart of bustling New York City, in the vibrant energy of a local bar, I engaged in conversation with a striking companion. Both of us exuded a sense of style, though our choice of beverages couldn't be more different—she with her martini and me with my rum and Diet Coke. As the evening unfolded, the city's pulse seemed to synchronize with our conversation, punctuated by the emergence of spring outside.

"Have you heard the latest news?" she asked.

I shook my head. "What news is that?"

She looked straight into my eyes. "The EST training."

I shrugged, admitting my ignorance. "I'm afraid I

don't have the foggiest. What is it exactly? Could you enlighten me? What's the premise?"

In this lively setting, my companion introduced me to the enigmatic world of EST training, a self-help phenomenon. It promises transformation through personal responsibility, aiming to help individuals understand and take control of their lives. Intrigued yet skeptical, I listened as she described weekends spent delving into life's mysteries, all under the guidance of a charismatic guru named Werner Erhard.

"I've been contemplating attending, so I've done some investigating. It's expensive, but it promises a retreat over two weekends. You are on your own for the hotel accommodations."

"Impossible!" I said. "I can scarcely afford a night's stay, let alone two weekends."

"It's centered on assuming responsibility for your life. We can sign up together and maybe share a room at the hotel?"

"Thanks, but no thanks."

Despite my limited acquaintance with the woman, the prospect of self-discovery intrigued me. The following day, I navigated the bustling streets of New York to sign up for the upcoming seminar. Little did I know that this decision would set in motion a journey of profound introspection and revelation.

On the seminar day, an army of 200 civilians stood

shoulder to shoulder, locked in the hotel's grand ball-room, staring at a lighted screen. Prisms of hypnotizing black-and-white designs danced over our heads. "Repeat after me," spouted the leader, his voice as sharp as his pleated navy trousers. I was in the middle of a sea of humanity, bound by a shared quest for under-standing and freedom from emotional pain. As the leader's voice echoed through the grand ballroom, I felt a sense of trepidation and exhilaration pulsating through my veins. The seminar was a surreal blend of chanting affirmations, baring souls, and confronting long-buried demons. Each participant's story added a layer of depth to the collective journey toward enlightenment.

We uniformly shouted, "We got it!" Magically, the exit doors swung open, releasing us. A man, his eyes clouded over, confessed to having intimacy with his mother.

Not believing what I heard, I gasped at the implica-tion of such a confession. My problems were insignifi-cant by comparison. How does anyone live with such behavior? Imagine the suffering and guilt.

Another, his knees buckling as he gripped the walls, bracing himself, said, "My brother took a murder rap for me. I must confess."

Yet, it wasn't until I emerged, blinking in the harsh light of reality, that the true impact of the EST training

sank in. It was a pivotal moment of realization—recognizing the power of personal responsibility and the profound effect it could have on shaping my destiny. Forgiving my mother might be a beginning. As I navigated the streets of New York once more, I couldn't help but feel a sense of liberation coursing through my veins. The training had been more than just a self-help seminar; it had been a catalyst for transformation—a journey of self-discovery that would forever alter the course of my life.

I flew to Florida to confront my mom and break free from the burdens of the past. Despite a brief exchange of words where she denied any unfair treatment, I felt a sense of relief. I forgave my mom, understanding her lack of patience then, and promptly took the first flight back home. Writing this memoir took my understanding deeper.

As for EST, it grew, and so did criticism. Some critics accused its leaders of mind control, as well as it might have been. Some labeled EST a cult, saying that it exploited its followers by recruiting. However, having gone through the seminars, I believe EST was part of my journey that led me to Jesus. It's important to acknowledge the criticisms, but it's also important to note that personal experiences can vary and that the impact of EST can be different for each individual.

Red Hot Blues by Gail Ingis

Chapter Twenty-nine
My Single Life ~ 1976-1992

H oping to shake off my blues, I cruised the Washington Bridge toward Michael's Pub on West Fifty-Fifth and Third in New York City's dazzling nightlife. Traffic slammed to a halt. Emergency vehicles, EMTs, and cops were everywhere. Misery clung tighter. Nowhere to escape. Tears streamed down my face. Maybe I'd join the person eyeing the bridge's edge, but how could I leave my kids? Their dad had already bailed on them. One longs for their mother in times like this. Where was mine? She'd said Bob was a cheater, and I didn't buy it.

Dad was no help, always fussing over Mom. "Don't worry, it all works out," he'd say, but not this time. My brother was predictably MIA—he'd probably tell me he warned me about going steady with that guy.

When I said no to Bob in Sunset Park, it was the beginning of the end. We were young, navigating the mixed messages about intimacy—yes, wait till marriage, no, don't wait. "Be a good girl." What did that mean?

How did a sheltered woman handle heartache? I was clueless about single life. Was it different for the once-married?

Decked out in black, from slacks to a long-sleeved blouse and blazer, it was in 1975 that I commemorated the death of my marriage. News of the day shouted that Egypt had reopened the Suez Canal. Summoning courage, I slipped into the pub to catch Woody Allen jazzing it up. Head down, hoping to blend in with other singles, I braved the bar crowd, contemplating a Diet Coke or maybe a rum and Coke. As I contemplated if I should drink on an empty stomach, a server led me to the bar. A handsome guy offered his stool, asking, "Would you like a drink?" I half-smiled, not wanting to send the wrong message. "Yes, a rum and Diet Coke, please," I replied. He ordered it for me, introducing himself as Willie. "And you?"

I grinned. "Gail."

"Nice to meet you, Gail. Have you heard Woody play before?"

"This is my first time." The place reeked of cigarettes and liquor. Willie grabbed my hand.

"Your hand is soft. You're beautiful."

Uh-oh. I slapped two dollars on the bar.

Willie raised an eyebrow. "This one's on me."

"I don't think so," I said, slipping off the stool. "Thanks. Nice meeting you, Willie." I squeezed through the crowd, exited, and hurried to my car parked on the street. Streetlights cast long shadows—the roads were quiet, except for some kids scattering as I passed. I should've stayed home and baked cookies.

Back home, I pulled into the garage, my headlights revealing someone smoking. Initially, all I saw was the red tip of Bob's cigarette. As my eyes adjusted, his white T-shirt and the phone he was talking on came into view. When he noticed me, he ended the call.

I didn't smile. "Bob?" I asked. "What are you doing here?"

"Picking up a few things. I'm leaving shortly."

He went back into the kitchen, hung up the wall phone, and went upstairs to pick up the rest of his clothes.

In the middle of this commotion, I got a call from Bob's roommate, Jay, who told me that Bob was never there. "He lives with his mistress. He stuck it to me like he's sticking it to you. Your husband is a rat."

I didn't need his verification.

Bob absconded from his responsibilities with his roommate and bolted from his wife and children. I

didn't know this man I married. Bob's twisted sense of responsibility confused me. Following our separation, he bought me a trip to Club Med, a well-known club for singles whose rampant reputation was loose. I didn't know what to expect or how to behave. I felt lost!

At Club Med, I accepted an invitation from a tennis player for mixed doubles. We won the tournament. I loved tennis no matter who, what, or where we played. But this place was worse than Michael's Pub—women in teeny tiny bikinis, the men in brief trunks. There were beaches for those who preferred no bathing suits. You couldn't go unless you joined the ranks unclothed.

Bob initially volunteered to watch our kids while I was away, but upon my return, he departed, leaving me solely responsible for the children. Bob told me he met a woman at his new job, but according to Paul, he had been seeing her for months before he got kicked out of his company. Bob left everything and everyone he knew to be with this no-name adulteress. She knew he was married and had children. What kind of woman would get involved with a married man with kids? She'd never been married, was getting on in years, and she wanted him to father her unborn. He obliged her. She was beautiful but poisonous, like the jack-o'-lantern mushroom.

Having grown weary of the dating scene and banal conversations, I immersed myself in work, tennis, and

attending to my design clients. I had married young, had the expected kids, and enjoyed the comforts of home. At forty-one, I had spent two decades alongside Bob, building a life filled with the clamor of children, a backyard boasting a tennis court, and the scent of chocolate chip cookies. Despite my efforts to make our house feel like home with his favorite dishes and cherry pie, something went awry. Weren't we happy with all we'd accomplished? my heart screamed, questioning why he didn't want me anymore. Life without him seemed unimaginable. But that choice was no longer mine. Did I still love him, or was he merely a convenience?

Painful pressure filled my chest, making it impossible to understand my genuine emotions amid misery and disappointment. Bob suggested family counseling, leading to biweekly sessions with a psychiatrist who prescribed medication. The medication, specifically Valium, alleviated my pain.

One day, post-session, Bob, Paul, and I grabbed lunch in Chinatown. After dropping me off in New Jersey, Bob took Paul to his new apartment, separate from Jay's. Paul mentioned his dad hadn't seen his mistress during their time together. He told me about the pain of his father's absence from his life and hinted at his father's infidelity. Further therapy sessions uncovered Paul's suppressed memories from eleven to four-

teen, highlighting the pain and disappointment of losing his father. I lost a husband, but Paul lost his father. He didn't have the time a father gives a son when they live in the same house. The weekends were unsuccessful visits. Paul was an early riser, and his father was a late sleeper. Paul said he rode the subway until he knew his father was up. Their relationship was never the same after Bob left home.

Valium's addictive potential wasn't the reason I quit taking it. The potent drug made me dizzy, rendering me useless on the tennis court—I couldn't play, walk, or react appropriately. I was a disaster. I cherished tennis too much to play dead, so I ditched the drug (praise God). Tennis brought me peace and pleasure, a brief escape. However, once the game ended, my misery returned. Battling depression became my focus. Despite months of therapy and changing therapists multiple times, my battle with depression persisted, leaving me searching for a solution.

During the two years we were in therapy, the men I met—from all professions, the trades, tennis, sports, married or not—wanted reinforcement of their masculinity. During one blind date, I met a man from my town. I knew his wife. I refused the evening's entertainment and went on my way. They were all searching for intimacy, a change outside their marriage beds, where complaints varied from variation to boredom.

After a few brief encounters, I felt tired and empty. Avoiding intimacy worked the best for me. Yet, the invitations kept coming to accompany men to shows, the theatre, dances, and anywhere requiring a fashionable, handsome woman. Men wooed, wined, and dined me. We'd eat and talk. I'd end it with a thank-you and good night and never see them again.

I once modeled for a magazine with a professional photographer I respected. (I had lost weight and found my figure again.) Swingers crossed my path as well. I had a good friend who lived around the corner. She trapped me into babysitting for her so she could be with her lover. She admitted that later. "How could you ask me to be part of your indiscretion and not give me a choice?" I asked her. I cut her off, ending a wonderful friendship. I felt defeated and brokenhearted. I could only imagine how her husband took the news.

I came to realize that returning to school while my children were still young was a grave misstep. With Bob and I juggling work, academics, and tennis, we needed more stability and the presence our kids deserved. Mom warned me about the pitfalls, drawing from her experience as a parent. She was right. She had been absent after they opened the store and knew it wasn't a good idea.

I delved into my interior design career, but amid my pursuits, I failed to recognize the depth of my

youngest's distress. As I mentioned before, Paul confided in me after therapy one day, revealing the extent of his sorrow. My heart hurt. "My deepest apologies, Paul," I said to him. I can't believe I never knew he felt so sad, and I didn't understand how I added to the complexity of parental loss. My tears were in earnest— mourning the anguish I inadvertently inflicted upon my dear son.

I hesitated to burden my mother-in-law with the unraveling of our marriage, knowing she had already lost her husband from a heart attack and lacked his support. Yet, despite my efforts to suppress my emotions, my throat constricted, my face grew numb, and tears welled up in my eyes as I told her about the fruitless sessions with the inadequate therapist Bob had chosen. A desperate moment led me to seek solace from Jewish Family Services, where I found Bonnie, a compassionate and insightful therapist. Through her guidance, I rediscovered myself and cultivated the strength to move forward. Together, we delved into the reasons behind the dissolution of my marriage, allowing me to ultimately free myself from Bob and our union.

We can never reclaim those lost years. However, my children have assured me of their forgiveness. I can't rewrite the past. I can only hope I am a better mother and grandmother now.

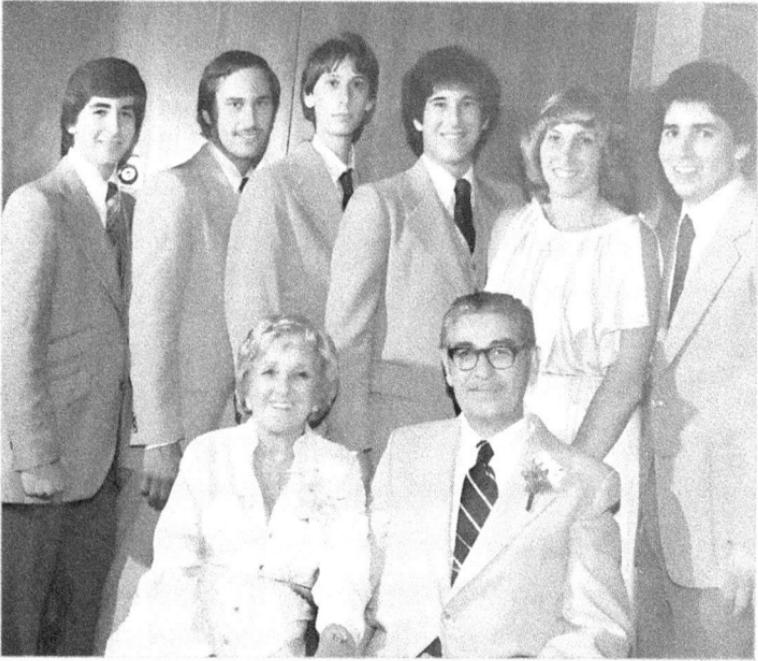

(back row from left to right)
Jeffry Gerber (Jay & Barbara's son)
Rick & Paul (Gail & Bob's sons)
Michael (fiancé) to Linda (Gail & Bob's daughter)
Steven Gerber (Jay & Barbara's other son)
Grandmother (Claire) & Grandfather (Bernie)

Chapter Thirty
The Other Woman ~ 1978

Our daughter Linda got engaged to the man she'd been living with. As I said, Bob and I didn't know how to advise her when she asked us for an opinion on moving in with Michael. Society was much looser than when I was Linda's age. Was it right to be intimate with someone you might marry? Michael Sklar seemed to be a good man. If we said no, she'd go her own way. We gave her our consent. Unfortunately, I didn't know what God would say then.

Friends and family filled the house on the day of Linda and Michael's engagement to join this celebration.

My best friend Andy and I strolled into my kitchen, where Bob was—with her.

"Hi, Andy. Meet my wife," my ex-husband said to my friend, who greeted her with a kiss on her cheek.

I gasped, shook my head, turned, and left the room. Andy followed me into the front hall and grabbed my hand. "What's wrong? Why are you upset?"

"You call yourself my friend? No way. My friend wouldn't kiss my enemy."

"You know me, Gail. I was just being myself. I hold no grudges."

Andy, the man I thought I knew, who was thoughtful and genuinely generous, a deacon in our church and a giver to the poor, couldn't possibly be my friend kissing that, that, that ... "How could you be okay with my ex-husband's marriage breaker? She ripped us apart."

To hell with Andy. I hoped no one noticed my sour, burning face. "You are not my friend." My stomach churned, just short of throwing up.

"This isn't a good time to talk, Gail. Come to our house tomorrow night."

"Okay, okay," I kept my voice down, not wanting my guests to notice my clenched fists and heavy breathing. What possessed me to agree? What would we accomplish? Who was this man who crushed me? He was a traitor. I wanted to run in the opposite direction, but this was to be a happy day. It was my daughter's time to shine.

I felt stabbed in the back by a friend. My ex and his mistress disappeared. I had no clue where Bob had taken his new catch or if he stuck around. I didn't lay eyes on them for the rest of the night.

I figured Linda wanted to make her dad happy, so I told Bob on the phone he could bring his woman, unaware her status had migrated to his current wife. How did that happen so quickly after our divorce?

I could feel him smiling through the phone wires. "Really? That's nice. You know, the two of you could be friends," he said.

I can't recall my exact words, but that was a joke. We'd be friends when hell froze over. His words just deepened the pain of his rejection. My blouse sleeve came in handy to wipe my tears. What did she have that I didn't? Did Bob and I have problems? Why didn't he talk to me? I had thought our marriage was solid. Linda revealed that the woman her father married had never been married before. She also mentioned that he appreciated her good-paying job. When did Bob's mistress become his wife?

Why was I kept in the dark?

I realized that inviting her father and his mistress was a mistake. With his paramour by his side, he displayed his unfaithfulness, casting a shadow over the joyful occasion.

Despite this, Linda and Michael's party brought me

a heart filled with gladness, a missing piece since the day Bob asked for an open marriage. The walls bulged with the 125 invited friends, family, and neighbors milling about, eating and drinking, unaware of the tragedy in my life.

Linda's childhood friend, Grace, stood before the bronze-colored wall where a Siqueiros painting hung, a favorite of mine.

"Hi, Grace." We hugged.

"This is some bash. Did you do all the cooking? It smells good in here. Your lasagna?"

"I did my usual. Can I get you a plate?"

"No worries, I'll get it. You're busy."

Once, believing Grace was a negative influence, perhaps because of my assumption of her smoking, I insisted Linda avoid her company. Linda, respecting my wishes, befriended "Barbara," but she never introduced her to me. Little did I know, "Barbara" was Grace in disguise. Later, we all laughed about my misguided perception.

We celebrated the engagement of Linda and Michael, two young people I loved. Despite the crisp December Sunday, smokers gathered outside on the tennis court. Poking my head out, I offered racquets and balls to anyone interested. My neighbors, John and his wife Jean, sporting warm-up suits, declined with a chuckle. Instead, they joined the warmth of the house,

settling by the roaring fire on the raised hearth. "Brr. It's cold out there. Will I ever feel warm again?" Jean said, still shivering.

The group from my book club sat on the cocoa-colored velvet sofa, drinks in hand.

"Let's toast to the engaged couple." The air filled with the evocative fragrance of glasses filled with wine. "May the young couple have a life filled with joy, happiness, and a long life."

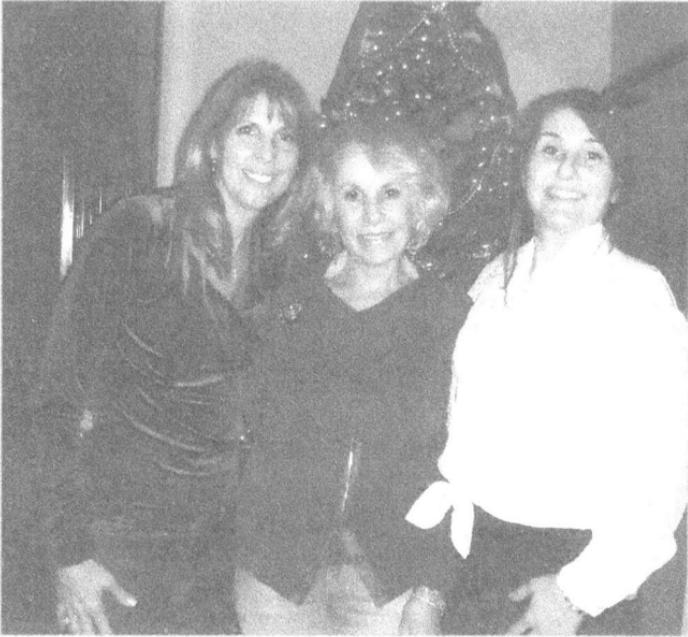

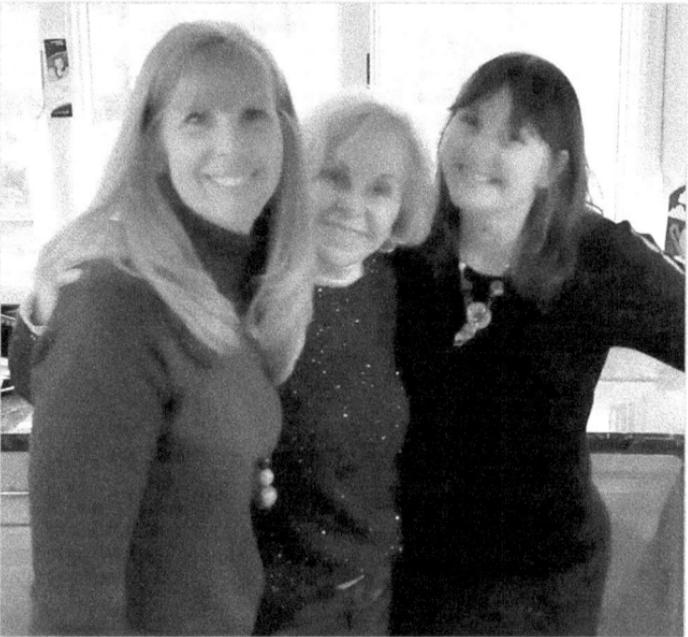

Gail and her lovely daughters-in-law
Tammy (Rick's wife) & Joanne (Paul's wife)

Chapter Thirty-one
A New Beginning ~ December 4, 1978

It was early evening—darkness draped the earth like a cozy blanket. Dressed in my casual pair of faded jeans, and a cashmere gray Bogner turtleneck, I walked up the Stewarts' driveway to the side door, the last dried leaves crackled underfoot. Their shingled house, nestled among others, had windows shuttered for charm. Tall trees, now bare, offered shade in the summer's heat.

I entered the always-open door, announcing myself in the dimly lit surroundings. This visit seemed like another dead end. What could Andy say to lift my spirits?

As we settled in the family room, Andy in his recliner and me on the sofa, there was a sense of comfort in his presence. The room was not grand, but it

was a sanctuary filled with the familiar chaos of family life. Andy's smile was a reassuring sight.

Confronting him, I felt shame from the previous day's actions. Tears filled my eyes, obscuring my view. My heartache overwhelmed me. After my divorce, an unfamiliar realm of hatred and resentment extended beyond my marriage. A tissue from my pocket absorbed my tears. With a shaky hand, I brushed my hair away.

Andy came and sat beside me, wrapping his arm around my shoulders. He embraced me until my sorrow became despondency, then returned to his recliner.

Two years had passed since Bob left me for someone else. My friends had stood by me, offering their support and love. I wept, my tears blinding me, grief weighing on my heart. The divorce had already ousted me from my safety net into hostile environments, dating whoever, going wherever, and seeking peace with weary impatience. What more could I do to escape? Drugs, perhaps?

Andy embodied a gentle soul, a virtuous man, an exemplary Christian, and my closest confidant—alongside his wife. A beacon of Christian living, he frequently spoke to me about Jesus. Though I heard Andy's voice, I failed to truly listen. Over the years, they showed their Christian values. She invited me to Bible studies, and they both shared the importance of surrendering my heart to Jesus.

Tonight was no exception. "Gail, if you become a Christian, your life will be transformed, Jesus will accompany you every step, and you'll experience a peace unknown to many," Andy reassured me. "Accepting Jesus doesn't mean giving up your Jewish identity."

"How can I be a Christian and a Jew?"

"You'll always be a Jewish girl from Brooklyn. After all, Jesus himself was a Jew." Andy paused, and it felt like a long minute. "So, will you embrace Jesus?"

I nodded, locking eyes with him. "You will?" Andy asked, his voice raised.

"Yes."

Under Andy's gentle guidance, I reached out to Jesus in prayer. I confessed my sins, acknowledging their weight, and asked for His forgiveness, recognizing the immense sacrifice He made for me. As I invited Him into my heart, something extraordinary happened. My words connected me to a divine presence far beyond anything I had ever felt. At that moment, a wave of peace washed over me, enveloping me. The unbearable heaviness pressing down on me, that burden I had carried for so long, lifted. It felt like the sky had opened and God's angels were wrapping me in their embrace, filling me with a sense of love and belonging I had never known.

In that instant, I felt God had reached down and

recreated me from the inside out. The old me was gone, and in its place stood someone different, someone whole. My friends, who had been there for me, became the vessels of this transformation. Through their love and guidance, they had shown me the path, and now, through them, God would teach me how to walk in this new life. I always knew God loved me, but my friends led me to the God who saved me. Jesus gave Himself for me.

In a whirlwind of emotion, I was suddenly face-to-face with Andy's wife. Her embrace left me stumbling, entirely overtaken by the moment. Stepping back, I couldn't help but marvel at her abrupt appearance. "Where did you come from?" I gasped. She was a constant source of strength and faith, always there when I needed her most.

Her piercing blue eyes met mine, igniting a spark within me. With a radiant smile, she responded, "I've been in the laundry room, on my knees, praying and waiting."

"I feel different, the weight on my shoulders is gone," I said as I hugged her.

"This is a miracle, Gail."

Tears welled up in my eyes as I brought my hands to my cheeks, overwhelmed by her faith and the power of her prayers. "Thank you," I whispered. "You've been praying for this for years, right?"

Her voice was soft but filled with conviction. "You bet. Both of us have been lifting you in prayer," she assured me, a testament to their devotion and the strength of their love.

I drove home in the pool of a waxing moon. I was a spring flowing over the rocks of a babbling brook. Free, like a whippoorwill.

The next day, as the sun painted the sky in hues of pink and gold, I woke up with a newfound sense of peace. The weight that had burdened me for so long had lifted.

Sipping my morning coffee, I found myself filled with a sense of hope for the future. The road ahead was not without its challenges, but I was ready to face them. I felt the support of my friends and the newfound strength of my faith.

I stepped into the sunlight and felt a renewed sense of purpose. This was not only a new day, but the beginning of a new chapter in my life. With a heart full of gratitude and a spirit rekindled, I was ready to embrace the journey of self-discovery and newfound faith.

And so, my story unfolded like the petals of a blooming flower, each day revealing new colors and opportunities. With the love of friends and the guidance of faith, I walked a path of healing and growth, leaving behind the shadows of the past and stepping into the light of a brighter, more hopeful future.

Living with Jesus began with faith and accepting Him as the Son of God and my Savior. It involved inviting Him into my heart and praying for guidance, gratitude, and comfort. Reading the Bible was essential for understanding God's teachings, principles for a purposeful life, and the importance of forgiveness.

Incredible happenings unfolded after that significant shift in my life. When I returned that night, I eagerly shared with my son, Paul, that I'd accepted Jesus. His reaction surprised me. Paul was upset because, he thought that if I wasn't Jewish, I must be Catholic. He had Catholic friends who held anti-Semitic views.

I raised my brow. "So now I'm Catholic and an anti-Semite?"

Paul's lips turned down. "It's like you've become my worst enemy. How could you acknowledge my enemy? I don't want to hear anything about this."

Paul fought back against my Jesus pitch, but my newfound serenity became contagious. Before you could say "divine intervention," my sixteen-year-old son hopped on the Jesus train. Having him on this mystical journey with me was like a cosmic high-five moment. And guess what? My first son, Rick, caught wind of the divine wave after quality Jesus talks with Paul. Rick, influenced by conversations with his brother and first-hand witness to the uplifting changes in my life, also

embarked on the same transformative path. That was about the same time he found the love of his life at his office job. He brought Tammy home to meet me. Before long, Tammy was Rick's bride.

The tale continues! My mother, visiting our home, felt the love and peace Jesus brought. Our home radiated warmth and joy through our faith. Minor miracles continued, like my car radio switching to Christian Family Radio, WFME, from my always-listening classical music station, WPAT.

During a Nor'easter, I asked the Lord to stop the rain for a pizza pickup. Miraculously, it did, resuming once we were safely home. Linda and Michael's wedding faced a three-week rain streak. Hoping for sunshine, I prayed for a miracle. After carpeting the tennis court on May 18 and vacuuming the rainwater, a miracle happened—the rain stopped. The carpet dried, and their wedding unfolded under a clear sky on Sunday, May 20, 1979. The rain returned the next day on Linda's birthday.

These little miracles reinforced my connection with Jesus, ensuring I'd never let Him go. Daily, He gives me peace I have never known. Pastor Hickman baptized me, marking a journey filled with love and faith.

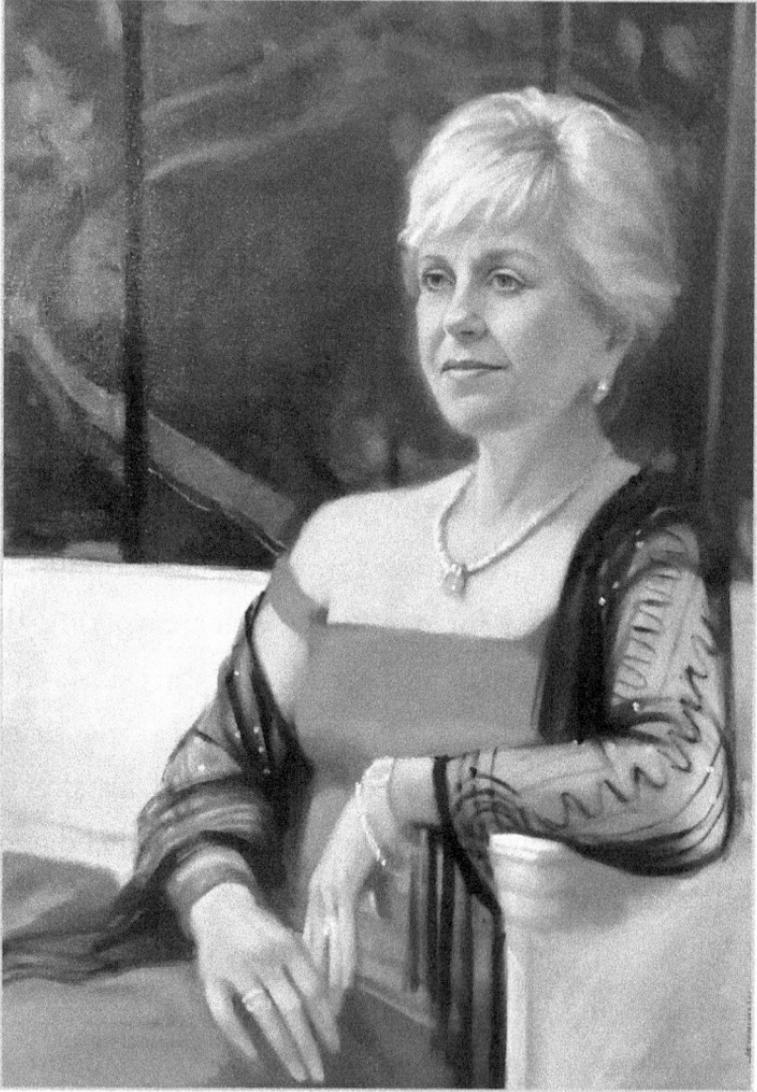

Portrait of Gail Ingis by Diane Aeschliman

Chapter Thirty-two
My Father's Second Marriage ~ 1984

fter celebrating fifty-five years of marriage, Mom, who had not been well, departed from our lives on December 1, 1984. Dad, left in his seventies and grappling with loneliness, reached out to our unmarried cousin Katy, proposing the idea of marriage. Despite my hopes for her companionship with Dad, Katy declined. The rejection saddened me, as I cherished her like a second mom. Undeterred, Dad persisted and extended a proposal to his and Mom's long-time friend, Pauline, who happily accepted.

I assisted in the planning and organization of Pauline and Dad's wedding, which took place at Delray Beach. The celebration was splendid, with Pauline extending invitations to friends and family. The picturesque scene unfolded under a floral-adorned

huppah, accompanied by a delightful feast featuring cheeses, veggies, bread, and an array of delectable desserts, including macaroons and an exquisite cake. A chocolate fountain added to the festivities. Music played, and the older folks danced to Sinatra, Andy Williams, and Tito Puente. Someone shouted, "Play a rumba!" Dad danced slowly with his new wife, though his legs were weakening.

Dad and Pauline enjoyed cruising together and invited me along on one trip. It was a treat to be with them. While the dress code leaned toward casual for most occasions, the captain's dinner demanded more formal attire, compelling me to elevate my wardrobe. In the confined space of our cabin, I found the only semblance of privacy in the small but tidy bathroom. As I discreetly stepped out, adorned in a striking red gown and wrap, my father turned toward me.

He nodded and smiled. "You look beautiful."

I straightened the handkerchief in his breast pocket. "You do, too, in that spiffy tux."

Pauline smiled, her gaze flickering between Dad and me. She wore an ankle-length black lace dress with a matching bolero.

Pauline cantered her head. "You make a perfect father and daughter."

I caught my breath. "Thank you. You look gorgeous."

She nodded. "Thank you."

"My beautiful women, one for each arm. Shall we?"

We left our cabin. Pauline linked her arm with Dad's. I followed in the narrow corridor, walking to the captain's quarters.

The cruise ship welcomed an impressive three to five thousand cruisers, metamorphosing into a floating metropolis with restaurants, entertainment hubs, gambling facilities, cinemas, and swimming pools. Navigating through this city on the sea, I explored its diverse offerings.

Our cabin featured a queen-sized bed with an upper bunk. Dad and Pauline designated the upper bunk for me, of course. While my excitement for the adventure was palpable, the prospect of sleeping elevated posed a challenge. Visions of rolling over and tumbling to the floor in the middle of the night crossed my mind. Though the experience didn't instill a newfound love for cruising, I embraced the opportunity. Despite avoiding mishaps on the bunk, I graciously declined future invitations for similar adventurous accommodations.

As my father's legs gradually weakened, the challenges mounted, ultimately stopping his travels. While medications effectively prevented a stroke, they introduced neuropathy, rendering walking an impossibility.

Over a decade, Pauline's health succumbed because of cancer, leading to her transition to a nursing home.

In response to my father's evolving needs, my brother enlisted the services of Rita, a dedicated home aide, to provide daily care. Eventually, my brother moved Dad to assisted living near Pauline's facility. Rita continued to be a steadfast presence in his daily life. In 1993, when my father expressed a desire to meet my new husband, Tom, we journeyed to Florida. A handshake and a smile marked the meeting between Dad and Tom. Dad warmly expressed, "Tom, good to meet you. I have one question." He paused before earnestly asking, "Are you going to care for my daughter?"

Tom smiled. "You bet I am."

Dad, still smiling, nodded in my direction, remarking, "Good choice, Gail."

That felt good. I loved it when my father fussed over me.

Yearly visits to Dad brought comforting hello hugs. Clad in his customary short-sleeved shirt and tan trousers, he welcomed us from his wheelchair. Despite his mobility challenges, we cherished walks, exploring the serene surroundings. The beauty of the place unfolded with a water fountain gracing the center of an artificial lake framed by vibrant flower beds.

Dad, always resilient, never complained. He mentioned that Jay's moving away broke their hearts

after he had opened a podiatrist's office near them in Florida. They counted on one of their children being there.

Celebrating his ninety-fourth birthday, he reveled in the joy of our expanding family. The Ingis and Sklar clans gathered in Florida for the occasion, and with a sense of pride, he slapped his knee, recognizing the legacy he had started. "Look what I've done!" he said, sweeping his arm toward his growing family. The room erupted in applause, and soon attendants, nurses, and neighbors joined in, harmonizing to sing "Happy Birthday." Rita continued to care for him until he passed away on September 21, 2002, at the age of ninety-five.

My father had a heart-to-heart talk with me before my wedding to Bob in 1955. "My precious daughter, you hold a special place in my heart. Life comes with trials, and you've faced them. There will be more. Trials can bring you down lower than you think, but stand back up and keep going. You'll find what you want. My story will live on through you. You are my story. You are me, so go now, and remember, I'll always love you."

The Interior Design Institute founded in 1981
Building generously donated by
Graciano Duarte (Gigi's husband)

Chapter Thirty-three
The School I Founded ~ 1981-1991

To expand my horizons in teaching, I called Betty at the King's College in Briarcliff Manor, New York, where, coincidentally, my son Paul was a first-year undergraduate. I asked if she would like me to teach an adult education class in interior design.

"Oh my, Gail, what a great idea. In the evening, correct?"

My class attracted homemakers, architects, artists, and the general population. All intrigued by color, space planning, and antique furniture. I taught for three years and loved every minute. The students were terrific.

And then my life was about to change again. A phone call ignited my passion and set me on a path I

never imagined. The voice on the other end belonged to Georgia, who lived in a neighboring town. She asked, "Do you offer courses in interior design?"

"Yes, I've been teaching at Kean College in Union, New Jersey, and King's College in Westchester. Why do you ask?"

"I want to learn. Can you teach me?" Georgia's words hung in the air, promising a journey yet to unfold.

I couldn't believe what I was hearing. "Sure, let's see how we can do it. What were you thinking, Georgia?"

"I want the basics to do it myself and maybe help family and a few friends. I like the idea of transforming space," Georgia said.

Captivated by her infectious enthusiasm, I divulged the intricacies of my teaching journey. Witnessing her excitement, we collaboratively crafted dynamic, tailored sessions aligned with our schedules. We conducted our sessions at my home, using the drafting table nestled in the cozy family room. I imparted knowledge from my experiences at NYSID's color theory, space planning, historical perspectives, and decorating. Since I had already immersed myself in teaching design principles at Kean, I was eager to share my expertise with her.

Georgia and I embarked on a journey of learning and growth for over three months. Her enthusiasm and our shared love for interior design prompted me to

pause and reflect. Teaching at Kean College had been transformative, both for my students and me. Their passion for unraveling the mysteries of interior design left me at a crossroads. The satisfaction they experienced and the joy I felt while teaching planted the seed of an idea that would soon grow into a business venture, a testament to my commitment to their learning.

In a twist of fate, I received a call about an opportunity to earn an additional degree from NYSID. The institution had transitioned from a private school to a college and secured accreditation from New York State to confer a Bachelor of Fine Arts. However, I needed nine more credits to qualify. Seizing the chance, I completed those credits at Ramapo College and seamlessly transferred them to my beloved alma mater. The culmination of this endeavor occurred in 1981, marking my second graduation from NYSID. This time with a BFA, all while my design company thrived. Note: I did all of this with a general high school diploma.

As days turned into weeks, establishing a school dedicated solely to interior design took root in my mind. I envisioned a place where creativity flourished and aspiring designers could learn and grow under my guidance. This dream solidified, and I committed to bringing it to life.

To kickstart the endeavor, I contacted Sol, an adver-

tising agent, who had started Toys for Tots for a local Realtor before anyone had heard of it. He was a talented thinker and knew how to promote. Sol greeted me with enthusiasm.

Before launching an advertising campaign for my idea, I contacted the education department in Trenton, New Jersey. Frank, a helpful individual, patiently stayed on the phone with me as I multitasked, holding the phone by my chin and typing on a small electric typewriter. He provided crucial information, emphasizing the need for a building with two exits and two bathrooms. Armed with this criterion, I began the search for such a place.

I meticulously crafted a comprehensive program that seamlessly blended theory with hands-on projects, ensuring that my students would receive a well-rounded education. This involved researching the best practices in interior design education, consulting with experienced instructors, and considering the needs and interests of potential students. The result was a curriculum that provided a solid theoretical foundation and allowed students to apply their knowledge to practical projects.

Generously, my friend Graciano offered me a building in Woodcliff Lake to establish my school. This former truck garage boasted a spacious meeting room in an auditorium style, suitable for 125 people. The two

exits and two bathrooms aligned with the safety standards recommended by the education department in Trenton. Though lacking in charm or haunted tales, the building required no painting, and its curtained windows ensured privacy from prying eyes. These features made it a practical and suitable location for a school. Initially intended as a classroom for children learning Portuguese, my friends had plans to sell the building, but in the meantime, they graciously allowed me to use it for my school. In preparation, I cleaned and polished the space and the bathrooms.

I handpicked experienced instructors, each bringing a unique perspective to the curriculum. To enhance the educational experience, I also invited industry professionals as guest lecturers, providing valuable real-world insights.

The anticipation of my new venture peaked with a successful marketing campaign. Despite the rainy weather on the registration evening, I eagerly waited in my new workplace, entertaining myself with my guitar in case no one showed up. However, my worries were unfounded as prospective students arrived, marking a promising start to the endeavor.

As the portals of my design school opened, they embraced a myriad of creative minds, each yearning to embark on this odyssey of learning. On the first day of instruction, I found myself positioned before my

students, expounding on design principles, buoyed by a thrill reminiscent of Julia Roberts' character in *Pretty Woman*. I felt much like Richard Gere's character, when, braving his fear of heights, he ascended the fire escape to reunite with her. A similar sense of exhilaration coursed through me.

I encouraged my students to read and study the recommended books in the bibliography. The classroom buzzed with energy. Upon completing the courses in color, space planning, architecture, and interior design history, they earned a certificate. I wasn't teaching alone—a network of support was in place. Harvey, an instructor at FIT, commuted from New York to teach history. I taught space planning and design elements, while Marilyn, an interior designer and artist, taught the color course. As the number of students applying increased, I expanded the offerings by introducing additional courses and adding more instructors to enrich the design education. Stephanie Bower, for instance, who held degrees in architecture and interior design, taught drafting.

Networking became a top priority as I cultivated relationships with local businesses, design firms, and industry associations. These connections proved instrumental, opening doors for internships, partnerships, and potential job placements. As a result, a diverse board of directors emerged, comprised of designers,

architects, journalists, financial advisors, marketing advisors, and educators across various mediums. But as the seasons turned and time marched on, I faced a bittersweet realization. The demands of my classes at King's College clashed with the responsibilities of daily life and the development of the Interior Design Institute. Workloads forced me to bid farewell to the night classes that had become a source of inspiration and joy.

The journey from teacher to entrepreneur began with a vision and ended with lessons I never expected to learn. My story, once whispered through the corridors of my flourishing school, took an unexpected turn that even I could hardly believe. It all started on a breezy afternoon when someone called to inform me that they had sold the building. Financial limitations made it impossible for me to secure the property, despite its perfect fit for our school. The cost likely reached into the millions, far beyond our means.

We moved to various facilities, eventually settling in Temple Emanuel on the hill in Woodcliff Lake. IDI flourished over seven dedicated years, earning national accreditation and offering school loans to aspiring designers. Our successes outgrew our humble beginnings, and the Jewish Temple could no longer contain our ambitions. I had to choose my thriving design business or my burgeoning school. The decision was simple; teaching was far more gratifying. While

focusing on my students and their dreams, I redirected clients to other designers.

Ingis and Company managed the school's finances, and a marketing company handled ads and promotions. My brother Jay, always the supportive sibling, offered to help, but then everything suddenly fell apart. My sons dropped a bombshell—they said I wasn't making any money. Jay returned to his previous work, and my marketing company demanded more public appearances and networking from me. The students needed better facilities, and I questioned the entire endeavor. Discouragement had set upon me.

I should have called Graciano for a pep talk and some wisdom, but I didn't think of it then. Instead, I gave up and made a drastic decision. I merged my school with the Berkeley School of Business. The owner of Berkeley questioned my resolve, knowing IDI was my baby. I was firm. My lawyer drew up an unprofitable agreement, but my priority was my students. Berkeley hired me to run the program and gave me an office on the school's upper level. I set it up with my library, blueprint machine, and conference area. The students expressed satisfaction, and Berkeley managed the logistics. It seemed like the perfect arrangement.

But then, the head of the education department at Berkeley called me into her office at the end of the first year. She respectfully informed me that the high school

graduates felt pressured and were concerned about their grades. I admitted I was tough; interior design was no joke. Many believed it was easy—they thought all you had to know were colors and where to put a couch. Even Bob had once asked what the rules were in interior design. People failed to understand the depth of our field, the state boards we had to pass to be licensed, and the responsibility of designing spaces for how people live and work.

I promised to make the students happy, but they fired me two years later, in June of '91. They gave me the shaft right there at the graduation culmination. Devastated, I couldn't hide my tears from my friends, teachers, collaborators, and students. I had no clue this was coming—no warnings, no discussions. My promise to the students to go easier on them had apparently failed.

Two semesters before losing my job, I hired an architect to teach the history of architecture and furniture. He claimed his Italian curriculum included interior design training. After interviewing him, I felt his design philosophy needed to comply with my criteria, but his knowledge of history was satisfactory, so I hired him. When they fired me, he filled my position. I told the head of the school he was not an appropriate replacement—my degrees and knowledge were unmatched by his. They thanked me, gave me a lovely

letter of recommendation, and said goodbye. After six months, they fired him.

In the end, I had given my school away. Shortly afterward, I received a letter offering to buy it. Oh, well...

The tale of my school is bittersweet, filled with dedication, love, and an unexpected end. While it didn't turn out as I had hoped, I cherished its impact on my students and the lessons I learned.

Pratt's Power Plant sketch by Gail Ingis

Chapter Thirty-four
Academic Armor ~ 1984

F ive years of dedicated learning at the NYSID
honed my design skills and infused me with
confidence. A second graduation in 1981 from
the NYSID with a BFA, as noted in Chapter 33, led me to
the world at Pratt for my master's in interior design in
1982. Surprise! I was in for a roller-coaster ride that
would challenge my knowledge and the core of my
passion. Enrolling in Pratt Institute was a natural
progression for me. I had excelled in my prior educa-
tion, graduating summa cum laude from the NYSID.
Battle-ready with this academic armor, I ventured into
the world, expecting it to be a breeze. Spoiler alert: it
wasn't.

My journey at Pratt differed from what I had
expected. Instead of delving into the intricacies of inte-

rior design, the program focused on architecture, a field I needed to familiarize myself with. In an instant, my honed knowledge felt inadequate. The self-assurance that had propelled me through previous academic pursuits now faced its ultimate challenge. Reflecting on these unforeseen events, I pondered: Do I need another degree? Is my amassed expertise, along with my satisfied clients and many design projects, insufficient? I had an insatiable hunger to push boundaries and affirm my skills. Perhaps this came from a desire to prove to my late mother or myself that I had genuinely mastered the depths of my craft. These unexpected challenges made me question my path, but they also connected me with the struggles many others face in their academic journeys.

Amidst this chaos, a chance encounter at Pratt brought Stephanie Bower into my life. Armed with an architecture degree, Stephanie was pursuing a master's in interior design. Our introduction was memorable, with Stephanie standing in a corner of the room with her arms at her side, ready to share her story. "I'm Stephanie Bower from Texas," she said, "and I'm suffering from culture shock." Her words resonated, cutting through the tension in the room—two individuals navigating the intricate world of design education connected us. This ordinary meeting would be a pivotal

moment, a serendipitous turn in my academic and personal journey.

Embarking on a new academic journey can be daunting, especially when one faces unfamiliar territories and challenges. For me, this became clear during an assignment that took Stephanie and me to the school's power plant, a space demanding sketching skills I hadn't fully honed.

Seated on the floor beside each other, I turned to Stephanie, seeking guidance in this maze of machinery. "Stephanie, how do I do this?" I asked.

With a sympathetic smile, Stephanie said, "Measure with your pencil like this." She held it up in front of her and then said, "Sketch the big shapes. Details are last."

While I had experienced drawing boxes and chairs, the intricacies of the power plant's machinery was a different beast. Following Stephanie's lead, I sketched the larger forms and then delved into the meticulous details. It was a revelation. Stephanie's guidance demystified architectural sketching and marked the inception of a profound friendship. Our connection extended beyond the confines of the classroom. Stephanie and I ventured from the city to the ocean and through the mountains, including an excursion to Frank Lloyd Wright's iconic Fallingwater, capturing the essence of each stop through our sketches. In those shared

moments of creativity, we created a bond that went beyond the challenges of academia.

However, as the program unfolded, I wrestled with negative criticism and an educational structure that didn't seem to fit my objectives. The head teacher, Harold, an architect, focused on architecture, neglecting interior design. Our divided concerns reached a boiling point during a design argument, during which Harold emerged victorious with his architectural perspective.

The instructor expected me to have a foundational scholastic understanding of architecture, a prerequisite I needed to gain, but my identity as a graduate interior designer appeared overshadowed. Navigating this program with an instructor whose priorities differed significantly from mine would be an uphill battle. Time and energy were precious commodities, and I questioned whether this program aligned with my goals, so I dropped out.

I still had a quest for a final degree, and my search took an unexpected turn when I initially aimed for Columbia University. The dean at Columbia suggested a different path—the New Jersey Institute of Technology. Described as a "sleeper," NJIT had an excellent reputation to those in the know, and the dean, in 1985, welcomed me with open arms.

While I ran my school, Interior Design Institute, a

demanding instructor at NJIT marked my initiation into the architectural program. The clashes of opinions regarding space led to many heated arguments. Despite successfully navigating the challenges and securing a passing grade, the constant debate drained me.

When I questioned my academic journey, I asked the dean for guidance. Instead of letting me leave the program, he extended an olive branch. He proposed a customized program that would align with my schedule at IDI, presenting a tempting opportunity for a tailored path that could accommodate both my students and my academic pursuits. This support reassured me I was not alone in this journey, instilling a sense of hope and determination in me.

The prospect of juggling architecture studies with a demanding professional life gave me pause. The hesitation lingered as I weighed the feasibility of maintaining the delicate balance between my students and academia. The challenge was clear—studying architecture demanded a significant commitment of time and energy, and integrating it into my existing schedule seemed impossible. Yet, I was determined to find a way.

The journey into architecture, initially embarked upon with enthusiasm, now required a reassessment of priorities and a thoughtful consideration of the road ahead.

It wasn't a matter of a lack of effort on my part. I was

eager to learn and willing to bridge the gap between interior design and architecture. However, the disconnect between the instructor's expectations and my background created intense tension, and so I left the dream of an architectural education.

Stephanie graduated from Pratt, and, having left her role as the drafting instructor at IDI (the school I founded) with a glowing recommendation from me, she found a new home teaching at the Parsons School of Design Manhattan, pursuing a position that aligned with her passion.

Stephanie and I had become good friends and took sketching trips together. One day, Stephanie suggested I attend Parsons School of Design if I still wanted to pursue a master's degree.

Encouraged by Stephanie's enthusiasm, I applied for a master's degree at the Parsons School of Design and was accepted into their Architecture and Interior Design Criticism program.

The sketch class with Stephanie became a highlight of my time at The New School. Despite the logistical challenges of travel, the experience of learning under

her guidance and earning credits toward my degree was invaluable.

Despite my best efforts, the program stirred familiar challenges related to reading and interpreting architectural theories. The instructors, recognizing my determination, provided teaching and support, guiding me through the intricacies of the coursework. I passed the classes with their help, navigating the hurdles of writing papers with in-depth criteria.

Yet, the difficulties escalated in Herbert Muschamp's class. He was a renowned figure in architectural criticism. My struggles to decipher assigned papers reached a point where Muschamp's patience wore thin. Despite concerted efforts, I couldn't meet the writing requirements, and Herbert hesitated to complete my grade for the degree.

The writing assignments proved impossible, and the choice was clear—I left the program feeling defeated and with my academic journey unfinished. It was a moment of disappointment, recognizing the limits of my abilities in reading and writing critiques of architecture.

While I couldn't complete the master's program at Parsons, the journey provided valuable insights into my academic pursuits and a deeper understanding of the challenges I faced in architectural theory and criticism.

It was when I ventured into a writing career that the fog lifted.

My struggles with reading comprehension were not a barrier but a bridge to a new path. The path led me to discover my passion for writing and storytelling, showing me that inspiration can emerge from the most unexpected places. And in embracing my journey, with all its twists and turns, I found not just resolution but a renewed sense of purpose.

As a best friend, Stephanie's impact on my life is immeasurable. Words cannot capture this remarkable woman, whose friendship has withstood time and distance. Beyond academia, her influence has been a guiding force, offering artistic inspiration. I am profoundly grateful for my connection with Stephanie, a friend whose presence enriches my life. Her journey, characterized by creativity, passion, and a commitment to teaching, reminds me of the power of pursuing one's desires and sharing knowledge with the world. I've found a friend and a source of perpetual inspiration in Stephanie Bower.

Reflecting on this odyssey, I felt compelled to share this story. By unveiling the struggles and triumphs of this part of my journey, I inspire others to embrace their paths of self-expression, find inspiration in unexpected places, and recognize that every stumbling block is a potential catalyst for growth.

La Dolce Vita detour
Rome, Italy
on the way to Bangladesh (arranged by AIM)
(courtesy Canva)

La Dolce Vita detour (cont'd)
Florence, Italy
on the way to Bangladesh (arranged by AIM)
(courtesy Canva)

AFRICA INLAND MISSION INTERNATIONAL

P.O. BOX 178, PEARL RIVER, NEW YORK 10965 ● 914-735-4014

This is to certify that

MRS. GAIL INGIS

IS A MISSIONARY SERVING WITH **AIM INTERNATIONAL** AND IS
WORTHY OF ANY COURTESIES ACCORDED THERETO.

This credential
expires 12/31/96 ADMINISTRATOR, MISSIONARY PERSONNEL

Africa Inland Mission (AIM) (Pearl River, NY)

Chapter Thirty-five
Africa Inland Mission ~ 1991 & Italy

The transition from entrepreneur to employed worker was a significant turning point in my life's journey. Little did I know that a sanctuary lay beneath Africa Inland Mission's unassuming exterior that would profoundly influence my professional and spiritual life. At AIM, the collective spirit exuded a warmth that exceeded the typical office.

Tuesday mornings started with communal prayers for the president of our country and our work with missionaries. This shift in my career path was not just a job change but a transformative journey of personal growth and spiritual exploration.

As an entrepreneur who had weathered the storms of business ownership, the allure of a job without the entanglements of those obligations proved irresistible. I

experienced a change from the usual routine by fulfilling my responsibilities and seeking solace in my space. What a novel concept—a departure from the relentless demands of free enterprise, a respite for my weary soul.

My role, assisting the finance director, unfolded with its diverse responsibilities. In the daily tasks and spiritual fellowship, no friendship was more cherished than with Barb and Warren Day. Their guidance and support were instrumental in my transition from entrepreneurship to missionary work, and their friendship was a source of comfort and strength during this period of change.

Social and culinary collaborations with Chet and Joan, the specialty chefs, were an added delight when preparing meals for missionary gatherings.

My appointment as a missionary made it possible to accept my son and daughter-in-law's invitation to visit them while they were serving as short-term missionaries in Bangladesh. They had accepted jobs as an accountant and emergency room nurse listed at the Association of Baptists for World Evangelism (ABWE). Those jobs had to be God's plan. They were what Paul and Joanne did at home every day.

My father worried the trip was too risky, so I made an international call to Paul to tell him about his grandfather's concerns.

"Mom, I can't tell you what to do, but if you come, it'll be a trip you'll remember for a lifetime."

I decided I had to go. I considered including a stop in Italy to visit Rome and Florence. Paul suggested I call the ABWE and ask if anyone was traveling to Bangladesh. Two women from ABWE were going my way and agreed to join me in making those tourist stops. AIM's travel agents helped me with prerequisite shots and travel arrangements.

ITALY

The Vatican and the Sistine Chapel were closed for extensive renovations, leaving us disappointed. Our collective gasp echoed through the air like a chorus of midwives as we pleaded with the guard to allow us to glimpse the masterpiece.

"Please?" I asked, my voice tinged with desperation. "Could we at least have a peek?"

I guess he understood English, because his expression softened, and he rubbed his chin before offering us a tentative smile. With a gesture, he removed the stanchion barrier, allowing us to step closer to see the wonders of the Sistine Chapel's ceiling. Though I had

seen countless images in books and online, nothing could prepare me for the breathtaking magnificence of Michelangelo's work. As I gazed upward, the vibrant colors, lifelike faces, and intricate details of the frescoes mesmerized me. Each brushstroke seemed to breathe life into the biblical scenes depicted above, the nine panels from the Book of Genesis, including the iconic "Creation of Adam." The figures, clothed and nude, danced across the ceiling, their outstretched arms almost touching. Our time was all too brief. The guard reminded us gently that it was time and then ushered us away as the barrier slid back into place. "*Grazia*," I murmured, tearing my gaze away from the masterpiece.

Determined to make the most of our time in Rome, we walked by the Pantheon in the middle of the city, which was still a functioning Catholic church after 2000 years. It disappointed me that the church was not open. According to images online, the interior resembled St Paul's Cathedral in London. We took a sightseeing bus to the ruins of the Colosseum, Roman Forum, and Palatine Hill. Whole villages of ruins hung on hills beneath volcanic mountains, crumbling stadiums where Roman gladiators killed each other entertaining crowds.

Scientists have been researching how these architectural treasures remain, despite earthquakes, volcanic mountains, and wars.

We ended up shopping in Italy's largest, most famous market. Porta Portese Market, a mile long, spilled over into the surrounding backstreets. Endless stalls and traders of carpets, materials, antique goods, clothing, and even pets ensured no end of browsing. We wrapped colorful silk scarves around our necks, draped soft leather bags over our shoulders, plopped large sunhats handmade of straw on our heads, and donned fashionable Italian Gucci and Armani sunglasses. I bought a scarf, and my travel friends bought sunglasses. There were barking dogs nipping at our ankles, looking for treats.

The next day, as the sun rose over the city, casting its golden light upon the waking streets, we savored a moment of quiet, sipping steaming hot espresso and inhaling the rich aroma that hung in the air. Rome was waking up. No one was around except early birds like us. There were no big noisy groups, no traffic horns, only silence. I took a deep breath. The fragrance was invigorating, filling the air with a sense of calm and peace.

"Hey," I said to my two friends, "let's not miss our train to Florence." The anticipation of the upcoming journey filled us with excitement and eagerness to explore the next destination.

The taxi driver whisked away our luggage and sped us to the station, and the conductor's "All aboard!" cry

echoed through the air. The train's windows were slightly open, allowing the aromatic essence of the countryside to waft into the carriage. With each passing moment, scents danced through the air, mingling with the rhythmic clatter of the wheels on the tracks.

As we journeyed, the train carried us past quaint villages and verdant pastures with the earthy aroma of turned soil. The breeze carried the faint scent of woodsmoke from distant chimneys, a reminder of cozy hearths and warm hospitality.

Among the picturesque landscape, ancient bell towers dotted the horizon. Their crenelated silhouettes, towering sentinels, once symbols of protection in times of siege, now stood as silent witnesses to centuries of history.

The train's route wound its way through landscapes rich with odors of antiquity, passing by weathered stone churches and majestic palaces that seemed to exhale the essence of centuries past. Each breath was like a sip of history, filling me with awe and reverence, inspiring a deep respect for the enduring legacy of these structures.

Once in Florence, for an assignment from my instructor at Parsons, we trekked through the arches of the Palazzo Del Vecchio. The stone residence was a mix of Romanesque and Renaissance architecture, with the familiar faint smell of antiquity—musty and moldy. Vast halls echoed our footsteps as we listened to tall

tales told by our guide. Draped fabric veils covered the bedrails in a bedroom, hiding secrets beneath. Tapestries depicting battles and hunt scenes hung on concrete walls, softening the sounds of life.

Imagine me living out my art lover's dream in Florence, standing before Michelangelo's *David* at the Academia Gallery, satisfying my artist's curiosity. I stood there, craning my neck to take in the standing full frontal view of David, and couldn't help getting stuck in the sculpting of David's, uh, sculpted manhood. Michelangelo's choice to depict David before his battle with Goliath resulted in a youthful and influential figure. The statue stood seventeen feet tall, carved from a single block of white marble, a testament to the artist's ability to breathe life into stone. I was in awe of this massive interpretation of the male form.

We treated ourselves to an Epicurean pizza and sampled the tradition-infused coffee culture. My favorite was café cappuccino and dark coffee with lots of foamy milk. We explored the contrast between the city's love of pork and its kosher traditions in the Jewish quarter. Food originating in the old ghetto sat atop every list of what to eat in Rome. We tried the famous ragù sauce on top of fresh tagliatelle pasta and a traditional, gluttonous lasagna. Smells swirled around the server coming out of the kitchen as he placed the food on our table. Antipasto was an assortment of cured

meats, cheeses, olives, and vegetables. Then came Fiorentina steak grilled to medium rare for my tastes, a platter of puff pastries with lemon gelato for dessert, and red wine with each bite.

Filled beyond full, we took a taxi back to our B&B, where we collapsed, content, and a bit drunk. Well, maybe a little more than a bit. I splashed my face with cold water and did some toe touches to get my body working.

Hangovers presided the next day as I did more toe touches.

"What good will that do?" Nancy asked.

"Gets the blood flowing, and exercise gives me energy. Have you ever tried?"

Nancy's eyes bulged. I thought they might roll onto the floor, but she turned and left the room.

I left my companions, hopped a cab to see Florence's architecture, and walked according to my map through the familiar architectural history. Smells and sounds of traffic, people walking and talking, bounced off the old stone surfaces of buildings, streets, and roads. I imagined the women of the fifteenth century dressed in flowing gowns and the men's garments with puffed sleeves and form-fitting waists over tights.

The highlight of my exploration was the Santa Maria Novella church, a masterpiece of fifteenth-

century architects Leon Battista Alberti and Filippo Brunelleschi. I rested on a bench opposite and sketched the church in my handy sketchbook, remembering my talented friend, Stephanie Bower, who taught me to sketch. This church had a secret as one of the world's oldest pharmacies. It was still creating botanically inspired beauty products.

When I returned, my companions were halfway out the door for another Italian feast. Satisfied with my architectural discoveries, I went to bed early for the next day's travel to Bangladesh.

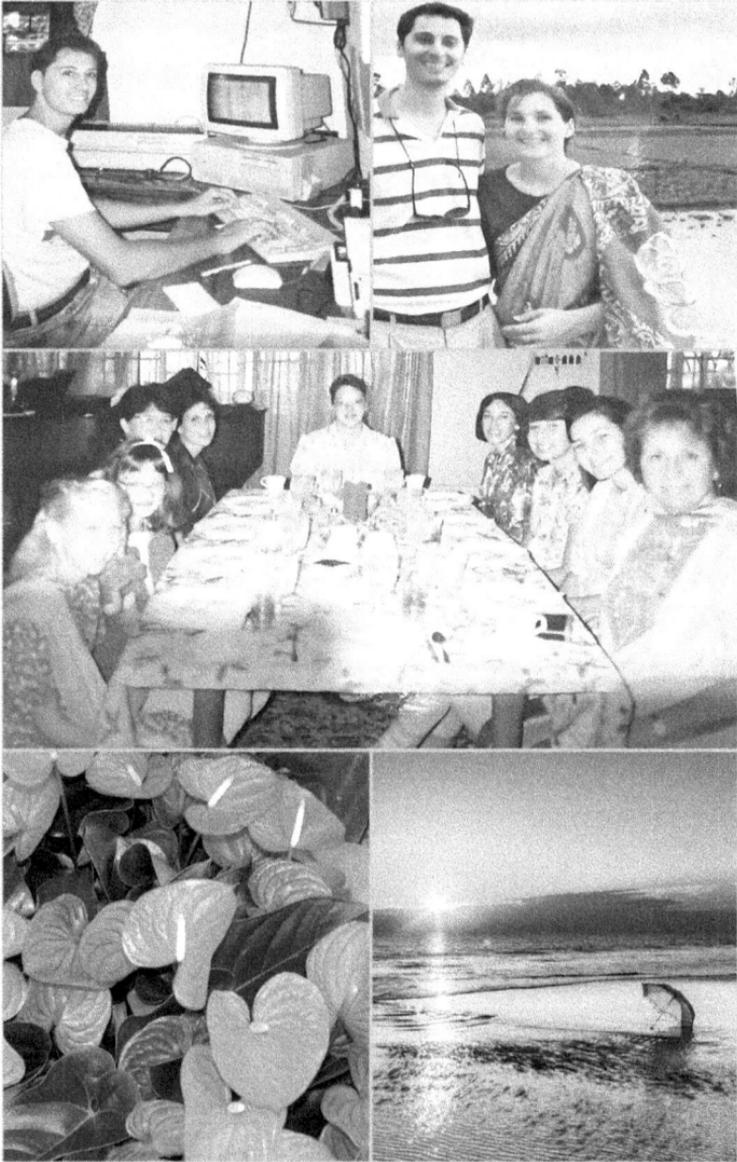

Memories from Bangladesh
Paul working at Malumghat Memorial Christian Hospital
Paul & Joanne at the rice paddies in Chabagan;
Christmas Ladies Missionary Brunch (Joanne & Gail seated on right);
Anthurium & Sunset

Chapter Thirty-six
Trip to Bangladesh ~ 1991

S tepping off the plane in Dhaka, Bangladesh, I walked onto the tarmac, welcomed by a blast of hot air. December in Bangladesh is like the middle of July back home. Spotting Paul and Joanne in the crowd, I waded through fellow passengers. Their smiles and waves in return brought tears to my eyes. It felt like an eternity since I had last seen my kids six months ago. Clad in his casual blue shirt and beige chino pants, Paul waited with Joanne, who looked radiant in strange apparel. When I reached them, I grabbed their hands and pulled them into a hug. That felt good!

Paul stepped back. "Hi, Mom, you look great."

"You're saying that because I arrived in one piece, but I'm exhausted. I can't wait to rest."

Paul laughed. "Knowing you, you tried to see Italy in four days."

I chuckled. "Of course. Not all, but as much as I could."

I let out a sigh of contentment, took a tissue from my pocket, and wiped the sweat from my brow. "I'm thrilled to be here, I think. Is it always this stifling?"

Paul nodded. "Yup. This time of year, they have monsoons. You can smell it. But no rain is coming today."

"Joanne, you resemble a fairy. Do the locals dress like this?" The sheer, flowing fabric reminded me of Joanne as a bride at their wedding two years ago.

"Yes," Joanne smiled. "They do. Good for you, coming on this trip."

I nodded. "No kidding. I had no idea. I loved running all over Rome and Florence to breathe in the past. I walked through places people lived in long ago. It's been eye-opening and a privilege."

"Come on. Let's go." Paul took my arm. "We have a flight to Chittagong. From there, a hospital van will pick us up for the three-hour drive to Malumghat."

As we ventured beyond the gate, I couldn't shake the disorientation that swept over me. The sights, sounds, and smells all assaulted my senses. I had stepped into a world removed from my own. Animals roaming through the streets filled me with awe. The children's

eyes were wide with curiosity. Their innocent fascination tugged at my heartstrings, reminding me how foreign I must appear in this unfamiliar land. There was a certain beauty in the children's radiant smiles. Despite the heavy smog, vitality permeated every corner of this bustling city.

As I took it all in, I couldn't help but feel a whirlwind of emotions—curiosity, apprehension, wonder, and perhaps a hint of fear. There was a sense of exhilaration at the prospect of exploring this vibrant, unknown world.

"Nancy, Jane, this is my son, Paul, and my daughter-in-law, Joanne."

Paul put his hand on my shoulder. "Thanks for watching my mom."

Nancy and Jane smiled and nodded with enthusiasm.

Nancy said, "Your mother has more energy than a housefly."

Jane blurted out, "Nancy and I started our day in Florence with Gail. By the end, we collapsed after trekking over Rome for two days. The next day, she kept going. We felt guilty sending her off alone while we rested."

Paul smiled at me. "That's my mom!"

Nancy gave me a look and rolled her eyes. Amused, I smiled in acknowledgment.

Jane cleared her throat. "We had a blast with Gail, especially when she was asleep—but let's be honest. We owe much of our adventure to her lively spirit."

Nancy flicked her hand. "Those Spanish Steps in Rome. She waved us on to follow, but we couldn't. She wore us out."

Jane nodded. "Gail, regardless, it was a pleasure."

"Thanks."

Nancy laughed and added, "We visited multiple historic sites in Rome and Florence."

I looked at my traveling companions and smiled. "We went to that Palazzo in Florence for my master's. That worked out well. Didn't you enjoy walking through the house?"

The ladies looked at each other, nodding. "We did," they chirped.

The narrow, one-lane, bumpy road out of Chittagong gave me a stomachache. I prayed an oncoming vehicle wouldn't kill us.

I held on to my seat. "Paul, what's up with the road and drivers?"

"All the roads are like this, and there's an unwritten rule: whoever has the loudest horn has the right of way."

"Comforting," I said, mumbling so no one could hear.

We pulled over, allowing buses to pass us with

people in the bus and on top of the bus waving at us. There also were lambs and chickens. Where in the world were they going with the animals? I never asked that question.

Upon our arrival in Malumghat, the mission guest-house, a modest gray building reminiscent of a humble motel, greeted us with its unassuming presence. Inside, each room branched off a long corridor, offering the missionaries and me our private sanctuaries. Several of the missionaries and doctors, learning of my skill in design, implored me to enhance the comfort of their quarters. I cheerfully obliged, rearranging furniture and optimizing office space during my visit to Chittagong, where ABWE has offices.

Thrilled to have reached our destination, I promptly collapsed onto the bed in my room. The journey may have been exhausting, but the anticipation of seeing my children and spending time with them kept my spirits up and sense of humor intact.

Paul stood at the door, smiling.

I raised my brow. "What?"

"Comfortable?" Paul asked.

"Survivable, thanks for asking." Paul's addictive smile was reassuring.

"Where did Joanne go?"

Joanne had vanished, leaving me worried. Did she have safety assurance, no matter where she went? That

was a silly thought, since they had been here for a few months and were fine.

"She wanted to show your friends around before they get to their accommodations."

"Hey, here are those condiments you requested," I said, opening my suitcase. "Five pounds each—kosher salt, sesame, and poppy seeds."

Paul's eyes widened. "I forgot about them." He lifted the packages out and held each up, one at a time, all intact. "Great, thank you. I'm surprised you got them through customs."

"In one piece, and no smells, thank goodness. Imagine what the authorities here would have said if they had checked the contents of my baggage?"

"The cook and I will make a batch of bagels tomorrow morning."

I laughed. "I never thought I'd be having bagels in Bangladesh. Oh, where's the bathroom?"

He grinned. "You have your own private bathroom right behind that door across from the bed," he pointed. "It has running water."

I let out a sigh of relief.

"Not so fast. Listen carefully. The water looks clear and sparkly, but don't drink or brush your teeth with it. Your stomach will rebel against the unfamiliar. Ask for boiled water."

"I brought anti-diarrhea medicine."

Paul threw his head back and laughed. "There are never enough meds, trust me!"

"I won't get sick."

Paul shook his head, grinning. "You could. Come on, Mom, here's Joanne. Let's get you fitted for an outfit like hers."

The fabric wrapped gracefully around Joanne's legs as she moved, and she smiled. "It's lightweight and airy. Perfect for this hot, humid weather. It's called a *shalwar kameez*, a traditional three-piece outfit—pants, dress, and jacket—in the fabric you choose, like cotton or silk."

I raised an eyebrow. "These are custom-made to order?"

Joanne held out a small section of her shalwar skirt and nodded. "Yes."

"Custom-made clothes in a third-world country. Cool. At home, these outfits would cost a fortune."

Joanne shook her head. "I never gave cost a thought. Damara, the dressmaker, lives across the village meadow. She'll measure you for size, cut the fabric, and sew it together. We can hurry over there for a quick visit and fitting."

With that, we made our way to the village. Damara greeted us warmly, her smile radiant. Her small, modest hut had vibrant bolts of fabric.

She took my measurements with experienced

hands, working quickly and efficiently. She then presented an array of beautiful fabrics for me to choose from. After careful consideration, I settled on pink and green cotton. The pink was a soft, blush hue, reminiscent of a delicate rose petal, while the green was a simple, bright shade, standing out amid the muted landscape.

Damara nodded approvingly at my choice and quickly began cutting the fabric, her hands moving with the practiced ease of someone who had done this countless times before. I watched in awe as she transformed the raw material into an elegant, practical garment suited for the climate.

The promise of a custom-made shalwar kameez excited me as we returned to the compound. The thought of wearing a beautifully crafted garment made me feel a part of life in the village. It was a small luxury in a place where such things were rare. I'd never had anything custom-made before.

"I'll lend you my other one until Damara finishes sewing yours," Joanne said.

We enjoyed the welcome and the food. Not so much the howling of the jackals. I was not a fan of the howling. It was eerie and frightening!

"No monsoon rains today, thank goodness. We're grateful to our guests, Gail Ingis and friends, for giving us a reason to party. Thanks for coming," the

missionary speaker said as we bowed our heads in prayer. The cooks served regular hamburgers accompanied by Kachhi biryani (baby goat), basmati rice, and fresh greens. When I'd gone to the dining room earlier, I couldn't ignore the tantalizing smells in the corridor. I asked Paul what smelled so good. He said it was the rice. The cooks infused it with cinnamon sticks, cloves, star anise, nutmeg, fennel seeds, and lemon.

Early the following day, the aroma of bagels baking wafted through the entire mission house, making my stomach rumble with anticipation for breakfast. I brushed my teeth with the boiled water then slipped into Joanne's shalwar. The soft cotton fabric felt comfortable against my skin. I couldn't resist twirling around to admire the colorful patterns and elegant drape of the garment. I couldn't wait to get my own.

The breakfast room had long tables set up family style. Each table had a mound of bagels in the center. Bagels everywhere. It was bagel heaven. While dining on our fresh bagels, one missionary stopped by Joanne and whispered in her ear. Joanne perked up, looked at me, and said, "Your shalwar is ready."

Paul, Joanne, and I finished breakfast. I only had one bagel. It was hard not to take another freshly baked one, soft inside and crunchy outside. We made our way across the sunbaked field toward the village. We were

on a mission to pick up my shalwar kameez from Damara.

It fit perfectly and was a small indulgence that made me feel a touch of glamour. "How do I look, Joanne?"

Joanne nodded. "You look good. The colors are perfect."

"Why do the missionaries dress like the locals?" I asked, twisting back and forth to feel the lightweight fabric.

"We wear the same clothes out of respect," came Joanne's reply. "It's important to dress modestly and appropriately, covering up as the locals do. This helps us build trust and shows that we understand and honor their culture."

"Do they wear these types of outfits all the time?"

"Pretty much. Dangerous, though. The women cook in the clothes, and the loose fabric often catches fire, causing severe burns. Burns are the main problem we see in the emergency room."

I smoothed my hands over the sides of the top. "The cotton is cool and comfortable. No problem with fire. I'll not likely cook in this over an open flame."

Paul laughed. "Of course not, Mom. We don't cook. Now that I showed the kitchen workers how to make the bagels, they'll be on their own, and I can get back to teaching the locals about finance, bookkeeping, and how to keep records."

The next day, another surprise awaited. "Ready for a tour, Mom?" Paul asked. "The villagers are waiting to meet you."

It was a warm, beautiful day, with Poinsettia flowers on ten-foot-high, rangy shrubs rustling in the quiet breeze, bursting with color. While crossing the vast expanse of the grassy, flat meadow, I couldn't help but notice the stark contrast between the simplicity of the landscape and the richness of the human spirit that inhabited it. I saw something move out of the corner of my eye, turned, and gasped.

Paul reassured me, laughing. "The cow is harmless. He wants some grass, that's all."

"The cow is sacred. It's not edible. It doesn't get enough to eat and lives along with other free-to-roam animals," Joanne said.

Despite the poverty that surrounded us, there was a palpable sense of warmth and camaraderie among the people we encountered. The locals greeted us with open arms.

Villagers welcomed us into their homes with warm nods, genuine smiles, and food offerings. They lived in humble huts with thatched roofs and bamboo walls. In areas prone to flooding, they ingeniously protected their homes by building them on stilts or mounds and digging large ditches to absorb excess water. Upon arriving at a house, we respectfully removed our shoes,

leaving them outside the entrance, as was their custom. At five foot three, I had to bend slightly to enter, but watching six-foot-four Paul duck significantly to pass through the doorway was amusing. Every home we visited had a Bruce Lee poster opposite the low entrance.

"Why do the houses have that poster?" I asked Paul.

"Bruce Lee is the Bengali hero, fighting the bad guys," he replied with a smile.

Once inside, the ceiling rose to about seven feet, allowing the smoke from the cooking fire to dissipate. Everyone gathered on rugs spread over the dirt floor. The women cooked over a fire, either in the center of the floor or outside, and we enjoyed meals at long, low tables. These beautifully woven rugs, crafted by children and adults on weaving machines, were a significant business for the villagers.

For privacy, latrines were simple outdoor holes in the ground, enclosed by walls. Instructions from Paul included eating everything offered. If I couldn't bear the smell or the visual, he told me to slide the food onto his plate. Hopefully, no one noticed the one time I did it. As we sat with them, listening to their stories and sharing their joys and struggles, the strength and resilience of the human spirit moved me. In their simple way of life, I found a profound connection and belonging that transcended language and cultural barriers.

"Thank you for arranging this visit with these warm people," I said.

"No problem. The villagers couldn't wait for you to come," Joanne said as we returned to the compound.

The Memorial Christian Hospital, where Paul and Joanne worked, offered general medical, surgical, and obstetrical care, a newborn nursery, an emergency room, and much more. Doctors and nurses from all over the world came to help. Amid the entire complex sat a tennis court, whose presence struck me as odd. It turned out the doctors had a choice between a wishful nine-hole golf course or the more practical 60x120-foot court for tennis and basketball. Paul came up with two racquets and a few minutes to hit the ball with me. The concrete court reminded me of the courts in California, where I always got shin splints. We didn't play long enough for me to get injured.

The hospital and mission complex sat deep in a forest overlooking the Bay of Bengal, where boats came and went when the tide was high. Many locals lived in huts along the bay and on barges in the bay. On April 29, 1991, two months before Paul and Joanne arrived in Bangladesh, one of the deadliest tropical cyclones made landfall in the area with winds as high as 162 mph. A 20-foot storm surge inundated the coastline, causing over 135,000 deaths and about $1.7 billion in damage. In response, the United States sent clothes, food, and furs.

Furs for the tropics? What were they to do with them? Ever resilient and inventive, the missionary women worked with the locals to create mink teddy bears and export them, turning them into an unusual and valuable source of income. I purchased one to take home as a souvenir.

My visit coincided with the retirement of orthopedic doctor John Bullock and his family. John invited Paul, Joanne, and me to join his family on a Bengali adventure, showcasing his thirty years of service at the Malumghat Hospital. The pinnacle of the experience was a visit to a local doctor whose daughter, seventeen, once suffered from bowed legs because of rickets. John had straightened her legs. The doctor, grateful to John, kneeled and kissed John's feet at the entrance to their home. This shocked me, but Paul said kissing the feet was a common custom.

The doctor treated us to a spread of British teas, yogurt, and a tray filled with gulab jamun—fried milk balls soaked in sweet honey syrup—and jalebi, dough fried in a coil shape and dipped in sweet syrup, all to accompany the tea and yogurt. The flavors were delicious but sweet, dripping with sugar and a spicy aroma.

We also enjoyed our visit to the home of a musician, his wife, and three young children. Music and Bengalis go together like tea and crumpets. Doctor John and I sat in folding chairs. The rest sat on the floor in a semicir-

cle, entertained by the husband, who played a dotara, a stringed instrument, accompanying himself in song. The high-pitched music was smooth, rhythmic, and sweet. During our mini concert, a platter of traditional after-dinner desserts appeared. I sampled another of the Bengali sweet treats, not worrying about gaining weight.

Another adventure was a trip to the town of Cox's Bazar. There was a bazaar on the beach, one of Bangladesh's most popular tourist attractions on the longest uninterrupted natural beach in the world.

Paul waggled his finger at me. "This is a sea of tempting goodies."

I wanted to haul away all the fun, unusual trinkets made for tourists.

"Never pay the first price," Paul said.

Here's where I used what I learned from listening. Bless my mom for Delancey Street bargaining. She took me along to buy merchandise and got the best prices from the salesman. Whenever the man at Cox's gave me a price, I shook my head—but the language barrier spoiled the fun. Paul came over to help. I'm not sure I walked away a winner, but I had a few souvenirs, and the seller had a few dollars.

Paul said the villagers spoke a dialect called Chittagonian. By the time I arrived, he said he had a little grasp of the language, but mostly, he hung out with people

who spoke English, like the medical staff at the hospital.

I almost forgot my day in the delivery room at the hospital. The staff invited me to witness a baby's birth if I promised not to faint. I didn't faint and watched with interest. It was good not to be the mother, as they had to do a cesarean and ushered me out.

It was an unforgettable three weeks. When it was time to bid farewell, Paul accompanied me by van to Chittagong and then by an overnight train to the airport in Dhaka. Our train compartment resembled a scene from the 1974 film *Murder on the Orient Express*, with an air of mystery surrounding our travel. The journey to the toilet was an adventure. Navigating the train's narrow corridors, we carefully stepped over sleeping men scattered on the floor, creating an atmosphere reminiscent of a bygone era. Paul waited patiently outside the bathroom. The toilet seat resembled a horned saddle similar to that used when riding horseback. The bumpy train ride left me hoping I wouldn't fall off and find myself on the tracks below.

We returned to our compartment, where sleep eluded me, and uncertainty lingered. As dawn broke, Paul ensured I reached the airport for my onward journey. Our goodbyes weighed heavy on my heart, leaving my children in this unfamiliar land. His reassuring words echoed. "Don't worry about us, Mom. We'll be

fine." Still, the ache of parting lingered as I turned, waved goodbye, and embarked on my flight.

Airport layovers became a peculiar interlude in my solo adventure. I improvised a makeshift bed on the terminal floor, using my carry-on as a pillow while waiting for connecting flights. Upon reaching JFK, the embrace of familiarity greeted me as my son-in-law, Michael, picked me up. This homecoming marked the commencement of answering queries from friends and family about my extraordinary adventure. Little could I have expected that the plot would take an unforeseen turn.

Once back home, life resumed its usual rhythm. While rummaging through my tennis paraphernalia, I stumbled upon a relic—a Jack Kramer wood racquet made by Wilson, hidden in the depths of my closet. It was July 1991 when I had a bright idea and called the International Tennis Hall of Fame in Newport, Rhode Island. To my delight, they asked about my vintage racquet and offered me a ticket and prime seating for the matches on July 21 as a token of appreciation. Pam Shriver was the star player that day. It was a treat to watch her in action.

During an intermission, I stood to stretch my legs when a deep, booming voice echoed around me, saying, "Be still and know that I am God." I froze. Huh? Was that God speaking to me? I gasped and pinched myself

to make sure I wasn't dreaming. Sure enough, I was wide awake. I realized what I'd heard was a Bible verse. But why me? Feeling a mix of awe and confusion, I couldn't wait to get home and call my son Paul, who would surely know the verse. He quickly identified it as Psalm 46:10.

When I shared my divine encounter with my friends at AIM, their eyes widened with empathy and excitement. They leaned in closer, touched by the profound moment I had experienced. "How extraordinary," one of them said. "It seems you've heard a special message. Will you listen?"

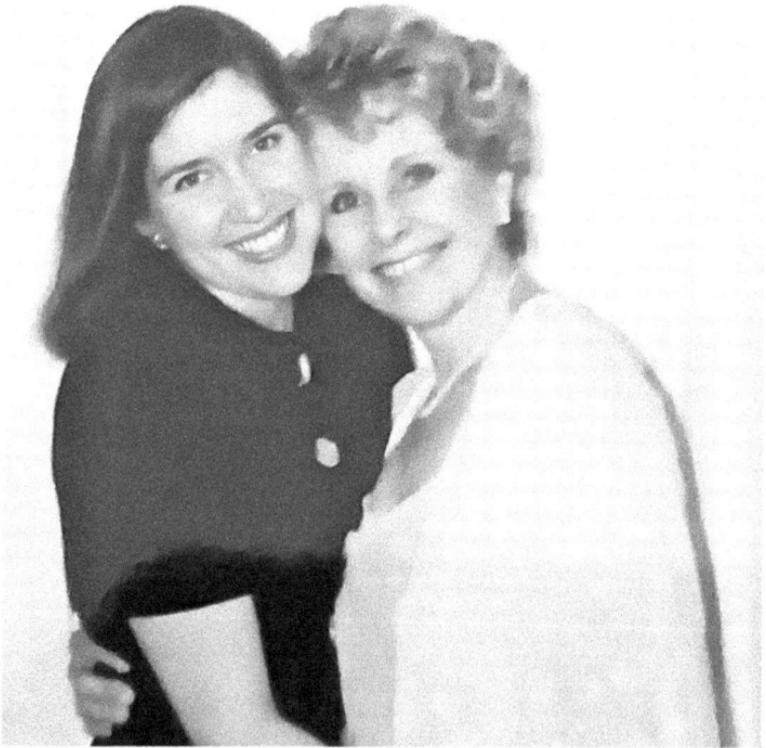

Rebecca the "matchmaker" & Gail

Chapter Thirty-seven
A Makeover & A Matchmaker ~ 1992

~~~

A s I bid farewell to my abode of twenty-three years, Gigi, my ever-blunt confidante, graced me with her signature honesty.

"Gail, it is important for you to present yourself with elegance as an interior designer. With the proceeds from selling your home, why not venture to New York and consult Dr. Thomas Loeb? He's the best plastic surgeon. He'll fix your neck."

I inherited a neck embellished with a poultry-like appendage—a familial legacy we all got stuck in our genetics. This physical trait, often associated with aging, was a source of self-consciousness and discomfort for me. Once upon a time, I held fast to the belief that such traits were irreversible. Even my patriarchal figures, possessed of undeniable charisma, bore a resemblance,

with my father sporting a similar feature and my charismatic brother carrying an excess of sagging skin. However, a shift in perspective followed when my friend clarified the prospect of transformation. Intrigued by the potential for a rejuvenated look, I eagerly awaited my rendezvous with Dr. Loeb.

In August of my fifty-sixth year, 1992, I had an appointment with Dr. Loeb for my new neck. Upon consultation, he reassured me, "Not to worry. I will attend to your problematic neck, which shall not resurface." Fast forward to my eighty-eighth year; his words rang true.

His discerning gaze then alighted upon my proboscis (nose), and he proposed a subtle refinement. "What's wrong with my nose? I like the way it is." Doc asserted that he could heighten its fine look further. Though content with my nose as it was, the call for enhancement proved irresistible. Our discourse then wandered to my eyes, and with a nonchalant shrug, I surrendered the illusion of autonomy. "Do what you want." Dr. Loeb adhered faithfully to our agreed-upon procedures with no illusion of a facelift.

The outcome was a triumph, and I daresay I would have received my mother's coveted approval. I nestled in my daughter Linda's care during recovery, and then, once the bandages unfurled, delighted with my rejuvenated neck, nose, and eyes, I resumed the duties of my

daily existence, seamlessly blending back into the fabric of life, unnoticed by the casual observer. Such subtleties often evade the notice of the uninitiated.

A FELLOW GYM enthusiast at the adjacent machine introduced herself only four months after my fashionable procedure with Dr. Loeb amid the clinks and clangs of weightlifting at the Westwood Racquet Ball Club. "Hi, I'm Rachel. I've noticed we're on the same workout schedule."

Returning the friendly gesture, I nodded and smiled. "Yes, I've noticed that as well."

One day, during a shared jogging session, my workout companion posed an unexpected question: "Would you be interested in meeting a man?"

"Who?" I asked.

"My best friend's dad."

Now, I will digress for a few moments to fill you in. After navigating the single life for the last seventeen years and weathering two engagements, I had become somewhat disillusioned with the elusive prospect of romance.

In my story I neglected to delve into the two signifi-

cant encounters, so let's dive in. One was Al, a divorced individual with adult children, who initially seemed promising, notably when he adorned my vacant ring finger with a substantial diamond. However, it didn't take long for his abusive tendencies to surface. His children and mine gathered, orchestrating a commendable effort to dismantle this ill-fated engagement.

The second saga was a crash course in compassion, understanding, and patience—all thanks to Ron, the bipolar agoraphobic maestro. His comfort zone was home, except for earning a living or catching divine vibes at church. Why did I get involved with him, you ask? He was a messianic Jew like me—a unique way to bring Jesus into the picture. Besides unraveling the mysteries of messianic melodies, Ron taught me to play the guitar. The main plot twist leading to our separation was his unexpected ultimatum. After being a key player in kickstarting my school, his ex-girlfriend suddenly appeared. That was when he dropped the shocker, demanding I choose between him and the school.

Seriously? Without missing a beat, I opted for the school, sending him off with blessings. As I returned the hefty sparkler he gave me, he presented me with his nylon string guitar handmade in Spain. Now, whoever heard of a breakup gift? And what a gift it was, no complaints here.

Rachel stood by, waiting for my answer.

"No thanks," I replied.

But then Rachel dropped the bombshell. "He's a top tennis player."

My obsession with tennis instantly overrode my skepticism. "Set it up," I declared, ever the tennis enthusiast. And so, my journey of selling my house and unexpected romantic possibilities took a turn with a touch of humor and a nose that had never looked better.

I had unloaded the man who taught me how to play the guitar, returned his engagement ring, merged my school into an established business school that became a college, headed up the design program for a brief three years, and found my dream job with AIM.

There's more to the story, and with a dash of past-tense wit, the rest is history, but keep reading for the details.

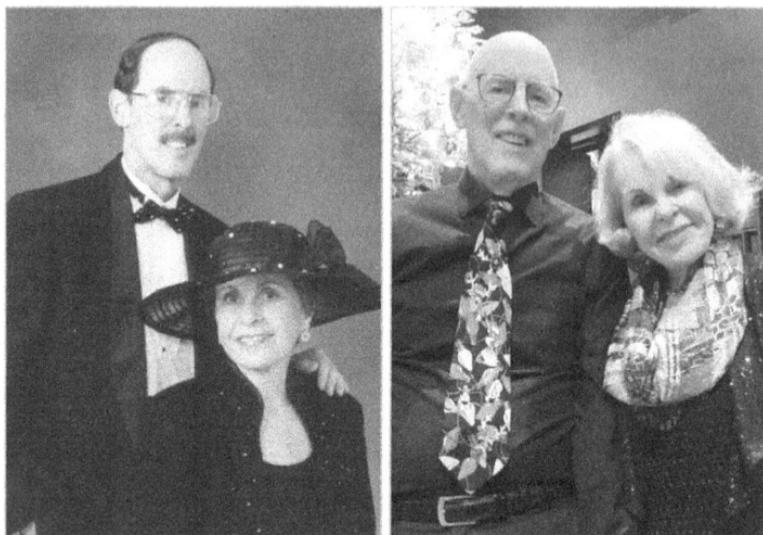

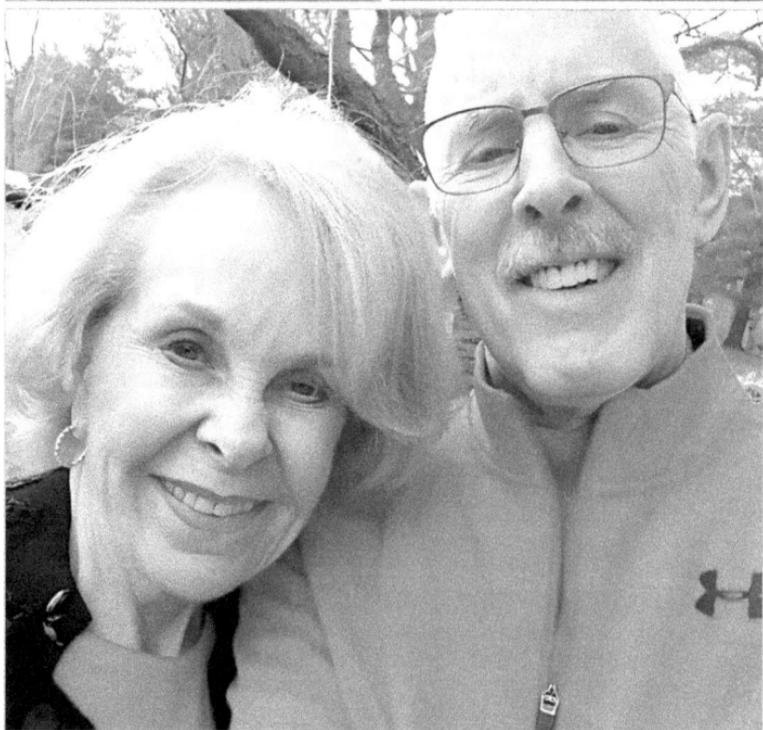

*Gail & Tom ~ A Love Story*

# Chapter Thirty-eight

## Gail & Tom: A Love Story ~ 1993

I glanced at my reflection in the vanity mirror, applying soft pink lipstick. My new look gave me confidence, but who was I kidding? Romance? A hint of nervous excitement fluttered within me. Who would have thought? At fifty-seven, divorced, and having given up on romance, I was about to embark on a blind date—a first, a tenth, maybe my last.

Opening my hand-painted (another one of my tricks of the trade) antique chest of drawers, I selected a bright, fluffy yellow sweater. I carefully slipped it on, and its warmth embraced me like a hug from an old friend.

With a few swift strokes of my fingers, I crisply creased the pleat of my black slacks, carefully chosen for their hoped-for slenderizing effect. New Jersey's

January chill prompted me to pull on warm socks before sliding into ankle-high black boots. One last glance in the long mirror made me wonder if my brother's voice was right. "If you're fat, you look fat."

I brushed aside the lingering doubt, focusing on the reflection of my short, blonde, wavy hair that shimmered around my face. Maybe, I thought, I'd dare ask for bangs at my next haircut. Whether to meet Tom, though, lingered. Was I in my right mind? Instead of dwelling on doubts, I closed my eyes and pictured adopting a Sheltie, the type of dog I once had and that was still my favorite fluffy dog breed. No turning back now.

I stepped into the bitter January night, wearing my winter coat and my purse over my shoulder. A short walk from my condo, over the railroad tracks into the heart of Park Ridge, the Ridge Diner awaited. The familiar hum of Sunday dinner chatter filled the air. It was New Year's weekend in 1993, and families indulged in traditional fare of meat loaf, mashed potatoes, and steamy broccoli specials.

As I walked down the aisle, nods and smiles from familiar faces greeted me. It was a neighborhood spot where the warmth of community wrapped around you like a cozy blanket, making you feel you belonged. The air buzzed with the lively energy of shared stories and

laughter, setting the stage for a meeting that would become a turning point in my life.

Rachel's parents, Barb and Warren, who were good friends of Tom, a lively duo with a love for laughter, played prominent roles in this evolving narrative. Warren must have said to Tom, "There's Gail."

As I approached the table, Tom stood as though we had already met. Oh my, he was aristocratic. Little did I know our meeting was about to uncover a string of coincidences, leaving us scratching our heads in disbelief. Tom was about to become a significant part of my life.

The uncertainty of life played out in a way that not even the most skilled storyteller could have scripted. It was an unassuming evening, with the familiar clatter of dishes and the soft hum of conversation creating the backdrop. But it was the shared laughter and stories that truly set the stage for what would become a love story for the ages, filling the air with joy and warmth.

Dressed in a striking ensemble of a red sweater paired with tan cords, Tom exuded a timeless charm that instantly caught my attention. As I looked at his appearance, an uncanny resemblance struck me—his mustache, his height, and that warm smile bore a striking likeness to my father, the most handsome of all my friend's fathers. Tom's summer-sky-blue eyes, a captivating hue mirrored by the open expanse of a clear

day, met mine with an easy warmth. The subtle crinkles at the corners of his eyes spoke of a lifetime of laughter and genuine kindness. As if extending an invitation into his world, he offered his hand with a graceful gesture.

The contact was immediate, his hand conveying a unique blend of softness and strength. In his hand-shake was a silent reassurance, a promise of sincerity. "Tom Claus. Pleased to meet you."

In those few words, a connection sparked. Tom's presence left an indelible impression, from his chosen attire to the sincerity in his handshake. Unknown was that this encounter would set the stage for a journey spanning decades filled with shared laughter, enduring love, and joy lingering in the heart's fondest memories. With our hands melding into one, I smiled and tucked my hair behind my ear. "Gail Ingis, pleased to meet you as well."

Barbara cleared her throat. "Hey, you two, why don't you sit down?"

He let go of my hand, leaving an emptiness. "Yeah, I guess we should," Tom said with a chuckle.

Tom and I sat across from each other, with Warren next to Tom and Barb beside me at the table.

After we agreed to have dessert, Tom chose cheese-cake. I would've liked the same, but I ordered tea only, always watching my carbs and fats. Our eyes connected and remained that way.

Tom and I had more in common than a shared friendship with Barb and Warren. It felt like the universe was playing a game of connect-the-dots. And let me tell you, the more we talked, the more those in-common oddities piled up like pancakes on a Sunday morning.

I inclined my head and said, "Oddly, life brought me to the Africa Inland Mission. While checking my Rolodex, I found a former student with the same surname as you. My boss verified she was your ex."

Tom's expression shifted, and he shook his head and raised his brow as I revealed the connection. "Really? Did you know that Rachel and my daughter are best friends?"

His blue gaze captured my heart. "Yes, she told me you were her best friend's father."

As the evening progressed, I did not have to manufacture the chemistry between Tom and me. Our shared laughter, the ease of our conversation, and the way our eyes met and held each other's gaze, all of it felt like a natural progression. The minutes turned into hours as the diner transformed into our private sanctuary.

Tom leaned his elbows on the table. "Tell me, how did you meet Rachel?"

"At the Westwood gym. She proposed setting me up with a man," I said.

"Who?" Tom inquired.

"You," I confessed, prompting a smile from him. "She said she had known you for years and added you were a Christian, divorced, and a top tennis player. That's when I said, 'Set it up.'"

"So here we are, and you love tennis?" Tom chuckled.

"Obsessed is more like it. I'm a teaching pro."

"Teaching pro? What do you mean?"

I took a deep breath. "I took a two-day exam, written and on-court, for teaching certification from the United States Professional Tennis Association."

"I'm a USTA member. Is that different?"

"Yes, the USTA is for the players. The USPTA members are certified tennis teachers."

I gave a gander over to our quiet friends sitting beside us. "Hey, are you hearing this conversation?"

Barb smiled. Warren rolled his eyes and asked how he could not, and both nodded enthusiastically.

"You're friends with a college student?" Tom asked.

"Why not? Rachel is fun and astute."

"But how did you get to know Barb and Warren?"

"Rachel asked me where I worked. When I said AIM, she laughed and told me Barb and Warren, her parents, worked there. I told her we were friends. She said she would tell her mother. Then Barb called me and asked if I wanted to meet you. I said yes. Then Barb

called you to ask if you would like to meet me. When you said yes, she set it up here at the Park Ridge diner."

Tom shook his head. "We're friends from church. Small world."

"Smaller than you think."

"Hey, you two, it's midnight. The diner's closing," Barb said. "Let's go. We'll take you home, Gail."

We stood outside the diner, saying our goodbyes. I didn't want the evening to end. And yet there I stood, my heart racing. Tom looked at Warren and Barb, then at me. "I'll take you home."

"Gail, what do you want to do?" Barb asked.

My heart fumbled. "Do you mind if I go with Tom?" I asked feeling like a teenager asking Mom permission, but I didn't want the evening to end.

Barb didn't laugh, but I was sure she wanted to. "Of course not."

"Thank you so much. I'm sorry if we weren't much company."

Barb smiled. "We didn't notice."

We all laughed.

Tom piped in. "I would like to spend more time getting to know you. Where can we go?"

"The bowling alley should be open." I felt pressured. If I didn't answer quickly, Tom might leave without me.

Tom shook his head. "Not the bowling alley. It's noisy, smoky, and smelly."

What else was open? Should I offer my place? Go for it.

"My condo is nearby if you promise to keep it friendly." I looked at Barb, who nodded.

The Days said goodnight and left. I sensed I could trust Tom, but my experiences in single life had left me wary of cheating husbands. I liked that he didn't have a wife to cheat on.

His smile warmed his eyes like honey in tea. "I promise."

Tom held the door of his 1972, beat-up, two-door, burgundy Toyota and handed me into the well-worn beige fabric seat. His car smelled musty, but it didn't matter for the short drive across the train tracks to the condo complex.

I gazed up at the sky to search for the Milky Way, but clouds covered anything that twinkled. My palms were sweaty, and my heart raced. Was I in the middle of a romantic moment? Had the stars obscured my vision, inviting this man into my home? But Barb gave me the nod of approval. I needed to stop being so reticent.

I unlocked the door to my condo; I'm not entirely sure I made the right decision. So what, if I was a woman of the world? Not by choice. I ignored the pounding in my head.

Tom and I settled in for a chat, trying to ease the awkwardness with some smooth tunes. He offered me a spot on the couch, but I opted for the floor, keeping it casual. We traded our musical tastes. Tom preferred country and gospel, while I was more of a classical afficionado. Our conversation weaved through childhood memories, my piano lessons, and his missed ones. As the night crept on, we reluctantly bid each other good night with a simple hug, promising to pick up where we left off. After I opened the garage door, he moved with graceful strides toward his car, and I savored his tall silhouette and visualized his elegance on the tennis court. The next day brought me back to reality, but the late-night chat left a lingering melody in the air.

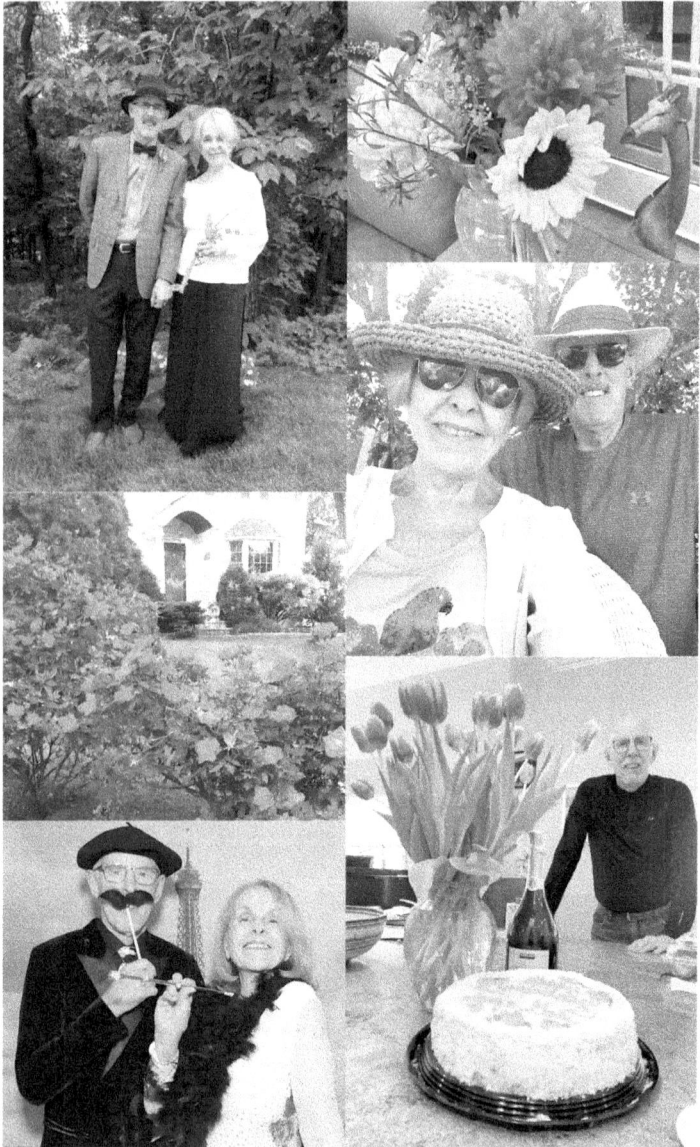

*Gail & Tom over the years*

# Chapter Thirty-nine
## The Agony and the Ecstasy ~ 1993

Time seemed to stretch like taffy in the ensuing days, and curiosity gnawed at me without a call for four sunsets. Did I inadvertently drive him away by disclosing my passion for saving things? Could it be he despised my yellow sweater? I recalled my former instructor at NYSID, Mr. Breckenridge, harboring a disdain for yellow. Yellow, disliked by a color expert, somehow made it acceptable. Was I perceived as too curvy? What on earth was the issue with this guy?

Despite embracing feminist ideals, I clung to the traditional expectation of waiting for the man to make the first call, and it unsettled me that he didn't even make a simple thank-you call. The uncertainty of whether I would cross paths with him again weighed heavily on my

mind. Torn by the ambiguity, I finally gave in and dialed Barb. "Tom hasn't called me," I said, suppressing my frustration. Of course, it wasn't Barb's fault he hadn't called, but as friends, I hoped she might offer some insight.

"Gail, Warren and I couldn't help but notice the chemistry brewing between you two at the diner. Your delightful facial expressions and the overall enjoyable vibe didn't go unnoticed—we were front-row spectators to the unfolding connection."

"I guess you can't answer for him, but I hoped you might know why he hasn't called. We had a fabulous time talking and sharing—until two in the morning."

"Who understands what's going on in his head? He's a good man, kind, caring. What more can I say?" Barb, the ever-curious cupid, took matters into her own hands and dialed Tom's number, nudging the wheels of fate.

Finally, he called. "Hi, Tom," I said, keeping my voice relaxed. It was impossible to remain calm. I had goose bumps all over.

Laughter danced through the phone lines as we shared a knowing chuckle about Barb's matchmaking antics. With that call, a door swung open, leading to more than a three-decade journey. His smooth voice was music to my ears, and the negativity dissipated with a sigh.

I hoped I didn't give away my thrill, but maybe that would be acceptable. Showing I liked him couldn't be a bad thing.

"Would you be up for dinner and a movie on Saturday night, the ninth?" he asked.

"I'd love that," I replied. Suppressing the urge to jump up and down joyfully in the office posed a real challenge. "But instead of going out, how about I make us a steak dinner?"

"I'll bring the wine." Tom's voice gave me a deep, warm buzz.

The following two days dragged on and on and on.

At seven on the dot, the doorbell rang. I wore my black leather slacks and a white cashmere cowl neck-line sweater. My ankle-length black boots were on my feet—soft pink lipstick and matching blush on my cheeks. My hair was fluffy and bouncy.

"You look beautiful, Gail."

Clean-shaven, Tom sported a white turtleneck beneath a red sweater paired with slim black corduroy slacks that stressed his broad shoulders. His neatly tied ordinary brown shoes left a brief impression on me. A pair of loafers would better complement his easy-going personality.

With my sincerest smile, I placed my hand over my heart and thanked him for his compliment.

"Mind keeping me company while I cook, or would you rather sit at the table?"

"Keeping you company would be my pleasure. Can I do anything for you?"

"The table's set." I handed him the salad plates. "Please put these on the place mats."

"My ex-wife furnished our house in Ethan Allen style. Your style is new to me."

"I won't ask if you like contemporary," I said. "I will ask if you like New York strip steak and how you like it cooked?"

"It's my favorite, medium-rare."

"Does Caesar's salad appetizer pass muster with you?"

"Yes. If given a choice, I opt for Caesar's salad."

Those words rang through my head like the sweet sounds of a violin. I'd chosen an appetizer he liked.

"Open the wine?" I handed him the corkscrew.

"Sure."

"Let's have the salad while the steak is cooking," I said, removing my apron.

He popped the cork and poured us the wine. "When's your birthday?" he asked.

That question came out of the blue. I had yet to learn about his age. Did I look like a senior? I never let my age deter me, but that question could make or break a relationship.

"I'll be fifty-eight, the first day of November," I said. "You?"

"I have a birthday coming up, January seventeenth."

"What birthday is it?"

"I'll be fifty," he said.

We polished off our salads, and Tom efficiently loaded the dishes into the dishwasher. I then presented the pièce de résistance—braised steaks accompanied by freshly baked, steamy potatoes. The melted butter cascaded over the top, with bacon and sour cream on the side. The aroma wafting through my condo was reminiscent of my favorite spot, New York's Delmonico's Steak House.

I took a deep breath. "I've got seven years on you. How do you feel about that?"

Tom gave me a warm honey smile. "What's seven years?" he said, taking my hand.

I raised my glass. Tom clinked his with mine.

"Do you mind talking about your ex?" I asked.

Tom tipped his head. "What would you like to know?"

"Tell me, why divorce?" I took a piece of steak.

"She was unhappy, moved out, and left the kids with me. What about you?"

I finished chewing before answering. "Bob had a mistress. He was quite the gadabout, running around for years without my knowledge. Then one day he came

home and proposed an open marriage, eventually resulting in divorce. It was a sorrowful ordeal for everyone, but we all persevered. I've navigated through seventeen years of singlehood with two engagements. I eventually stopped dating altogether, so meeting you was an unexpected and refreshing twist. Turning fifty calls for a party. Let's celebrate."

"Sunday, the seventeenth?" he asked.

I smiled. "I'm glad your birthday ended up on the weekend."

"Sounds like a fantastic plan." He savored a sip of his wine.

An hour later, we nestled into our seats in the theater, anticipating the opening credits of the recently Oscar-nominated film *A Few Good Men*. Luck had graced us with the last two seats in the front row, a golden ticket to an unobstructed view of the cinematic magic about to unfold. From our prime position, I could feast my eyes on the actors' every expression, and even my less-than-perfect hearing found solace in the clear enunciation of their lines, drawing us into its captivating world.

Tom gently held my hand during this journey, sensing the plot's upcoming twist. His warm breath tickled my ear as he leaned in and whispered, "I've seen the movie. You won't like this next part," punctuating his words with a reassuring squeeze of my hand. In that

simple gesture, amidst the flickering lights of the theater, his compassion enveloped me, turning a shared movie night into a touching connection that outdid the silver screen.

A marine lieutenant colonel placed a pistol barrel in his mouth and pulled the trigger, splattering blood and brains over the walls and floor. My stomach churned as I squeezed my eyes shut. I'm not sure Tom holding my hand made the scene more tolerable, but I welcomed his warmth and concern. After the movie, Tom took me home. We went in through the garage and said good night. Standing beside my car, we kissed, and then Tom got into his vehicle in the driveway, his window open. My stomach was queasy. I wanted another kiss.

"Can I have another one of those?" I asked, dabbing my lips, savoring the lingering taste of the moment.

"Yes," he replied with a grin. He gracefully exited the car to get another one of the delightful treats.

I met him with a kiss—not fueled by passion, but by a gentle warmth and affection. Our connection spoke in the language of tenderness, a silent conversation that resonated in the quiet intimacy of the evening.

"Good night," I said, breaking away from the kiss with a contented smile. The sentiment lingered in the air like a sweet aftertaste.

The next day, his voice, akin to a melodic flute, danced through the receiver.

"Thank you for a delicious steak dinner," he said, the gratitude wrapping around his words like a familiar tune. In that moment, the flavors of the night before lingered in our memories, creating shared experiences that transcended a simple meal.

"Don't thank me, just send flowers," I quipped, injecting a playful note into the air. In that lighthearted moment, the idea of flowers became a whimsical currency of appreciation, a colorful gesture to express the unspoken gratitude that bloomed between us.

As I entered AIM on Monday morning, flowers and thank-you balloons arrived at the mission. "Oops." I nearly stumbled over the poor chap making the delivery. "Sorry."

The man from the florist smiled. "No problem." He walked to the information desk.

I was going down the hall to my office when I heard footsteps not far behind. He headed my way.

"I'm looking for Gail Ingis. Can you point her out?"

As I entered my office, I raised my hand. "You've found her."

The delivery man handed it all to me—gorgeous flowers, their fragrance reminiscent of roses encircling me. Balloons adorned with ribbons and bows accompanied a heartfelt thank-you note.

The bookkeeper, Elaine, rushed over to me. "What's all this, Gail? Did you see the card?"

I tilted my head to the side, unable to comprehend all the commotion. It could be a moment of confusion. I nodded to Elaine and gave her a rose. Tom had been married to the finance director's assistant. A wry smile played on my lips in that shared moment of recognition. The tangled web of connections and past relationships seemed to weave into the present.

News of "Tom and Gail" flowed like a river through the entire company. The whispers and glances exchanged in hushed tones painted a vivid picture of intrigue. I shook my head, amused by the current of gossip, and kept my giggle to myself. Amid the corporate river, I navigated the waves of speculation with a knowing smile, relishing the private amusement of a story unfolding in the public eye.

THE MUCH-ANTICIPATED day of Tom's fiftieth arrived, Sunday, the seventeenth of January. As I opened my front door, there stood Tom, balancing flowers in one hand and a bottle of wine in the other.

"It's your birthday, Tom, but you brought wine and flowers. How lovely. Please come in," I said. In that simple gesture, the air filled with the spirit of cama-

raderie and the joy of shared moments, turning the threshold into a portal of celebration and connection.

The table was a vision of celebration, draped in the timeless elegance of Portmeirion, and at its center, I placed a tall vase overflowing with Tom's vibrant, thoughtful flowers. Two tall red candles stood proudly, their flames dancing and casting a warm, glittering glow over the table, making everything shimmer with a golden hue.

The spread before us was nothing short of a culinary masterpiece, a symphony of flavors that beckoned the taste buds to a feast. The succulent roast, with its outer layer perfectly crisp and an interior that remained juicy and tender, took center stage. Surrounding it was a vibrant display of colors and textures—velvety mashed potatoes, luscious green beans sautéed in butter, and a medley of roasted vegetables, each piece glistening with a mouthwatering glaze.

ON THE STOVE, the gravy simmered, its rich aroma mingling with the scents that filled the air, promising to cascade into the center of the mashed potatoes. The ambiance was one of pure delight, as though the setting

itself was celebrating along with us, bathed in the soft, glowing light of the glittering candles.

We delighted in every bite, savoring the flavors that mirrored the beautiful atmosphere. Dinner finished, the buttercream birthday cake, adorned with five flickering candles, each representing a decade of Tom's adventures, was a perfect dessert. The entire scene was a visual and aromatic symphony, celebrating Tom's milestone with lighthearted joy.

Tom and I transitioned to post-meal rituals, enjoying the last morsel. We swiftly cleared the table, loaded the dishwasher, and set the stereo to play—a perfect encore to a delightful feast.

As Tom settled onto the sofa, I announced, "I'll be right back," and disappeared into my bedroom to get his gift. Upon my return, I handed Tom a small box wrapped in gold ribbon. He looked at me quizzically and asked, "What's this?" with his gaze locked on mine.

"Open it, please," I said, sitting beside him on the sofa. His eyes widened—a subtle surprise painted across his face. "I'm speechless. A birthday gift is unexpected. Thank you, but that doesn't quite cover it."

After he opened his present, I leaned in with a smile and asked, "Would you like help to put it on?" He hesitated for a moment, his eyes scanning the room as if seeking silent approval, a hint of bashfulness in his demeanor. But then, with a quiet resolve, he extended

his left hand, passing me the exquisite yellow gold bracelet. Each link, meticulously crafted, caught the light with a dazzling brilliance, shimmering as though each piece was infused with sunlight. I carefully clasped it around his wrist, feeling the weight and smoothness of the gold against my fingers. "I've never had anything so beautiful."

"It fits perfectly," I remarked with a touch of satisfaction, as though I had measured his wrist myself. The bracelet now rested elegantly against his skin, a perfect blend of luxury and understated elegance. "Happy birthday, Tom."

We walked down to the garage. "May I kiss you?" Tom asked.

"Yes, I would like that."

He took me in his arms. His lips were warm and soft. I didn't want him to leave. My heart pounded as he got into his car, and I watched him pull away.

On a radiant morning, eighteen days into 1993, to commemorate Tom's birthday the day before, I arranged for flowers and balloons to get delivered to his workplace at Lederle, as he did for me thanking me for the movie night dinner. The floral masterpiece traversed the campus to reach the main office. Tom retrieved the festive arrangement and proudly displayed it for everyone to admire as he carried it back to his office at the other end of the campus. He

expressed his gratitude in a phone call filled with laughter, deeming it a "great idea." His office became a floral haven, complete with festive balloons, sparking good-natured teasing from his colleagues.

Amid the playful banter, Tom faced the comical challenge of fitting his birthday bounty into his compact Toyota. Later, he recounted the amusing ordeal, taking it all in good spirits.

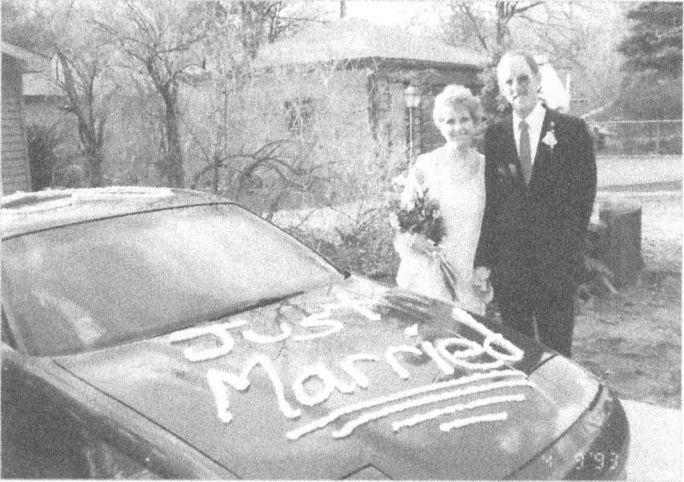

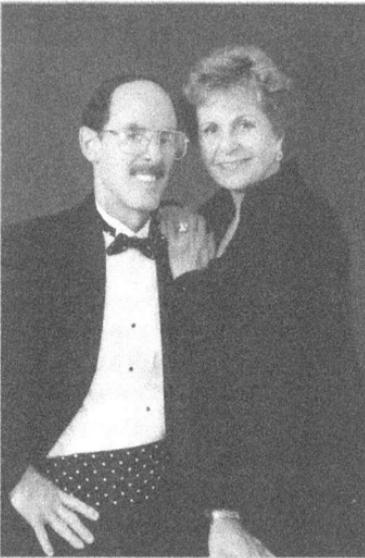

*Happily Ever After - April 9, 1993*

# Chapter Forty
## Gail and Tom's Wedding ~ April 9, 1993

**T**hree months had passed, and we were standing together, ready to start a new chapter as husband and wife. The decision to embark on this journey between two wholly different yet compatible individuals felt as natural as breathing. Tom's family, a warm and welcoming group, played a significant role in our wedding. They gathered to witness the union of two souls, contributed to the preparations, and added their unique touch to the ceremony.

Anticipation and love filled the air, weaving emotions etched forever in our memories. Rachel, a cherished friend who had played a significant role in our lives, since she introduced us, radiated her love and support. As she fussed over me, smoothing my hair and

adding blush to my cheeks, I couldn't help but reflect on how profoundly she had changed my life. She became integral to our story through her friendship, leaving an indelible mark we would forever treasure.

Tom adorned himself in the traditional attire befitting a groom, opting for a striped dark suit paired with a pristine white shirt, the epitome of elegance. Yet, characteristically, he added a burst of vibrancy to his ensemble with one of his most colorful ties, each designed to outshine the last. Meanwhile, I dressed for the occasion in a lace-infused cocktail dress, a soft hue of pale pink enveloping me in a subtle aura of sophistication. The silvery shoes I slipped into had not only weathered the passage of time but also symbolized the enduring legacy of my role as the mother of the bride, a title I had proudly held for my daughter, Linda, fourteen years prior. Remarkably, they kept their enchanting fit. As the moment to exchange vows approached, I attended to the meticulous details of my attire. A subtle gesture traced down my dress, ensuring an immaculate appearance.

Our journey had reached this significant milestone under the watchful eyes of Tom's brother, Bob, a pastor whose calming presence and spiritual guidance would bind us in matrimony—this sacred union, set in River Forest, Illinois, at Tom's brother David and Esther's home. Mother Claus, eighty-three years old, was

standing by a picturesque backdrop that embraced the moment's significance.

Presiding over the ceremony on April 9, 1993, Bob's words resonated with timeless grace, reflecting the wisdom gained from his years of pastoral service. The exchange of vows echoed through the sacred space, and we embarked on a journey as life partners in the company of our nearest and dearest. We exchanged vows with Jesus as the central figure in this union, recognizing it as a significant part of God's plan.

Amid the solemnity of the ceremony, an unexpected burst of joy erupted as my youngest son, Paul, and his wife, Joanne, added their musical touch to the celebration. Paul, a talented guitarist, strummed the strings with a melodic grace that filled the air. The familiar guitar notes signaled the beginning of a dance that transcended cultures—the hora. This unexpected musical interlude added a unique and joyous element to our wedding, making it even more memorable.

In a delightful fusion of traditions, we swirled and twirled to the lively rhythm of the dance that originated in Jewish celebrations. The energy was contagious, and we happily spun in circles, lifted in our chairs by Tom's brothers. With its roots in Jewish culture, this dance was a beautiful symbol of the unity and joy our marriage was bringing together. With open hearts, Tom's family

embraced the spirited celebration rooted in their Christian beliefs.

Laughter echoed through the air, breaking down any perceived barriers between traditions. It was a beautiful reminder that love, in all its forms, can bridge gaps and create harmony. A profound sense of unity prevailed in that dance beneath the Illinois sky, surrounded by familial ties and cultural exchanges.

And so, the story unfolds—a tale of chance encounters, laughter-fueled calls, and the magic of a life built together. It is an epic narrative of love and connection, with each passing day adding a new brushstroke to the canvas of our shared existence.

Our journey together is like a beautifully composed melody, each note blending seamlessly with the next to create a symphony of love and unity. From the moment Tom and I stood hand in hand at the threshold of marriage, it felt as though destiny had orchestrated a truly extraordinary partnership.

*Tigers & Zebras & Giraffes, Oh My!*
*Gail & Tom's trip to Africa*
*Photos by Gail Ingis (Nikon 900)*

# Chapter Forty-one
## The Winning Ticket: Amsterdam to Africa ~ 1995

N ow, buckle up for the tale of the winning ticket that would take us anywhere in the world! In the summer of '94, the Pathmark Supermarket Company sponsored the Tennis Classic at Ramapo College in Mahwah, New Jersey. Being tennis fans, we strolled into the event onto a welcoming promenade lined with tents and people bombarding us with commands to take this, buy that, and fill out tickets for a chance to win whatever. Not one to shy away from a potential jackpot, I filled out every ticket. Tom caught up with me as I was about to drop my last one in the bucket.

"Why bother? You'll never win anything," he said.

"What have we got to lose? Maybe we'll get lucky!" I replied, defiantly dropping my ticket into the mix. Off

we went to enjoy the tennis action. Two weeks later, while at AIM, I received an unexpected phone call.

"Hello, this is the Pathmark Tennis sponsor. You've won a trip, including airfare for two, courtesy of Marriott—seven days and six nights, anywhere in the United States."

I couldn't help but be skeptical. "Come on, who is this?"

The voice on the other end reassured me. "This is the Pathmark Tennis sponsor, and you are a winner."

"Seriously? This isn't a joke?"

"No joke, I promise. So, where's your dream destination?"

Dreaming big, I inquired, "Is it limited to the States, or are we talking anywhere in the world?"

The voice said, "Maybe. We might have to cut a day off the trip. Would that work?"

Oh Lord, am I dreaming this? "Yes! I'd love to go to England but must check with my husband. Can I call you back?"

"Absolutely. Here's my number. Looking forward to it!"

Choosing London, England, was not driven by its regal allure or tea traditions but by the practical consideration of familiarity with the language and the possibility of flying from there to Kenya, Africa, to visit the AIM mission and see parts of the country.

The following April, we flew British Airways to London and spent the night at the Foreign Mission House, an affiliate of AIM. The next day, we flew to Amsterdam, compliments of British Airways. We rented a car and spent a couple hours getting lost, but after going the wrong way several times, we found the Marriott. Our week in Amsterdam played out like a well-scripted mystery novel with a chance encounter in the Marriott elevator.

A friendly lady greeted us one morning as she stepped in.

"I'm Caroline Peterson from Fairfield, Connecticut. Where are you from?" she asked.

I smiled. "We live in New Jersey."

Small talk ensued while we walked to the concierge lounge for a complimentary breakfast. "I know a Peterson where I work," I said, not giving much thought to that remark.

"Where do you work?" she asked.

"The Africa Inland Mission in Pearl River, New York."

"Is his name Glen?" she asked.

"Yes."

"He's our son."

We laughed and agreed it was a small world indeed. After breakfast and meeting Carolyn's husband, Paul,

we laughed again about this odd meeting clear across the big pond.

Tom and I said our goodbyes and agreed to meet the Petersons back in the States. Off we went to explore Amsterdam on foot. We toured Anne Frank's house and walked through the famous Red Light District, one of Amsterdam's oldest neighborhoods. The area has narrow, winding streets and picturesque canals. Contrary to its once notorious reputation, the district felt safe during the daytime. But in any case, we wore our money belts under our clothes, a smart idea in any city.

Keukenhof Gardens, known as "Tulip Town," near Lisse, captivated us. We happened to be there when the tulips were in full bloom. The vibrant hues and myriad of tulips stretched as far as the eye could see. The sweet scent of blooming flowers filled the air, creating a sensory symphony. Every corner of the garden was a masterpiece. It was a glorious glimpse into the beauty of Dutch horticulture. The Dutch windmills dotting the landscape added a touch of charm.

My goal when we visited Holland was to visit Utrecht. I wanted to see the architecture of Gerrit Rietveld, which I had lectured about for years, but we got lost. The map was no help. Utrecht was where the Rietveld Schroder House stood, the masterpiece of modern architecture built in 1924. The house displayed

his popular red-blue chair, a fantastic example of the De Stijl movement with primary colors, geometric shapes, and asymmetry. One of the students at my school, the Interior Design Institute, created a winning model of this iconic red-blue chair. Rietveld's influence extended to the Vincent van Gogh's Museum in Amsterdam. We headed back to the hotel, returned the car to the rental agency, and walked to the museum.

We had every intention of buying tickets, but as we stood in line, a kind stranger handed us two tickets! We thanked the man, and he offered a nod. Our intentions were to visit Van Gogh's *Sunflowers, The Bedroom*, and *Irises*. Van Gogh lends character and color to his flowers rather than botanical accuracy. He voluntarily admitted to an asylum in Saint-Remy, where he created some of his most celebrated works. We spent about an hour and a half admiring his work.

We finished Marriott's free trip, paid for the journey to Nairobi, Kenya, and caught a sweet deal by flying out of London. Thanks to my AIM affiliation, our destination was the AIM Rift Valley Academy, a Christian boarding school and community in Kijabe, Kenya.

The Barnetts and the Taylors, our hosts and AIM missionaries, were not just guides but also our companions on this African odyssey. Their unique blend of hospitality and safari expertise infused our journey with a sense of adventure and camaraderie. Every

moment was a treat of a lifetime, from safaris to retreats in luxurious cottages. Our African adventure with the missionaries was wild, full of laughter, unexpected twists, and a few bathroom detours. Our electrifying safaris whisked us away to the wild wonders of Masai Mara and the breathtaking landscapes of Amboseli National Park, where we reveled in the thrill of overnight adventures in both!

We bounced along rugged trails, the jeep's suspension making its best impression of a pogo stick, while we played a thrilling game of spot the safari superstar.

Our first encounter was with a pride of lions, their regal presence unmistakable as they lounged in the shade. Then, a leopard lazily draped over a tree branch eyed us with the disinterest only a big cat can muster. Giraffes sauntered gracefully across the plains, their long necks swaying gently like slow-motion dancers. Zebras, with their snazzy striped suits, mingled with wildebeests, who seemed to be perpetually auditioning for a running competition. Each sighting was a testament to the rich biodiversity of the African plains.

We were lucky enough to spot a hippopotamus peeking out of the water, its eyes and ears barely visible above the surface. And, just when we thought we had seen it all, a rare sighting of a tiger treated us—yes, a tiger! Although not native to Africa, this beauty was part of a unique conservation project. Antelopes

bounded gracefully through the grasslands, adding to the richness of wildlife.

We basked in the resplendent glory of the sunset, where the acacia trees stood like golden sentinels against a landscape ablaze with vibrant hues. Every shade of orange, pink, and purple danced across the sky, as if the heavens themselves were putting on a grand finale just for us. The adventure, far from over, seemed to be merely reveling in the breathtaking beauty of nature's masterpiece. Our accommodations offered a front-row seat to nature's nocturnal ballet. So many animals came to drink at the watering hole under the cover of darkness. We watched in awe as elephants, hyenas, and even the occasional rhino made their way to the water. Despite their differences, they seemed to respect each other's space, like a well-rehearsed dance troupe performing a nightly routine. It was a fascinating sight, and we felt like privileged audience members at the greatest show on Earth.

The missionaries had acclimated to the local cuisine like true food warriors, showcasing their experience as seasoned travelers. We were still earning our culinary stripes. Case in point: the roasted corn incident. I naively thought, "How bad could it be?" Bad. Very bad. Let's say I had an unplanned marathon session in the bathroom later. The missionaries chuckled knowingly and gave me that "we warned you"

look while I swore off roasted corn forever. Of course, Tom succumbed as well.

Our journey wasn't all about wildlife, though. We also immersed ourselves in the local culture. A charming stop to buy handmade belts from local women was a highlight. Each belt was a testament to their skill and creativity. I tried to haggle like a pro, but they politely giggled at my attempts. In the end, I probably overpaid, but those smiles were worth every extra shilling. It was a small but meaningful interaction that added a cultural depth to our adventure.

Throughout our travels, the missionaries showed us the ropes as we climbed in and out of our safari jeep. They had adapted seamlessly to the local way of life, and their stories of past adventures kept us entertained and inspired.

As the plane carried us away from African soil, the echoes of those two weeks lingered—like a beautiful melody echoing back to the Africa Inland Mission. This African escapade became a unique chapter in our lives, filled with surprises, remarkable experiences, and the opportunity to explore new territories. Africa gave us more than just memories; it gave us stories to tell, laughter to share, and a newfound appreciation for well-cooked corn. We left with our hearts full and our luggage bulging with handmade belts, wood-carved animals, stunning photos, and priceless experiences.

*A Passion for Art and Music*
*Gail and Stephanie Bower;*
*Sketching in Sedona;*
*Painting workshop;*
*Speaking at senior center;*
*Strumming with Tom at an art show;*
*Tickling the ivories*

# Chapter Forty-two
## There's No Place Like Home ~ 1996

W e packed up our lives three months after our whirlwind return from Africa. New Jersey welcomed us with autumn's finest parade, flaunting leaves in shades of scarlet, butter yellow, and tangerine. The ground was a colorful, musty mosaic. It was a season that conjured up memories of spiced cider, blazing bonfires, and the fragrant embrace of pine trees—oh, and the inevitable sweater itchiness that always accompanied our fall adventures.

American Home Products swooped in and gobbled up American Cyanamid Company (parent company of Lederle Laboratories), thrusting Tom and me into the uncertainty of Princeton, New Jersey. There was no promise of job security, just a corporate game of musical chairs. But wait, there's more! Like a scene from

a job market thriller, Bayer Corporation knocked on our door in Montvale, New Jersey, with an offer for Tom in West Haven, Connecticut, seventy-five miles away. This commute would make even the most patient consider a career change to a stay-at-home professional.

I'd spent years brainwashing—er, encouraging—my children to always come home. "Home is where we're all together. Don't move away. Go to school, and come back. No matter where you go, come back home." So, I remarried, and Tom's job whisked us away to Connecticut. It was just an hour and a half away, but somehow, it felt like a different galaxy—no more spontaneous family drop-ins. Everything required planning. My whole family—children, grandchildren, and now my great-grandchildren, remained in New Jersey, but they might as well have been on Mars. Thank goodness for FaceTime, the modern miracle that connected us across the void.

When I mentioned we were temporarily moving to Branford, Connecticut, Tom's mother, Trudi Harrison Claus, informed us that her ancestors founded Branford in 1644. Her words inspired us to learn about the Harrison Heritage. This dovetailed with my historic home obsession garnered in design school. We discovered the Harrison House on Main Street, steeped in history, built in 1724. Originally built around 1680, it was

the second iteration after the original succumbed to fire.

We stepped inside, greeted by the scent of aged wood and the whispers of yesteryear. Tucked away in the kitchen was a journal from Captain Thomas Harrison, a Civil War veteran, coincidentally sharing my husband's first and middle name. The pages, in considerably good condition and intact, unveiled the richness of Harrison's history, urging future generations to continue the legacy. I copied a few pages before the docents clamped down. Tragically, during renovations, the book vanished. I called the town hall, asked about it, and visited the Branford Blackstone Memorial Library. No one knew what I was talking about. I suspected a Harrison House employee with the Harrison last name had a sticky-fingered streak. It's maddening to think anyone could abscond with such a family treasure.

We rented a condo for six months in Branford while designing and building our dream house in Madison, Connecticut. The popular shoreline small-town community was a mere fourteen miles from Branford. That short drive was simple to navigate to check on the building process. We infused our desires into every brick, every beam, and every corner and added a studio. The room was an expanse bathed in northern light, where colors were true and vibrant for my art. The

bookcases I had built in Montvale found their rightful place in the studio, completing the masterpiece of our new home. It was in Madison where I bloomed into a watercolor landscape painter. Those four years in Madison were a carnival of adventures and artistic escapades.

The legendary Bob Murray and the unforgettable Mr. Breckenridge, two of the finest instructors at the school, hammered the watercolor process into my brain at the NYSID. Their wisdom in color and form shepherded me from the regimented halls of design school to the boundless, free-flowing expanses of watercolor landscapes. Ah, Mr. Breckenridge! How could I forget the day he demanded I mix fifty shades of white for an interior project? Fifty shades of white! I thought he was joking. Who knew there were that many? Each subtle variation was a lesson in the nuances of color. Mixing custom colors became my hallmark, and every brush-stroke and hue was a joyful reminder of the laughter, lessons, and slightly insane challenges that had shaped my journey. Imagine explaining to friends that I was now an expert in white—from ghostly to ghastly and everything in between!

I enlisted in the masterful workshops of Lou Bonamart and Judy Betts, breathing life into my artwork. I discovered that the fluidity and mingling of watercolor were the beauty of the medium. On several summer

weekends, Tom and I set up our tent and panels at art festivals in local Connecticut towns, meeting and greeting new collectors. The Guilford Art & Craft Show was a steadfast fixture on our artistic calendar, a tribute to our unwavering dedication despite summer's sweltering heat and humidity. However, my curiosity soon stretched beyond watercolor to other mediums. Studying at Lyme Art Association with Charles Gruppe, I delved into acrylics then oil.

Fascinated by the transition from watercolor, I signed up for classes at Lyme Academy, immersing myself in portrait and figure painting. As part of my artistic journey, I modeled for several artists in Diane Aeschliman and Jack Montmeat's workshop at Lyme Art Association. Modeling gave me a new perspective on art. For three consecutive Tuesdays, I was a steadfast statue sitting in the same position for forty-minute intervals from ten to four, with a lunch break. My reward was the purchase of two terrific portraits, providing me with impressive examples to follow. Diane also painted Tom's portrait during several private sittings.

Continuing to develop my skills in the arts, I enjoyed the challenges and insights that came with working with different instructors. Art wasn't my only passion. Dancing had been a vital part of my youth and remained an activity well into adulthood. My passion

spanned ballet, tap, modern dance, social, and ballroom. The Lindy was the swing of my teenage years; its energetic twists and turns left me breathless and exhilarated, and it still does! I even danced on roller skates to organ music, as I described in an earlier chapter.

Dancing isn't just an activity; it's a sensory experience that bring color, sound, and movement into my life, weaving itself into the fabric of who I am. In Madison, I discovered clogging and danced every Monday evening in the Madison Recreation Center with a lively group of ladies. A woman led us, who, as a child, tap-danced on Sunday's *The Children's Hour* hosted by Ralph Edwards. I remember listening to the program with my father. The rhythmic clatter of tap shoes on the wooden floor was music to my ears, a symphony of percussive beats that made my heart race. Our group danced to songs like Willie Nelson's "On the Road Again." Wherever there was music, I was close by. We jammed with a Guilford music group. Tom played his dobro, and I played my Martin guitar.

We had our music but missed our New Jersey family. They were a two-hour drive from Madison. So, in 1999, we sold our Madison house and moved to Fairfield, a bustling little metropolis thirty-five miles closer to our family. This was an easier commute for Tom to West Haven. Besides, Fairfield was much more my style. Having grown up across from the BMT train lines, I

loved the sounds of a city. All the conveniences were within walking distance: the supermarket, Trader Joe's, and my beauty salon.

Black Rock Church invited us to sing in the choir. That inspired us to take voice lessons to ensure we would not abuse our voices. Tom didn't think he knew how to sing. It was a revelation for him. He learned how to move his voice from bass to tenor. "Fascinating," he said. I had voice lessons when I was seventeen and took them sporadically through the years.

We enjoyed our new relationship with the local church. But first, despite the conditional invitation, we had to try out for the choir director, Jim Marshall. I sang in my soprano voice to audition. It was a pleasant change switching from alto, which I had sung in my Montvale church. I learned how to strengthen my voice in whatever range I chose. The adage was critical: practice makes perfect. Tom wanted to sing tenor, so that's where Jim placed him. But he could also sing bass. He continued taking lessons on his resophonic guitar (dobro) with Stacy Phillips. This instrument is a guitar with a hubcap in the middle. It has six strings, similar to a guitar, but it's more challenging to learn.

I was busy painting and didn't make time to play my Baldwin upright piano or guitar. However, my dream of owning a baby grand was about to come true. New friends at Black Rock mentioned they were moving and

had a baby grand piano to sell. I couldn't believe it. I bought into my dream and placed the piano in our great room. My piano tuner comes every year to keep it sounding sweet.

Back to my portrait painting saga. I found a new instructor in Bedford, New York. Laurel was amazing. We made a deal: she would keep me rolling in portraits and I would do interior design work for her home. I loved bartering, so that was perfect. I painted all kinds of portraits, getting more adept. Laurel discovered my other skills in drawing and painting and asked how I would feel diverting from human portraits to Coney Island subjects? The Wonder Wheel, in fact. I bought a four-by-five-foot canvas to create the portrait. I loved the idea—landscapes and architecture were more my style. I schlepped this canvas to her studio in my car every week and painted. So now you know how the cover of this memoir was born.

Time's ticking, and I'm not getting any younger. In 2002, I geared up to tackle my weight with the help of my scientist husband. He spent his professional life finding new drugs for type 2 diabetes. The process of weight gain and keeping it under control is tricky. Tom does not have a weight problem, but he encouraged me each step of the way. I went on a low-carb diet and changed my relationship with food. A year and a half and thirty-five pounds later, my weight was acceptable.

I took it off and have kept it off. Over the years, I took off another ten. Nothing tastes better than feeling great and enjoying fabulous fashions. The scale, my unwavering companion, joins me in this enduring adventure a few times a week. I check in regularly to make sure I stay the course, a steadfast reminder of my journey. Recently, I discovered Ivor Cummins and Jeffry Gerber, MD, my nephew, who speak eloquently about the low-carb lifestyle changes in their book, *Eat Rich Live Long*. Published in 2018, the book shares a treasure trove of ideas for weight loss and healthy living, helping countless others to lead fulfilling lives.

Many women and men (yes, men) have asked me about my healthy, glowing skin at eighty-eight. I owe my smooth and mostly wrinkle-free facial appearance to a combination of facial creams I've used for the last thirty years and Botox for the last ten. Occasionally I have a facial, such as Forma. I make sure there's no alcohol, no parabens, no ETDAs in any product I use for my face and body. It's never too soon to take good care of yourself. I use a facial cleanser and rinse with tepid water at night, a toner after the cleanser has removed the day's residue. Choose a clean serum, stroking upward from the neck and decolletage, let it dry, and apply a clean cream for the night.

When you see your skin needs more hydrating, add the routine to the morning. There are several facial

treatments to choose from. I found options available through a cosmetic surgeon or dermatologist.

Beyond these treatments, I also credit my skin's vitality to a balanced lifestyle. Staying hydrated, eating nutritious foods, and protecting my skin from excessive sun exposure have all played crucial roles. Embracing a positive mindset and finding joy in everyday moments have also contributed.

Back to my art career, coinciding with workshops at Silvermine with David Dunlop. I dove back into my painting with renewed passion, painting landscapes and architecture. After fourteen years of outdoor festivals, we no longer took part. But the experience was enjoyable and profitable. To pass the creative torch, we donated our traveling equipment to Miggs Burroughs, an artist, good friend, and designer of this memoir book cover. Our tent, panels, panel covers, and lights were all passed on for others to use. I continued to create art, maintained art memberships, entered shows, and garnered prizes and publicity. Inspired by the vibrant energy of Coney Island, I created a project of forty-eight pieces, each capturing the essence of this iconic location. You can view a selection of my work on my website: www.gailingis.com.

But it all changed when I joined Lockwood-Mathews Mansion.

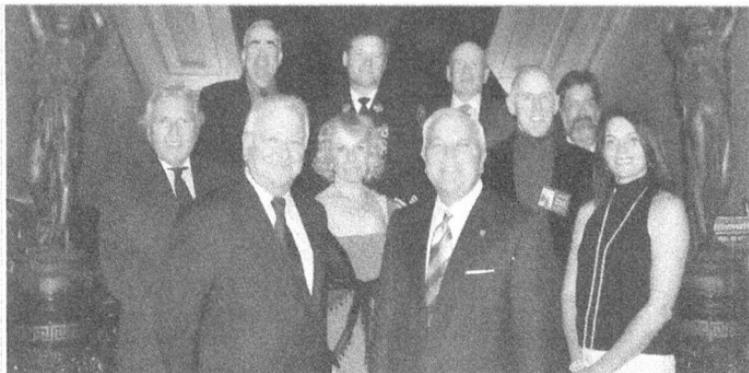

ABOVE: Faces of Fairfield County - the portrait models pose for a group shot: Front Row, left to right Norwalk Mayor Richard Moccia; Lt. Governor Michael Fedele; Middle row, Joseph Barrato, (Westport); Gail Ingis-Claus and Thomas H. Claus PH.D. (Fairfield); Sarah O'Brien, (Easton), Back Row, Cantor Richard Silverman, (Westport); Fairfield Fire Dept Assistant Chief Christopher Tracy, ( Fairfield); James Marpe, (Westport); Captain Joseph Hliva (Greenwich)

*Faces of Fairfield County at the Annual Gala;*
*Gail & Tom at Lockwood;*
*Gail's watercolor of Lockwood, donated to the museum*

# Chapter Forty-three
## Lockwod-Mathews Mansion ~ 1999

I wandered around Lockwood-Mathews Mansion, captivated and curious, exploring the magnificent edifice well before my scheduled meeting in the sixty-two-room mansion. LeGrand Lockwood, the owner, had acquired thirty acres of meadows and marshland, commencing construction in 1864 in collaboration with the architect Detlef Lienau. Drawing upon my extensive historical studies of the period, I couldn't help but marvel at the décor of the renowned Herter brothers.

Passing by the music room, now shrouded in a calm stillness, I envisioned a bygone era when the melodic strains of harpists and pianists undoubtedly graced the air. These master artisans, hailing from Italy, brought

their skilled hands and a rich cultural heritage, leaving an indelible mark on every inch of the estate.

The craftsmanship extended to the intricate details that adorned the interior. The double doors, archways, and hexagon-patterned floors bore the imprint of these artisans, with incised wood layered with burl and ebony trims. The ceilings became canvases for painted designs, reflecting meticulous attention to detail. All surfaces had designs, moldings, and carvings.

Despite the design, a tasteful restraint prevented the ornamentation from veering into ostentation. Each element contributed to a harmonious aesthetic that spoke to the sophistication of the era.

As I continued my exploration, the building became a living testament to the union of artistic vision and skilled craftsmanship. The Herters' influence, evident in the adorned surfaces, expressed an era that valued beauty and craftsmanship. Each detail, from the floor patterns to the painted designs on the ceilings, carried a sense of history and cultural richness.

In my early arrival, I found a grand edifice and a repository of stories awaiting discovery. With intricate design and historical significance, it stood as a witness to the dedication of those who shaped its past. It was a privilege to be present within its walls, a witness to the echoes of a bygone era resonating through its architectural elegantly appointed corridors and rooms. Long

ago, the family held magnificent balls, men and women in grandeur in the mid-nineteenth century. Young debutantes' coming-out parties graced the halls for the first time. Later in the Gilded Age, concerts and celebrations held during prohibition brought a reputation of sorts.

Ann Louisa Lockwood was quite the lady in the nineteenth century. She came alive for me, and I imagined her spending her summers and falls here while raising her children, bowling in the basement, tennis outdoors, horseback riding, and gardening. Her volunteer assignment at the hospital in New York City kept her busy the rest of the year. Mr. Lockwood was often gone, undertaking his business in trains and steamships. The Vanderbilts, impressed with the Herters' work, called upon the brothers to decorate their New York home on Fifth Avenue. Fellow tycoons, Jay Gould, Jacob Astor, and the richest of the rich then followed the Vanderbilts and hired Herter.

Connecticut ASID interior designers gathered for our monthly meeting in the Billiard Rooms. The meeting was convened to ask ASID designers to help restore this historic landmark to what it once was. Florence Mathews, whose father purchased the property after the death of Mr. Lockwood, left the property to the City of Norwalk when she died in 1938. The city used the estate for its offices and storage, hiding its

identity. In the sixties, the consensus by the Norwalk Women's Junior League was to save the building from razing. By this time, the building needed work from misuse and age.

The director asked for volunteers, which created a cacophony of discussion. Without much ado, amid the talk, I stuck my hand up in the air, the only one. What the director needed didn't matter. I wanted to be part of this magnificent piece of history. I dedicated myself to various tasks during my tenure, eager to contribute to its upkeep.

During this period, Mr. Dupont, the esteemed chairman of the board, extended a generous invitation for me to join the board of trustees—an opportunity I wholeheartedly accepted. Little did I know that this venture would become a significant chapter in the journey toward restoration and a turning point, shaping my perspectives and contributing to my growth in unforeseen ways.

My role on the board provided a unique vantage point, allowing me to witness the challenges and triumphs of the restoration efforts. Collaborating with dedicated individuals enhanced my sense of community involvement. Navigating the complexities of fundraising and strategic planning broadened my understanding of the processes.

Once a historical landmark facing financial

constraints, the mansion became a canvas for collective efforts and shared aspirations. As decisions and initiatives arose, I contributed to preserving a cultural treasure.

In the illustrious saga of this estate, unsung heroines emerged in the women's Junior League during the indifferent sixties, when the city considered the estate expendable. My modern-day heroine, Mimi Findlay, bravely fought on many committees, wielding her expertise in antiques, design, and a profound understanding of American history. Recognizing her gallant efforts, Lockwood invited Mimi to a position on the board. Swiftly, she set her sights on the library's restoration, returning it to its former glory with Scalamandre wallcovering depicting leather embossing. This meticulous process involved months of scrutinizing samples until garnering Mimi's approval. I hold Mimi in great regard.

Mimi also orchestrated the triumphant return of furniture, sculptures, and other precious treasures. Auction houses bought the valuable artifacts when Mrs. Lockwood faced the loss of her home because of the shifts in the gold market. However, Mimi's resourcefulness and determination navigated the complexities of acquisition, restoring the estate's treasures to their rightful place, albeit at a cost to the mansion.

Board membership cultivated a profound sense of

accountability and a deeper connection to the mission, and transformed the cause into a personal champion aligned with my values. The challenges and victories during my tenure collectively shaped my character and leadership skills, instilling a profound sense of purpose. This transformative period extended beyond the project, influencing my personal and professional development. The mansion's restoration journey mirrored my evolution, resulting in a newfound sense of self.

As the years unfolded, the financial limitations substantially hindered the mansion's revitalization. The struggle to secure funds became a recurring theme, creating a formidable challenge for the sustained preservation of this historical landmark. The need for innovative solutions became increasingly evident. In a moment of inspiration, I raised my hand and proposed the introduction of art exhibitions. Such an event would attract distinguished and gifted artists along with their guests. This endeavor promised not only to generate much-needed revenue but also to expand our membership base. It offered an opportunity for publicity, benefiting both the art show and the mansion. The idea garnered enthusiastic support, and the inaugural art exhibition signified a pivotal moment in our efforts.

However, the path to restoration could have been more straightforward. We navigated through leadership

changes, each director bringing their personal vision and approach to the table. Finally, Susy Gilgore assumed the role of director. Her leadership style, marked by vision and dedication, proved instrumental in reshaping the trajectory of the mansion's restoration.

Susy worked in tandem with Patsy Brescia, who not only held the position of chairman of the board but also demonstrated an unwavering commitment to the mansion's cause. Patsy's tireless efforts became a driving force behind our collective pursuit of restoration. Susy and Patsy formed a dynamic duo, steering the mansion through the complexities of fundraising, volunteer management, and strategic planning along with Doug Hempstead, chairman of the board, and the trustees. They, along with many others, etched their names in history.

While delving into the details of our challenges and triumphs would require an extensive account, it's crucial to acknowledge the indispensable role played by our donors, teams of workers, and dedicated volunteers. Their contributions, financial support, and hands-on involvement became the lifeblood of our restoration efforts.

Under the stewardship of Susy and Patsy and the collective commitment of everyone involved, the mansion is undergoing a transformative restoration. What was once a dream fueled by the passion of a few

has evolved into a collaborative effort that breathes new life into the mansion's historical splendor. With each step forward, the journey continues, revealing the resilience, dedication, and collective spirit that defines our shared commitment to preserving this architectural gem and restoring the mansion to its former glory. The completion date is coming closer. We might possibly move back in by Christmas 2024.

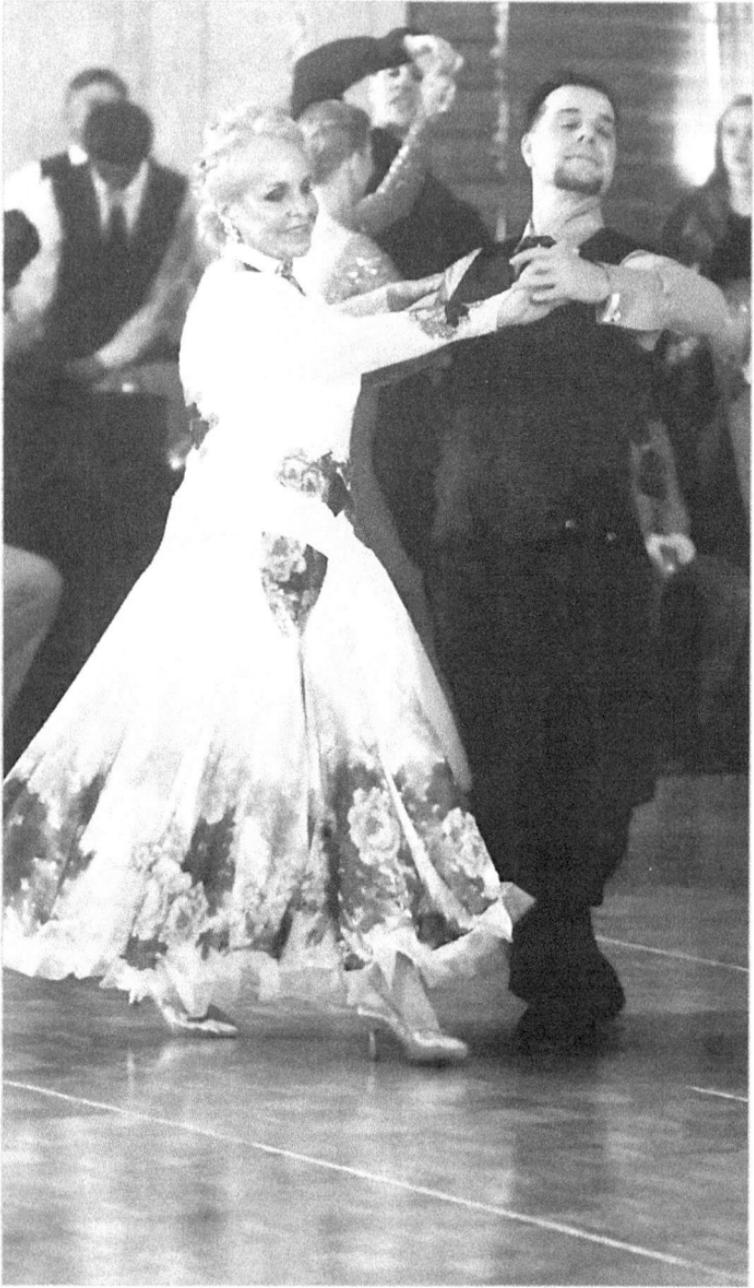

*Dancing Queen at 81!*
*(Gail & instructor/dancing partner Henry)*

# Chapter Forty-four
## My Heart for a Waltz ~ 2015-2024

A dream of enchantment and grace swept me away a month shy of my eightieth birthday. In the ethereal embrace of a partner, we twirled gracefully across a dance floor illuminated by the soft glow of twinkling lights. The timeless melody of Strauss's "Beautiful Blue Danube"sounded sweet in the background. Every step felt like poetry, every movement a brushstroke in a masterpiece. Draped in an ankle-length silk gown, I felt like a vision of elegance, the fabric swirling and cascading around my legs with each graceful turn.

But the dream didn't end there. After a lavish dinner, while Tom lost himself in the pages of a Julia Quinn Bridgerton book, a question lingered in the recesses of my mind, demanding attention. How could I

approach Tom with my heart's desire? Fidgeting with the comb in my hand, I felt a flutter of anticipation in my stomach. I pushed aside any lingering doubts, summoning the courage to speak. With a determined breath, I smoothed down my blouse and tucked it neatly into my belted slacks. With my short hair in place, I was about to embark on a new adventure.

"Tom, there's something I've been meaning to ask you," I ventured, interrupting his quiet reverie.

He looked up from his book, curiosity dancing in his eyes. "What is it?" he inquired, setting aside the book with a gentle sigh.

Summoning all my courage, I approached him. 'Will you learn to dance for my eightieth birthday?' It was a bold request but one that I felt compelled to make.

His brows furrowed in surprise, but a soft smile tugged at the corners of his lips as he leaned forward, clasping my hand in his and pressing a tender kiss to my knuckles. "And what might that entail?" he mused, his eyes alight with curiosity and affection.

A surge of warmth washed over me at his response, encouraging me further. "Embarking on this journey together, taking dance lessons side by side," I replied, the air between us crackling with newfound excitement.

His smile widened, a playful glint dancing in his

eyes as he pondered my proposition. "And where do you envision us taking these lessons?" he asked, his tone laced with playful intrigue.

Inhaling deeply, I summoned the courage to unveil our next adventure with a delicate cadence. "Fred Astaire Dance in Southport," I answered.

For a moment, there lingered a hesitation, a delicate pause that spoke volumes. Sensing Tom's uncertainty, I softly murmured, "Perhaps I shouldn't make such a request."

His nod was slow and deliberate yet accompanied by a tender gesture. Tom brushed his lips against my ear before giving me a kiss of reassurance and affection.

And so, our journey unfolded, leading us into the dance, an unexpected turn that promised challenge and delight. We wore special shoes with suede soles to help glide us over the wood floor as we danced. Our first lesson split us into two sessions—me with Henry and Tom with Monika. We learned the basic steps, the posture, and the rhythm. It was a lot to take in, but we were determined to master it.

"When will I dance with my husband?" I dared to inquire, a longing laced with hope, seeking reassurance in the unfamiliar steps of our newfound endeavor.

With a reassuring smile, Monika offered a promise. "After a few lessons."

Yet, as the moments unfolded, patience became

companion and adversary. This was a test of resolve in the face of anticipation. Daylight bathed the studio in a golden hue through four windows adjacent to the mirrored wall, silently witnessing our journey. In the evening, the track lighting's golden glow filled the space.

I cantered my head and didn't reciprocate the smile. "How many is a few?"

Henry interrupted. "Come on, Gail, let's get started. Monika will take good care of Tom. He'll be dancing before you know it."

Henry and I danced to the tune of Sinatra's "I've Got the World on a String." Monika tenderly guided Tom through the steps to the same music, each motion a testament to the promise of progress and growth.

We glided around the spacious floor counterclockwise, mirroring the steps precisely. Monika offered guidance to Tom, while Henry did the same for me. Before I knew it, the forty-five minutes had flown by, and our first lesson ended.

I took a deep breath, looked into Henry's eyes, and turned to Monika. "Maybe we can learn to dance together?" I suggested, holding my breath with a reasonable pause.

"No, it's better to teach Tom separately," Monika said.

Despite my eagerness to dance with Tom, I resigned

to the waiting game. "Well, I guess I must be patient," I said, determined to see this journey through.

As we set our course, our contract gave us thirty lessons secured at a senior discount. Although we were grateful, it was still expensive. We scheduled three lessons a week, with Fridays reserved for refining our steps in practice. In addition, Saturday night parties dancing to live music once a quarter kept us on our toes. The financial commitment was significant, but we were determined to make the most of it.

In the hush of the studio, amid Sinatra's croon, Henry led me through the intricate steps of the Foxtrot. I stumbled in the ebb and flow of our movements, coming to an abrupt halt. Arms dropping, Henry's voice pierced the silence. "Is there a problem, Gail?"

"Yes. I thought I knew how to dance, but I'm clearly in the dark."

Henry explained, "This is ballroom dancing."

"Ballroom?" I asked, curiosity piqued. "Why is this different from what I've danced all my life? What's the difference between your style and mine?"

"We teach competitive ballroom," he said, stepping to the stereo and shifting the melody to another Sinatra song. "It demands more—coordination, stamina, grace —qualities beyond social dance."

My gaze drifted to where Tom and Monika moved

in synchronized grace. Henry's words echoed in my mind. "So, what Tom is learning—it's not social?"

Henry's gaze met mine. "It is, indeed. But ballroom opens doors to a different world of expression and discipline."

Caught in the web of doubt, I pondered our path. "Perhaps we're not cut out for this."

As we danced through the third lesson, frustration mingled with resolve. Silence in the car ride home placed a palpable tension between us. In the quiet of our shared space, Tom's admission, "I'm not getting this," shattered the stillness. Doubt crept in, casting a blight upon my dreams.

As I lay in bed, eyes tracing the shadowy patterns on the ceiling, a sense of defeat washed over me. What had I done?

There we were, caught in a snare. I should have left, saving money and Tom.

I thought about Tom's statement. Perhaps inspiration would encourage him. Would he compete? I'd discuss it with him. Competing would push me to work harder, exercise, and do anything to improve my posture, dance steps, and rhythm. I lost myself in the idea.

But then—"You're a beginner," Henry said to me at the next lesson when I mentioned it to him.

I realized the difference: the hold of the dancers, the

Foxtrot's speed, the complicated steps. I only knew it as a slow dance. There was so much to learn.

"It's frustrating, Henry. I want all the instructions now."

"New students can't handle too much information. Like anything you learn, there's beginner, intermediate, and advanced."

Henry wore me out. I stopped to hydrate and looked over at Tom dancing with Monika. He cut me a wicked look. I lowered my eyes as Henry and I continued to dance.

We were quiet in the car. Tom told me he didn't like the dancing and felt it was too challenging. I lost the drive to dance with him and the reason to work hard and spend so much. That thought pounded through my mind as I lay in bed that night. I was on my back staring at the ceiling, totally still, totally humiliated. Is this what I wished for?

The supportive partner, Tom, agreed to take dancing lessons with me, even though it wasn't his cup of tea. My heart was set on us dancing together, but our teachers believed it would be better for us to learn separately. Their intentions were good—they wanted us both to grasp the fundamentals—but it made things tricky. I was eager to practice with Tom by my side, but instead, we found ourselves on different paths in the dance studio.

Despite his best efforts, Tom never quite found his rhythm with the dances, except for the waltz. Like *Waltz Across Texas,* a song by Ernest Tubb. I loved doing this with Tom. But he struggled with leading other dances, and the music, primarily contemporary tunes from the '60s and later, just wasn't his style—he's more of an old country guy. But he knew I loved dancing, so he kept taking the lessons.

"You're a natural with Monika, a vision in a crimson sweater and denim," I offered, hoping to buoy his spirits.

"But if I'm not at ease, what's the point?" Tom asked, his resolve tinged with unease. "I'll press on, but the discomfort gnaws at me."

"Could we coax some country tunes from Monika's playlist next time?" I proposed.

A glimmer of mischief lit up Tom's eyes, and a grin tugged at his lips. "Perhaps," he teased, a hint of rebellion in his tone.

With a single nod, Henry and Monika indulged my whims, and Tom found relief in the twang of a different rhythm, his steps tracing patterns of freedom across the studio floor.

"I can't figure out which dance goes with which music."

"Will you let me tell you?"

Our instructors hushed me.

I never dreamed dancing would raise so many negatives.

Monika told me, "You can't lead him, Gail. It isn't good for your marriage. We've had unpleasant experiences with ladies leading their partners."

"Perhaps if he never heard those words."

"I have no rhythm," Tom said, yet he was dancing with Monika in rhythm to Patti Page singing "Tennessee Waltz." "Dancing with a pro is easier than dancing with my wife."

I realized Tom kept dancing for me and to honor his promise. And while he didn't fall in love with the dance floor, I did. I ended up competing in the 65 and older category and was over the moon to win first place in the Waltz at the New England Tri-Star Championships 2016.

With the coveted first-place certificate in hand, I basked in the glow of victory, surrounded by jubilant comrades. Tom and I may not have shared the spotlight, but his unwavering support remained my steadfast anchor. He was proud of me, cheering me on from the sidelines, even if dancing wasn't his passion. I still wonder if things might have been different had we learned together, but in the end, I'm grateful for the experience and the joy it brought us both in our own ways.

WHEN HENRY and I took our final bow, the thunderous applause that ensued ignited a fire within my soul—a validation of dedication, a triumph of perseverance.

But as the echoes of applause faded into memory, the onset of the COVID-19 pandemic in 2020 brought our dance journey to an abrupt halt. With our contract prematurely terminated, I faced a crossroads, torn between my passion for dance and the harsh realities of circumstance.

We returned to the studio in 2022, but in 2023, in a bittersweet farewell to the dance floor, I decided to part ways with Henry and Monika. Departing lifted the weight of financial strain and Tom's promise. As I took Henry's hand for our final waltz, a sense of closure mingled with a tinge of sorrow. Then, suddenly, something happened. One moment, Henry and I were dancing; the next moment, I was not.

Sitting on the sofa with a cup of water, I heard Tom's gentle voice break through the haze. "What do you see, Gail?" he asked, his concern evident.

The world seemed to spin and blur, like emerging from a dream into reality. To my left sat Tom, a steady

presence on the sofa. Henry sat on the matching sofa across from me.

"Should I drink the water?" I asked as if it held the key to unraveling the confusion.

"Do you know where you are?" Henry's voice pierced through the fog of uncertainty.

"No, where am I?" I replied, searching for clarity in the dimness.

"You're in the dance studio. Can you see it now?" Henry prompted. His words were a lifeline in the darkness.

"No, not yet. Give me a moment," I murmured, squeezing my eyes, willing the pieces to fall into place.

The room remained shrouded, a puzzle waiting to be solved. With each blink, fragments of furniture materialized, slowly merging into coherence. It was a disorienting experience, reminiscent of the transient global amnesia I had encountered years before, yet this episode was mercifully shorter.

Flashback to 2008: The first time this happened, I was enrolled in a master's program concentrating on disability studies at Stephen F. Austin University, hoping they would accept my credits from Parsons. One afternoon, during a phone call with the program director, a wave of blackness washed over me. I must have been quiet for a moment, because she said, "Gail, are you there?"

"Everything is black; I can't see anything."

"Where are you?" the director asked.

"I'm in the basement," I said.

"Listen to me," she said, "Go upstairs, go outside, and wait."

I did as she said, walking up the first two stairs. That's all I remember. I woke up in the hospital. Tom sat on a chair opposite me, and my friend MaryAnn came later. Tom told me that our neighbors helped get me in an ambulance. I think I remember getting into the ambulance, then nothing. Our neighbor across the street had a cousin call Tom at work. Tom asked me for MaryAnn's number, and I gave it to him. At some point, she appeared. Six hours vanished from my memory. The sterile white walls enveloped me, and the hospital room emitted a stark antiseptic smell. The diagnosis: transient global amnesia. (TGA). The episodes seem to happen with stress or distress. Though worrisome, this this event became a part of my journey, a reminder of life's fragility.

But amidst the uncertainty, there came a glimmer of light. On a Saturday in June 2024, Monika invited us to a studio competition, and to my surprise, Tom agreed to accompany me. Over breakfast at the Paterson Club, Henry's spontaneous tango invitation caught me off guard, yet I found myself swept up in the dance, however unprepared I may have been. We moved in

harmony for sixty seconds, Henry's praise a testament to our unexpected synchrony.

As we watched Southport Studio's students secure second and third place, a newfound eagerness ignited me. Monika's invitation to return to the dance floor sparked a renewed sense of purpose, a reminder that even in the face of uncertainty, the joy of dancing remained a beacon of hope.

On a sun-drenched day in 2024, stepping back into the dance studio felt like crossing the threshold into a realm of magic and rhythm. The warmth of the welcome enveloped me, a tangible embrace that whispered of belonging. This studio was more than just a space for dance—it was a vibrant community that thrived on shared passion and celebration.

Henry and Monika, still the epitome of excellence as instructors, had blossomed into extraordinary dancers. Their movements were fluid poetry, each step a testament to their unwavering dedication and boundless love for the art. Their passion ignited a spark within me as they glided across the floor.

In their hands, the studio had transformed into a sanctuary of creativity and skill. Their commitment to pushing boundaries and exploring new horizons had elevated the studio to unparalleled heights, drawing renowned figures from the dance world to its doors.

"What sets them apart is not just their technical

prowess but their ability to inspire," I said to Tom, admiration coloring my words. The invitation of famous dancers and instructors was a testament to the studio's standing in the dance community.

After eight years of dedication, I can proudly say that my husband, Tom, has kept his promise to learn how to dance and has become quite the twinkle-toes! When the music starts, he turns to me with that mischievous grin and asks, "Alright, which dance fits this tune?" The catch? Tom isn't a fan of classic ballroom music; he's got a heart that beats for country. And let me tell you, he can keep rhythm with the best of them when those fiddles and guitars start up.

We've spun around the dance floor at our grandchildren's weddings, bringing a bit of honky-tonk flair to the celebrations. On Friday nights, we head to our local ballroom for a practice session, where Tom dances with me and I fall in love with him all over again.

*Travels with Gail & Tom*
*Bruce Museum, Greenwich, CT;*
*Fun at The Grand Ole Opry in Nashville, Tennessee;*
*Barcelona beach, Spain after dancing in the street!*

# Chapter Forty-five
## The Next Chapter ~ 2019

Allow me to spin the tale of Tom Claus, gracefully pirouetting into retirement five years ago. Yes, you read it correctly—Mr. Claus (or Dr. Claus) bid farewell to his illustrious career, but we are still in Connecticut.

We look toward the future horizon, eager to discover what new adventures await in the chapters yet written. And to keep things whimsical, it's yours truly, Mrs. Claus, steering the sleigh of life.

But let's rewind to the beginning of his career, a journey worthy of cheers—from a BS in chemistry at Wheaton College to a PhD in biochemistry at the University of Illinois, Chicago. There are no breaks for tennis, mind you. At Vanderbilt, he delved into the mysteries of glucagon (sounds like a cure for sore

throats) for a dozen years before venturing into the pharmaceutical world. (Is that a drugstore?) At American Cyanamid and Bayer, he led scientific expeditions to discover new drugs for type 2 diabetes. In his memorable twenty-six-year career, he even managed to get a drug to the FDA. Alas, the elusive market remained out of reach. But we don't dwell on what could have been; we celebrate the journey and the brilliant mind that led the way.

In the final twelve years of his professional journey, Tom donned the hat of a medical writer, weaving tales that allowed pharmaceutical companies to share the narratives of their clinical trials. After a half-decade of zooming down I-95 to Stamford, Connecticut, fate played its hand, and the company shuttered its office doors—blessings in disguise, as those in charge bestowed upon Tom the luxurious gift of working from home. My house hubby could now relish a local lunch and be home in time for supper. Despite his maintaining a regular eight-hour workday, or sometimes more, I couldn't help but revel in the joy of having him close by.

Now, let's dive into the heart of the matter. Tom's remarkable feat as a husband for three decades is beyond reproach. When we tied the knot thirty years ago, Tom made me an offer I couldn't refuse—he'd wash the dishes and clean the kitchen if I cooked. A fair

trade, right? Now, he has taken on the roles of launderer extraordinaire and vacuuming virtuoso until I'm available. He's become the perfect house hubby, and I must say, he's pretty good at it. Move over, Martha Stewart!

As the years have danced by, I reflected on the beautiful legacy I'm leaving behind for my cherished family, friends, and readers. It's not only about the devotion I've been fortunate to share with my adoring husband, Tom, over our remarkable thirty-one years. It's also about the love he's extended to the family I brought into our union—a family he wholeheartedly embraced as his own, supporting me through the challenges of being a single mother and grandmother after my first marriage ended.

And let's not forget his prowess on the tennis court. A high-level player, he once ruled the courts in New Jersey with his squad. Since our move to Connecticut in 1995, he's found new opponents, me being one, and trust me, he gave me a handicap, shortened the court, and although I made him run, he still won. He considered my hip and shoulder issues and was easy on me. It's all in good fun, though.

As for hobbies, Tom's not one to sit still. While he can't play the guitar anymore due to a finger quirk, he's open to learning the piano, painting, sketching, knitting —you name it. We're on the lookout for that perfect shared hobby.

So, what's next for Tom in this new chapter?

A hobby may be around the corner. Let the vibrant energy of retirement adventures continue. As we ponder the following steps, the specter of travel looms. Yet, the current climate casts shadows of uncertainty. The ground that my mother kissed in 1914 is no longer universally kissable. The troubled world outside raises caution flags when considering the prospect of traversing it.

Amid these reflections, the joy of singing in our church choir has returned. Perhaps there's a melody waiting for composition, a song of service for the church, a venture that aligns with our shared love for music and community. We still hold hands on our daily walk.

Yours joyfully,

Mrs. Claus (aka Gail Ingis)

**Enjoyed my book?**
I'd love to hear your thoughts!
Your feedback helps others discover new reads.
Please take a moment to scan the QR code below
to leave a review on Amazon.

Thank you,
**Gail Ingis**

Paintings by Gail Ingis:

Madison Marsh;
Waterfall;
Portofino Charm;
Victorian Foyer;
New York Fifth Avenue 1925;

Complete gallery:
gailingis.com

# Author's Note

*The Not-So-Grammatical Beginning*

Who would've thought that a third-grade grammar failure could one day be a writer? Certainly not my third-grade teacher, who saw my grasp of grammar stop short at nouns and verbs. Yes, I could identify a cat as a noun and jump as a verb, but stringing them together into something coherent? That was another story. Despite the rocky start, they never kept me back. Little did anyone know, I was quietly crafting poetry all along —though I didn't realize it was a gift, just that I liked the rhythm of words.

*A Historical Struggle*

High school rolled around, and with it, the infamous American History class. Let's just say, it didn't roll very smoothly. I failed it—not once, not twice, but three times, including two attempts in summer school. It's almost as if history itself didn't want me to pass!

*From Failing History to Teaching It*

Fast forward to adulthood, and irony came knocking. I was asked to teach History of Architecture and Interior Design—yes, you read that right, history! My first thought was, "You've got to be kidding me!"

But, instead of running for the hills I hit the books from what I devoured at the NYSID. I had immersed myself in the history of interior design and absorbed

it like a sponge at NYSID. Why? Because I loved it! I took the three-hour exam and finished it in 20 minutes and got an A. I armed myself with knowledge, and soon enough, my confidence blossomed teaching the subject at three universities for over fifteen years.

Those interior design students needed to know their furniture from their façades, and who better to teach them than someone who had failed history not once but thrice?

It turned out, history just needed a new perspective —mine.

*The Civil War Comes Calling*

And then came my foray into fiction, where my dyslexia had one more laugh at my expense. My first novel? It was set during the Civil War. Yes, the very war that once flunked me now found its way into my writing. Life, as they say, has a sense of humor, and so do I. So, here's to all of us who struggle—sometimes, the very things that challenge us become the things we conquer.

# Author's Note

*Memories*

I thought I'd wrapped up my memoir with a neat little bow. My story included most pieces, the professional life in design and architecture, the tennis teaching and matches, the art and painting sessions, and all the other adventures I'd embarked upon. But just as I was about to file it away as a well-done job, my mind played a little trick. "Hold on a second," it said as if casually flipping through the pages of my life. "You forgot a piece. A big piece, right in the middle."

Ah, yes. That detail about moving to Alley Pond Park in Queens. How could I have overlooked that? It wasn't just any move—it was the move. The one that happened because my cousin Marilyn, in all her wisdom, pointed out how perfect the neighborhood was for young mothers. And there I was, pregnant with my first child, ready to embrace suburban bliss.

It's as if my psyche had been saving this nugget of a memory for just the right moment, waiting until I knew the memoir was complete before dropping it on me like a plot twist in a novel. And what a twist it was!

Suddenly, the narrative had a gaping hole in the middle. I could almost hear my brain chuckling in the background, pleased with itself for pulling off such a clever trick, despite the memoir's apparent completeness.

But as I remembered Alley Pond Park, and the title glared at me from the page, the memories came pouring in. Each built on the one before. Just when you think you've got it all figured out, your memory throws you a curveball. And so, with a smile, I went back to my manuscript, adding in that missing piece. I've learned the mind has a way of keeping us on our toes, reminding us that occasionally the most important pieces are the ones we almost forget.

Writing this memoir was an adventure!

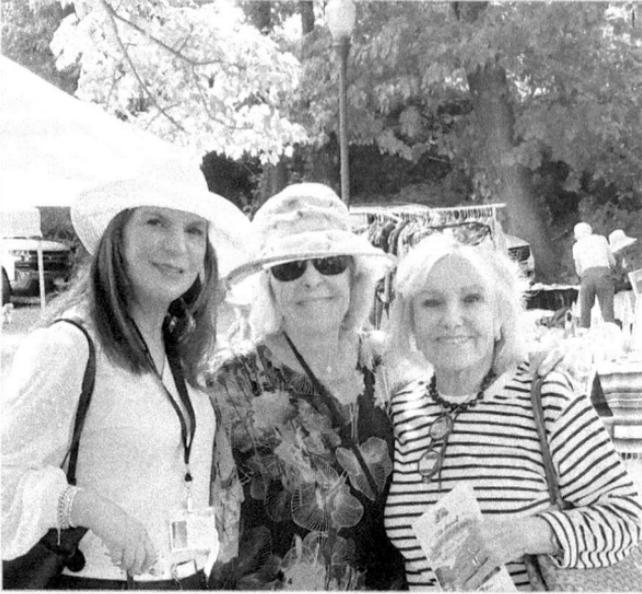

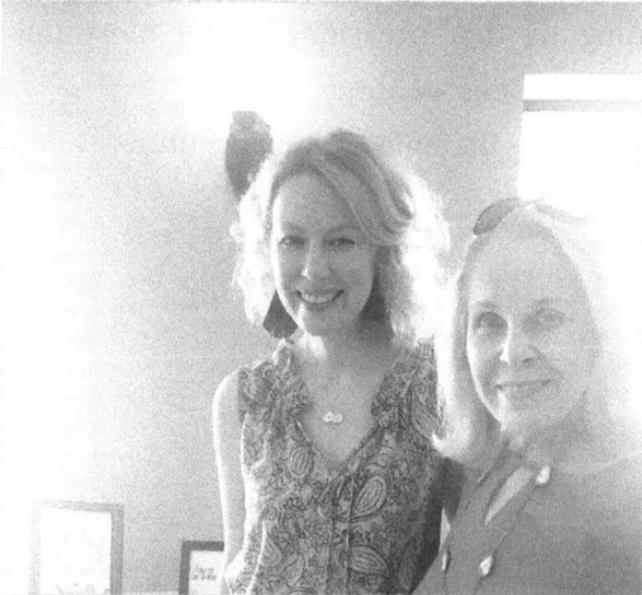

*Talented women - beautiful friends*
*Susan Gilgore, Executive Director of*
*Lockwood-Mathews Mansion Museum with Gail & Gigi;*
*Rebecca Lamvol, Executive Director of Beautycounter with Gail*
*at the Fred Astaire Dance Studio in Fairfield, CT*

# Discussion Guide
## More Than One Life
### By Gail Ingis

*For Bookclubs and Workshops:*

## Introduction

Welcome to the discussion of *More Than One Life*, a memoir by Gail Ingis. This book takes readers on a journey through the vibrant and challenging experiences of the author, exploring themes of family, personal growth, and the pursuit of passions. Use these discussion points and questions to guide your conversation and dive deeper into the rich stories within the memoir.

I. **Family Dynamics and Relationships**

- **Mother-Daughter Relationship:** Explore the

complex relationship between Gail and her mother. How has your relationship evolved throughout your life?

• **Impact of Loss:** Discuss the impact of the loss of Gail's mother in 1984 and how this shaped her reflections on their relationship. How does loss effect your life?

• **Friendship:** Lifelong friendships are like a cozy old sweater—sometimes a little frayed, occasionally mismatched, but always there to wrap you up when life gets chilly. From inside jokes that no one else understands to bailing each other out (literally or figuratively), these bonds withstand bad haircuts, questionable decisions, and decades of shared adventures. Through all the laughs, tears, and embarrassing stories, a true friend will always have your back—even if they're the one who pushed you in the first place! How have friendships shaped your life?

## 2. Pursuit of Passions

• **Music and Dance:** Examine Gail's early experiences with music and dance and how these passions

influenced her life. What are your passions, and how have they influenced your life?

• **Art and Teaching:** Consider how Gail's love for art, music and teaching manifests in her professional life, especially her founding of a school. How have your own pursuits affected your professional life?

## 3. Personal Growth and Resilience

• **Challenges and Triumphs:** Discuss the challenges Gail faces, such as her struggle with dyslexia and her difficulties with academia. How does she overcome these obstacles? Do you have similar crisis, how do you deal with them?

• **Evolving Identity:** Reflect on how Gail's identity evolves over time, particularly through her experiences in marriage, motherhood, and career. Do you see yourself evolved over the years, in what way?

## 4. Cultural and Historical Context

- **1950s and Beyond:** Explore how the cultural and historical context of the 1950s and subsequent decades influence Gail's experiences. How does she navigate the societal expectations of her time? Can you relate to how your expectations evolve and in what way?

- **Cross-Cultural Experiences:** Discuss Gail's experiences traveling and living in different cultural settings, such as her visit to Bangladesh. How do these experiences broaden her perspective? How has travel changed the way you perceive your life, and what are the changes you see in yourself and how they affect your family and those around you?

## 5. The Writing Process

- **Memoir as Catharsis:** Discuss how writing this memoir served as a cathartic process for Gail. What role does memory play in the construction of her narrative?

- **Voice and Style:** Consider Gail's writing style, particularly her use of humor, period-appropriate language, and descriptive imagery. How do these elements enhance the storytelling?

*Gail and Tom with friend Lorraine;*
*Graciano & Gigi with Gail & Tom*

# Acknowledgments

Several years ago, when I first delved into the world of memoirs, I never imagined that my life could inspire anyone beyond my immediate family. Yet, as I share my journey with you, I hope to offer a more intimate connection. Along the way, a vibrant ensemble of individuals has played pivotal roles in shaping the person I am today. At the tender age of seven, my first piano teacher, Mr. Bishop, enlightened my mother about the myriad benefits of piano learning: focus, perseverance, diligence, and creativity. His words proved to be a profound truth!

I would like to extend my deepest gratitude to those who have passed through my life, encouraging me, helping me solve problems, and pushing me to engage in activities that benefited others.

To my fantastic family, thank you for your support. Thank you to my children and my grandchildren, who have helped me become a better mother and grandmother.

My son Paul who asked me to record my memoir. *"Only your voice will do, Mom."* And my daughter Linda Sklar, who listened to the memoir and made corrections. *"Star Trek, not Star Wars, Mom."*

Gigi Duarte and Graciano, whose generosity changed the course of my life. Sadly, the world lost Graciano last year. Thank you to Harriet and Bernie Shavitz, brother Jay S. Gerber and Barbara, Ted and Judy Ingis, and our amazing supportive families.

Enormous thanks to my special team for encouraging me during the writing of my memoir.

Thank you Miggs Burroughs for your patience and fantastic cover design.

Joanna D'Angelo, without whom none of this would be possible. Joanna is my amazing editor, publicist, friend, and confidant, and I thank her for her enthusi-

astic support, plotting, creativity, wisdom, and guidance. She pushes me to reach higher with every word, every line, and every page.

Jennifer Catalano, graphic designer and artist: I want to extend my heartfelt thanks for the incredible work she's done in designing and editing the pictures for my memoir. Her talent and artistic eye have brought my memories to life in ways I couldn't have imagined. The attention to detail and care she put into every image is evident. I'm grateful for her dedication and creativity.

So, let me tell you about Lorraine Davis. We met at New Jersey's Kean College (now a university) on March 7, 1980 at an ASID student conference. ASID was in charge of roomies, guess what, I got paired up with Lorraine.

I knocked on the dormitory door, and when it opened there stood this tall women with dark hair who looked me in the eye and asked, "Do you smoke?"

"No," I replied.

"Then you can come in."

Lorraine's affiliation was with Paier in Connecticut, and mine was with Kean. After I moved to Connecticut, Lorraine and I connected through ASID and worked together on the ASID newsletter. She just celebrated her 97th birthday, and well, you know mine. I absolutely adore Lorraine.

Thank you to my former students in design and tennis, who have made me a better teacher, your belief in me has been a source of strength and inspiration.

A heartfelt thank you to ASID, an organization that has supported my professional journey in interior design for fifty years. Their unwavering encouragement when I founded my school, has been invaluable, support of my courses for professionals.

To the USPTA, the professional tennis organization, a pillar of support for almost 100 years that has gifted me life membership.

Other guides in art and writing: David Dunlop, artist, instructor, historian, and his team, his wife Rebecca Hoefer and manager Connie Simmons. My amazing orthopedist, Alan Reznik, who gave me back

my tennis serving arm, advised me, and gave me an opportunity to participate in his authoring.

In pursuit of this literary endeavor in 2009, I encountered writer Kristan Higgins at the Fairfield Public Library, who would change the course of my storytelling by suggesting I join the Connecticut Romance Writers of America (CTRWA). Thank you, Kristan.

Jamie Schmidt, an author who supported and helped me first get published. Thank you, Jamie.

Thank you to my first publisher, Soul Mate Publishing; Blake Schnirring, Executive Director, Westport Writers' Workshop; Susan Kammeraad-Campbell; Ellen Gelman; Sherry Soule; Gabi Coatsworth; Rahla Xenopoulos; Jessica Grunenberg; Adele Annesi; Libby Waterford; Connecticut Romance Writers of America (CTRWA); AK Nevermore; Diana Rock; Grace Hartwell.

Thank as well to the other incredible people in my life including: Lockwood-Mathews Mansion Museum Executive Director, Susy Gilgore; Beautycounter Executive Director, Rebecca Lamvol; physical therapist, Diane

Sell; Maria Volpe, RN, and Lia Kekovic, Practice Manager; Margie Lawson; Michael Hauge.

As you navigate your life's pages, I invite you to reflect on the heroes and antagonists in your story—figures that hold untold layers of joy and pain. How have you grappled with complexities within your family dynamics? This shared space is an opportunity for mutual exploration and reflection, a reminder of the compassion and resilience that grow through the structure of our stories. May we embrace the beauty of empathy and personal growth, finding solace in the shared humanity that unites us all.

In addition, your feedback is the beat that warms my heart! Reflecting on my journey feels like flipping through a scrapbook of the wild and wonderful—a roller-coaster ride of gleeful moments. Learning and growing have been my trusty sidekicks, with an ensemble cast of instructors and mentors who willingly became my life coaches.

Thank you to all who have believed in me, supported me, and shared in my journey. Your contri-

butions have enriched my life beyond measure, and I am forever grateful.

*Blessings. This memoir is a love letter to all!*

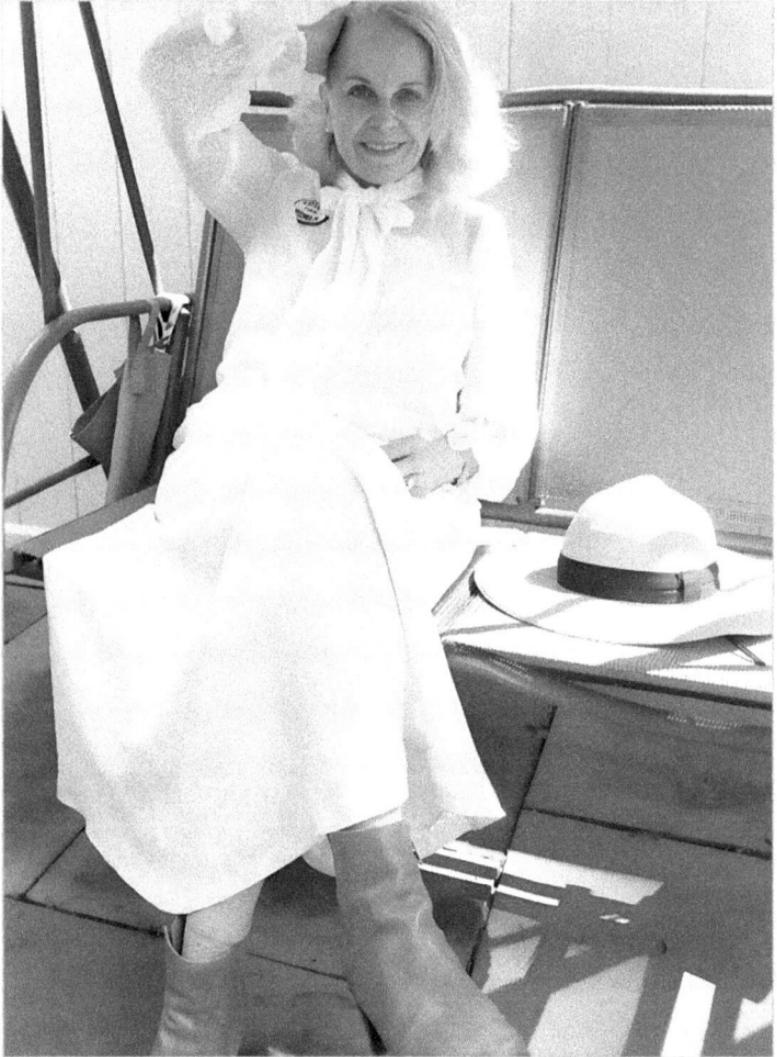

*Author ~ Gail Ingis*

# About the Author

Brooklyn-born Gail Ingis, the author who'll whisk you away into the whirlwind worlds of historical romance, pens tales like *The Memorable Mrs. Dempsey* (formerly *Indigo Sky*) and *The Unforgettable Miss Baldwin*. And just when you think you know her, she surprises you with her memoir, *More Than One Life*, proving she's got more twists than a double helix. Gail firmly believes everyone's life is a novel waiting to be written, and a chance encounter with a stranger is just a prelude to the next captivating chapter.

But wait—there's more! Gail isn't just a wordsmith; she's an award-winning artist whose masterpieces have splashed across the pages of the *New York Times* and other posh publications. If that's not enough, she's also a high-flying art juror, curating creativity at the Lockwood Mathews Mansion Museum in Norwalk, Connecticut, where she wears many hats, including trustee and art curator. No wonder the place snagged a *USA TODAY* award—Gail's got the Midas touch!

Born as Gail Gerber, she's been blessed (or cursed, depending on your perspective) with a name that's as alliterative as a tongue twister. A retired member of the American Society of Interior Designers (ASID) and a proud participant in the United States Professional Tennis Association (USPTA), Gail's interests are as varied as a buffet at a Vegas casino—rich, diverse, and delightfully indulgent.

In 1981, Gail decided to add "founder" to her already bulging résumé by establishing the Interior Design Institute (IDI), which eventually merged with Berkeley College. Her teaching escapades took her to the New York School of Interior Design (NYSID) and other prestigious universities in the New York tri-state area, where she shared her wisdom and wit.

Gail calls Connecticut home these days, where she and her dashing husband, Tom, are living their best lives. They indulge in tennis matches, gardening sessions, Beatrice Potter children's book marathons, popular writers' fiction, and epic Costco adventures, feasting on their delicious $1.50 hotdog, accompanied by a diet soda. Together, they've nurtured five well-bred children, seventeen grandchildren (including four spouses), and two great-grandchildren—and rumor has it, the family tree is still sprouting new branches.

Gail loves to hear from readers. You can email her at: gailingisclaus@gmail.com

Visit her website at: gailingis.com where you can dive into her blog; she's penned over 500 articles covering everything from books to ballroom dancing.

Follow Gail on social media at one or more of the platforms below:

# Books by Gail Ingis

*The Memorable Mrs. Dempsey*

*The Unforgettable Miss Baldwin*

*More Than One Life: A Memoir of Life, Lessons, and Laughter.*